THE BREAKING OF THE IMAGE

THE BREAKING
OF THE IMAGE

A SOCIOLOGY OF
CHRISTIAN THEORY
AND PRACTICE

DAVID MARTIN

Basil Blackwell · Publisher

© David Martin 1980

First published 1980 by
Basil Blackwell Publisher
5 Alfred Street
Oxford OX1 4HB
England

British Library Cataloguing in Publication Data

Martin, David, *b. 1929*
 The breaking of the image.
 1. Christian art and symbolism
 2. Secularism
 I. Title
 301.5'8 BV150

 ISBN 0-631-11041-0

Printed and bound in Great Britain at
The Camelot Press Ltd, Southampton

Contents

PART THREE: REAPING THE UNMARKED SEED

TO MY PARENTS

and Upwey St Lawrence, Dorset

Preface

This book is a considerably expanded version of the Gore
Lectures given in the Jerusalem Chamber at Westminster
Abbey during November and December 1977. It develops
material used for the Ferguson Lectures and given at
Manchester University in February 1976. These lectures
remain unpublished. Both the Gore Lectures and the
Ferguson Lectures were concerned with Christian symbols,
and with the complicated relationship between Christianity
and secularization. I gave further consideration to the
problem of Christian symbolism in a series of lectures
delivered at Durham University in February 1978. These were
concerned more directly with questions of liturgy and form
the second part of the book. The third part of the book
touches on the general relation between Christian symbols
and social change.

My original interest in the question of symbolism was
stimulated by my friend Thomas Luckmann. He asked me to
develop a notion which I had casually put forward
concerning the use of the *double-entendre* in Christianity. I
tried to do just that in a paper for the socio-linguistics section
at the Toronto International Conference of Sociology, 1974.
That paper is now decently interred in the proceedings of the
Conference but it underlies the argument presented here.

I would like to say how grateful I am to Professor Ronald
Preston for the original opportunity to present ideas on this

subject, and to Dr Carpenter, Dean of Westminster, for giving me space and room to bring them to a more mature expression. After all, the dialectic with which I am concerned could not be better illustrated than by that royal peculiar, the Abbey Church of St Peter, Westminster. I might add that I have employed several styles in the course of the book according to the subject matter and I have turned aside to use a specifically sociological style in Chapter 7. Some parts may even gain from being read aloud. All quotations from Scripture or the liturgy are from my memory of the Authorized Version or the Book of Common Prayer.

Chapter 6 appeared originally in *Theology*, March 1979 and Chapter 1 in *The Epworth Review*, May 1979.

PART ONE

FRAMING THE IMAGE

Christe, palma bellatorum, hoc in municipium
introduc me post solutum militare cingulum,
fac consortem donativi beatorum civium –
St Peter Damiani

For he is our peace, who hath made both one,
and hath broken down the middle wall of par-
tition between us; having abolished in his flesh
the enmity, even the law of commandments
contained in ordinances, for to make in himself
of twain one new man, so making peace.
Paul to the Ephesians, Chapter 2,
verses 14–15. (Authorized Version)

(The middle wall partitioned the temple between the
outer court for Gentiles and the inner court for Jews
only; here it also signifies the law and all separation
between man and man, and man and God.)

1

Transcendence and Unity

A sociologist has no remit to talk about God. If he were to talk directly about God he would immediately convert himself into a theologian or a philosopher of history or a prophet. To speak of God in the world is an act of unveiling. A prophet looks at the seeming flux of events and discerns the finger of God. He brings out the invisible writing and identifies it as *the* true Word. It is no business of the sociologist to distinguish the true and lively word from any other statement.

Sociologists are scientific scribes concerned with verifiable and falsifiable statements and with more or less correct propositions about social processes. They try to transcribe what happens as accurately as they can and give a reasoned account of the rules that undergird what happens. They make connected sense out of the patterns that are thrown onto their field of social vision and hope that this connected sense is more controlled, more rich and rigorous than everyday observation. Most everyday observation is *ad hoc* wisdom, or proverbial *nous*, broad expectations built out of the stuff of experience, without much attempt at refinement or interconnection. Sociologists are specialists in social connections and in making that web of connection tighter and more comprehensive. But that has nothing to do with finding the finger of God, unless of course his finger is in the making of every social pie. If that is so they may safely ignore

him. If God is up to everything then his activity may be elided. A God who contributes nothing distinctive does not matter, so far as social science is concerned.

So sociologists cannot point out 'God' because that is a normative activity outside the remit of science; and they cannot take account of what is merely coextensive with the whole. It is impossible to pick out a particular word and say *this* is *the* Word or to identify the Word of God with the sum total of everything that is said. So what is there to say?

Suppose we ask how men transcend their situations. Perhaps the proper adjunct to thinking normatively about God's activity is thinking positively about man's activity. I do not mean that one can make a transition from describing the activity of man to discerning the activity of God. But it could be that the act of describing, interpreting and ordering man's activity, that is sociology, can be used to circumscribe how we talk about God.

So when we describe man's activity as a social being we cannot insert a separate mysterious X as a God variable. God is not a part of the ensemble of variables. Nor is he a residual factor left over when the rest of the variance has been satisfactorily accounted for. Of course, sociology is constantly confronted by left-overs. That doesn't mean we can identify God as the murky residuum of multi-variate analysis. So I have already excluded two notions. God is not the Ensemble of all that is, that is the Totality, the All. Nor is He an Unexplained Remainder. There is not much interest in a God who is nothing in particular because everything in general, nor in a God who has been remaindered.[1] To put the matter epigrammatically: God is not *the* whole, nor is he *a* hole. A hole-in-the-multi-factor-analysis God will not *do* and cannot *be*.

The point can be extended a little before passing on. Social activity comprises rule-governed processes which are in principle understandable and explicable. We may find them

surprising from time to time, but they do not come as bolts from the blue. Social activity is no more visited from the blue than meteorology is disturbed by bolts from heaven. It follows that there is no room for a trickster-God or a being who suddenly suspends the rules for a brief period of pure inexplicable activity. A social mutation may occur but it does so within the ambit of understandable processes in which we discern no intruding arbitrary element. Social mutations are on all fours with natural mutations insofar as our webs of explanation do not require a randy spontaneous Divine Pusher. Indeed, there is another similarity. Most natural mutations are regressive, and only a few are eventually selected out of the range of mutations. Likewise most social mutations are defective and only a few survive the complex challenges of changing social environments.

However, at this point we have to pause and distinguish rather carefully. Social mutations are not discrete entities, confronting an environment. Societies are organic and continuous, and involve constant shifts, adaptations, adjustments. They absorb shock and incorporate experience. This does not mean that they are entirely shaped by the learning process, because they already possess a semi-determinate character. They have acquired profiles and their mode of adaptation is consistent with those profiles. A social group is of a particular sort and it will breed characteristic kinds of action and response. Yet the human beings who comprise a social group are not determined. They learn over time and envisage alternatives or variations. Men cognize their situation and recognize certain potentialities in those situations. Thus once cultural evolution takes off it is relatively swift in its operations.

This cultural evolution is one aspect of consciousness. We do not know how the germ of consciousness grew but it is abundantly clear that awareness of self and others and the world enormously accelerates the processes of change. It is

equally clear that there is a further acceleration once men grasp the fact that they can play a part in their own development and can re-act back on the slower processes of biological change. Consciousness is one great shift; consciousness of what consciousness can achieve is another great shift.

These standard observations are a necessary prolegomenon to the main issue, which is man's ability to transcend and transform his situation. However, this potential is rooted in limitation and constriction. An enormous amount has to be 'given' before men can even begin to envisage that which is not 'given'. The open-ended possibility cannot occur without an antecedent programme which is both genetic and social. Unless the biological base is automatic and the social base carefully programmed in terms of rote, role and rite the take-off cannot occur. Of course there is much dispute at the moment between sociobiologists, biologists and sociologists as to the precise point where the programmes initiated by socialization take over from the basic biological progammes. For this present discussion the line of demarcation hardly matters. The enormous variability of man's social arrangements and his cultural worlds at least suggests that a substantial sector of biological openness has been pre-empted by socialization. And since the patterns of socialization once set up remain fairly stable it seems that socialization involves a substantial degree of closure. So the human being is doubly stabilized by biological inheritance and by the patterning of culture as imprinted by socialization.

The central point is that man cannot envisage what transcends his situation unless he is built up and stabilized by heavy programming. What is not set cannot see. A man cannot speak a new word unless the basic grammar has been already imprinted in his system. He cannot initiate a new practice unless socialization has cut down the enormous range of social options to a limited more or less coherent sector. Socialization selects a limited group out of the overall

range of social options and gives them a minimal coherence. Without the bio-grammar and the pre-selection of a particular limited language of social intercourse the human being would be destabilized.

Without stability and without fixed points in the social universe it is impossible to generate new combinations and initiate alternatives. Without the given there can be no alternatives: no Alter, no Other. This is not to say that every set of givens contains equal potential for alternatives. Some of the options selected by socialization contain more potential for alternatives than others. Some societies, perhaps most, succeed too well in the primary task of stabilization. They over-conform to the pattern, and the imprint of the sacred template bites too deep to move beyond stability. Conquest or cultural contact may disrupt the stability but without such intrusions and disruptions the pattern tends to reproduction rather than development. Since the necessary condition of any creativity is a given and accepted pattern the majority of societies become over-adjusted and stabilized.

So we have an array of social patterns each of which has cut a limited sector out of the full arc of social possibilities. All of them embody closure in order to survive but some embody more closure than others. It is, for example, perfectly possible for the bio-grammar to be supplemented by a completely formulaic version of socialization. The little sect of John the Baptist Christians is organized almost entirely in terms of verbal and ritual formulae. Or again, upper-class Tibetans employ forms of speech bound in by proverbs and formulae. The formulae ensure stability but inhibit creativity. No contrary vision can disturb the repetitions. Culture becomes almost entirely cyclic. It turns for ever round and round. The cycle is necessary to existence, but once it becomes all-pervasive transformation is inhibited.

The cycles of repetition and stabilization are not inevitable. Some societies will explore those sectors of social option

which allow a historical trajectory: the idea of moving through time to a new era. They will achieve a creative balance between necessary stability and destructive openness. Their view of the world will have an open texture which can be exploited. How does that open texture work?

In such societies the basic images, words and acts go beyond reflection of what already exists. These societies contain possibilities and potentialities as well as reflections of the *status quo*. The Word and the Image transcend the ensemble of what is, and are able to suggest what might be. In the vast majority of societies of course the images and words will project what is, providing a screen on which the social order is writ large. That screen will contain the credits of the society, its company charter, its foundation stories, its sense of distinctive identity, its sanctions and prescriptions, the categories in which it organizes the social and natural worlds. Indeed, every society will project its identity onto a screen and individual members will then absorb and introject that projection, making the social image their own. A society *is* a shared image; and it is also an idea as to which groups are brought together by that image. Not even those societies where the images encapsulate other possibilities can escape the compulsory screening of the *status quo* and the limiting definitions of social self and social identity.

What are the alternative possibilities I have mentioned above? How do they work? Here I must restrict myself to some of the possibilities and potentialities best known to ourselves in our own society and derived from the Jewish tradition. The Confucian tradition, for example, lies closer to the extant reality of societies. In India some traditions reject the social image wholesale in order to protect the comprehensive withdrawal from the given found in classical Buddhism. One thing only needs to be said at this juncture about the major religions which stem from roots other than that of Judaism. Taken together with religions based on

Judaism, they comprise a basic limited set of perspectives on the world. Out of the immense variety of projections and possible social perspectives, there seems to emerge a limited number of basic generators, each of which contains a more or less coherent splay of potentialities and correlative limitations. In the world religions the chaos of options is dramatically reduced to half a dozen or so fundamental visions, each of which allows a particular range of developments, a set of possibilities. The sets overlap; they may meet, mingle and combine. But the distinctive, logically separate roots remain. There are various criteria by which these roots may be categorized and distinguished, such as, for example, Weber's 'Religious Rejections of the World and their direction'. Perhaps the fundamental criterion turns on the vision of 'the world'. Is God (or Truth) to be discovered in the world as it is, or in the world as it may be, or in a harmonized version of the present world, or away from the world in the recesses of self and not-self? There is, in other words, a continuum of degrees and kinds of transcendence.

As I have suggested, each root contains a specific range of potentialities and constraints. In the case of those religions deriving from the Judaic stem, the potentiality centres on positive transcendence and the idea of unity. The transcendent God is one. This is the word and the image. Men grasp at what goes beyond them and at the concept of the One. Because the one God transcends the world as it is and as we know it, His name and His image are both known and unknown. He is revealed and hidden; his name can be spoken and must not be spoken; He is like unto this and like unto that but He has no graven image. To whom then will ye liken God?

To what does the unity of God refer? To transcend is to go beyond. So we must name it and refuse to name it. Men point towards something and declare that it resists definition and nomenclature. Out of this positive and this negative various

possibilities may emerge. One is to bow before the decree of the unknown. The Almighty One has spoken: we obey. Another is to embody that decree in human exploits, more especially conquests, crusades, and holy wars. God's people enforce God's will. Yet another is to refuse to identify any human concept or notion or institution with the transcendent, and therefore to leave an open space in which man may share an undisclosed future with God. This is the way of negative theology: God is not a body, He is without passions or parts. So the idea of transcendence allows various combinations of obedience and co-operative sharing, of certainty and uncertainty. Men are not entirely disobedient to the heavenly vision and are ready to place their will in the hand of God, going out not knowing whither they go. Clearly this vision is open-ended, demanding and requiring movement and obedience, but not specifying the end or filling in the objective. It is a mighty Rorschach blot from which men draw ends and conclusions. They may pursue a holy war in the name of the supreme decree, or go on a pilgrimage to the holy land, or journey to some undiscovered country or celestial city. But whether it is holy war, pilgrimage or journey, there is certainly movement. The very ideas of movement and of *the* movement lie embedded in the apprehension of transcendence. To go beyond is to go *into* the beyond.

It follows that the idea of transcendence must include the possibility of alienation. The alien looks forward, upward and away. Of course, if a man bows before the supreme decree and sees God's rule in all that is, he may consent to the world as presently constituted and be at home in it. Islam is just such a way of being at home in the world, and there is much in Judaism that rejoices in the constitution of things as they are. This acceptance of the world is only a limited good. When men are too much at home in things as they are, and suppose that 'whatever is, is right' then they are aliens to the

possibility of a new heaven and new earth. Yet those who already claim their citizenship is in heaven can be alien to the normal joys of creation, procreation and recreation. There is a very nice point between the pleasures of earth and the hope of heaven which is impossible to reach and sustain. Moreover, although it is true that transcendence allows the emergence of open alternatives, yet the inevitable association between the transcendent cosmic powers and human political powers means that the forces of change may need to attack even the idea of transcendence from time to time. In so doing they are undermining their own long-term foundations.

Yet the radical strain remains active, capable of taking men away from home, or turning them into aliens who seek after another home. The beyond intrudes on the given, revealing its limits and inciting men to uncover new potentialities. The transcendent makes limitation visible. It works in the imperative mood and employs the verbs of coming and going:

'Arise, go down to meet Ahab King of Israel.'

'Arise, go to Nineveh, that great city.'

'Let us now go even unto Bethlehem . . .'

'Go ye into all the world . . .'

'Surely I come quickly . . .'

'The Spirit and the bride say, Come . . .'

Coming and going are the verbs of movement. Command is the characteristic mood of the Word.

Coming and going, alienation and movement are associated with roads and highways, and also with the imagery of marching and battle. These comings and goings can be cast in the mould of actual warfare, crusades and holy wars. Or else they can be cast in the mould of spiritual

warfare. There is on the one hand the marchings of Joshua, Mahomet, Cromwell, or Charlemagne; and on the other hand there are the journeys of Paul, or Francis, or Columba, or George Fox. The military comings and goings demand discipline; the spiritual warfare demands discipleship. This brings us back to the idea of obedience and of subjection. The freedom to move and to create movements depends on discipline and obedience. Every army, and every peaceful brotherhood for that matter, obeys a rule. Freedom is linked to authority. The transcendent impels. When men envisage their freedom to move they are moved by an impulsion. This is the source of very paradoxical language and of considerable philosophical perplexity. When a man is confronted by the transcendent claim there is no choice but to obey. He makes God's will his own and is thereby free. He finds that service is perfect freedom.[2]

So the idea of the transcendent includes in it a wide-ranging vocabulary: a fundamental grammar of motives. This comprises coming and going, pursuit and alienation, pilgrimage and arrival, the free acceptance of service, the compelling nature of choice. The characteristic images are the highway and the city, the exodus and the promised land. One says that the idea of the transcendent *includes* this vocabulary because there seems to be a dialectic of quiescence and movement. Transcendence can also be deployed as the legitimation of whatever is established. Things are established by God so that they *cannot* be moved. A commandment descends from God to man and man must obey the rules. Man bows before the weight of the given and cannot imagine how anything might be otherwise. How should he question what 'Th' unsearchable dispose of highest wisdom brings about'?

So much for part of the vocabulary of motives pendant on the idea of transcendence. It is not that there is a unique association between transcendence and movement or that

movement is impossible without the idea of transcendence. There is no need to assert unique correlations. It is simply that movement is one important potentiality lying within transcendence. It is at least notable that the three movements deriving from this idea – Christianity, Islam and Marxism comprise cultural areas which now contain the majority of the human race.

What then of unity? God goes beyond the given; He is also *one*.

Speaking of the oneness of God I am largely setting on one side generalized ideas of a high god, or a president of the immortals, or intimations of One who lies beyond the apparent diversity of phenomena and above the godlings which represent those phenomena. I am thinking rather of the divine unity as a fiercely apprehended principle which disdains the idols of the heathen and rejects henotheistic compromise. 'The Lord our God is one Lord, beside Him is none else.' The faith in the divine unity *also* generates a vocabulary of motives. These are centred first of all around the invocation of unity in general: the unity of a People and then the unity of mankind. But those who resist unity constitute the 'other', the contrary. There is no invocation of the one which does not engender the contrary; and no unification which does not encounter diversity. Unity must engender duality: us, them, those who inherit the promises and those who do not.

If God is one, then His people must be one, and the rest are those who lie outside the house and covenant of Israel. A passionate belief in unity unifies the community and expels all those who do not share the faith or honour the covenant between God and His people. The unity of God means that men may fall away from Him and from His people. The ordinary distinctions between in-group and out-group acquire a new edge. Indeed, the seductions of the diverse world outside reinforce that edge. The divine unity is encased

in the corporate consciousness of Israel. The normal tendency to remove intrusive elements and maintain minimal group homogeneity is reinforced by the belief in the homogeneity of the divine. The demarcations which mark off a people are reinforced by the boundaries between truth and falsity, true God and idols. Taboos which mark off a People become rules defining the Ark of Salvation. Oneness creates a sharp line of demarcation: 'Little children, keep yourselves from idols.' Oneness is easily associated with the idea of a peculiar people, a covenant, the elect.

From the unity of God springs the unity of the people of God, the unity of the human race, the unity of belief, the unity of human speech. Implicit in unity is the concept of something absolutely inclusive, and that in turn implies exclusion. Unity creates duality and encounters diversity. In the Jewish case, of course, the impulse to unity is held in check by the fact that the truth is located on a biological basis, the peoplehood of Israel. This lowers the tension with diversity, and all but destroys any impulse to bring everybody into the one fold. The capsule of the peculiar people does not expand or take off: it stays as an irreducible peculiarity, co-existing with other peoples.

Indeed, the pressure against Israel from the universal impulse of Christianity or Islam or Marxism makes the Jewish people into an instance of unreduced *diversity*. For that matter the Peoplehood of the Hebrews is a problem for all three universal faiths. Each faith has to 'place' the others. Every universal religion has to see the other as lacking something which could be realized by submission to the one true faith. Insofar as the rival versions of unity do *not* submit they have to be accepted as redoubts of diversity.

Unification is dialectically related to duality and to diversity. This is dramatically illustrated in the aspiration to one, true speech. The tongues of Pentecost united all men in a single speech. Even a sacred language is an archaic expression

of an eschatological idea: the united speech of humankind. (Perhaps I may add in parenthesis that the passionate desire for the unity of science, including even the reductionist impulse, may also derive from the overall notion of the divine unity.) The notion of the divine unity is related to the perception of a world which is a universe not a multiverse.

This vocabulary of unification and opposition, the people of God and the heathen, the people and the class enemy, the social boundaries of truth and unreclaimed soil or un-reclaimed souls is part of the fundamental structure of all those movements springing from the Judaic root. It envisages unity as solidarity in faith or in the covenant relationship. Like the vocabulary of coming and going, pilgrimage and alienation, it has a tendency to militant imagery. The warrior, either the soldier of Christ or the class struggler, is the natural symbol of solidarity.

However, I suggested earlier that transcendence and unity include the possibility of passivity as well as of militancy, of stasis as well as ecstasis. This is partly because there is a steady social pressure to maintain continuity. Societies cannot exist without continuity, so elements of quiesence and passivity are necessary to social existence. There is however another reason: the reservoir of potentiality has to be built up over time. Before a great movement emerges there seems to be a gestation in which there is a gathering together of resources. The Church is a dam and builds up enormous potentiality inside it. Unless the divine is held back in sacred space, inside churches, or behind altar rails under priestly control, there will be no build-up. Without quiescence, latency and passivity there is no power, only wastage. So the institutional church is a channel of power and also a temporary but necessary barrier against the premature realization of power. In any case, as Marx pointed out, mankind only takes up those problems for which it is nearly ready.

So far I have suggested that transcendence and unity

together breed a powerful vocabulary: a Word comes with power. I have also suggested that it takes the active form of 'the movement' and a passive, quiescent form. However, that is not the same thing as a pacifist form and I want to underline the pacifist tradition in the splay of possibilities deriving from the Jewish root. It is a possibility much more associated with Christianity than Islam and it is positively repudiated by Marxism. This is not pacifism simply in the restricted sense of the refusal to bear arms, but realized more profoundly in the acceptance of redemptive suffering. The acceptance of redemptive suffering is central to Christianity and generates some of the social forms more characteristic of that religion: the peaceable but revolutionary sect, the radical but loving fraternity.

Christianity stands accused of masochistic quiescence before human pain and social injustice. The vocabulary of peaceable love and redemptive suffering is charged with being just another form of religious quiescence. It is true that peaceable love recognizes the resistance of structures and is reluctant to engage in the violent overthrow of those structures. Love creates, instead, innumerable social experiments, each encountering different constraints and exploiting different possibilities. They all have to find some partial solution to the problems of ownership and sexuality and they have to inaugurate equality by some form of discipline. The first experiments are the monastic orders, trying to operate outside the frame of necessary social violence and attempting to realize the kingdom in the enclave or in the isolated spot. The later experiments include the radical sectarians of the Reformation and the utopian Christian communities of the eighteenth and nineteenth centuries.

Each of these experiments repeated in little certain aspects of the more central assault on society by the institutional Church. One such aspect is the sharp social edge of the

community: the unity of the brethren demands demarcation. Another aspect is the period of imprinting or latency in which the reservoir of potency is built up. The constant repetition is the means whereby the ink of the word bites deep into the substance of the collective Soul. However, the sect or the radical brotherhood can be exemplary in a way the Church cannot because it has siphoned off a spiritual elect. The elect are a tight capsule of possibilities maintained in being by strict limitations. When those possibilities have cut deep enough they may slip gradually through the protective covering. Again, this differs somewhat from the Church at large. The Church has to link itself with things as they are and can only manage to infiltrate the realm of images rather than of structural realities. Nevertheless these images lie poised in the realm of symbols awaiting the moment of release. And when they are released they fragment and disperse in the collective psyche, achieving their end by another route and under another name. The images poised by the Church in the ideal realm often enter and subvert reality in disguise, as well as under their native name.

What are these images, realized in the communal experiments of sects and monastries and infiltrating the symbolic canopy of society at large through the agency of the Church? They include the image of inversion: he who is lord of all must be servant of all. They also include the underlying oxymoron of Christianity: when I am weak I am strong, when I fall I rise, in my end is my beginning.[3] They utilize the points of ignominy, ugliness and vulnerability in the human situation as the redoubts of redemption. The process of imprinting the signs of inversion and paradox takes centuries: it was a thousand years and more before the suffering God and vulnerable child replaced the signs of simple, triumphant potency. Nevertheless these signs eventually reach the deepest level of the imagination, so that men can envisage the peaceable kingdom where the child

plays on the hole of the asp and there is no violence in all the holy mountain. Men understand what it would be for a valley to be exalted and a mountain and a hill to be brought low. The interior of faith is appropriated.

In all this nothing has been said about God since reflection on social processes can know nothing whatever about God. Nevertheless God is meaningful to men through word and image and these images are the means of transcendence. Signs are the means of grace: God is known in the making of signs.

Notes

1. I may add that the idea of freedom is often remaindered in the same way. Indeed it is all too easy to phrase the problem so that the autonomy of God and the autonomy of man are rival claimants for what science leaves over.
2. Or as the Latin of the collect has it: 'whom to serve is to *reign*'.
3. This idea I owe to Donald Davie, *A Gathered Church: the Literature of the English Dissenting Interest 1700–1930*, London: Routledge and Kegan Paul, 1978.

2

Peace, Blood and Brotherhood

The first chapter discussed the power of two signs, transcendence and unity. The sign of transcendence concerns the beyond and therefore implies that men must go into that beyond. What is still to come has an open texture, it may be named, and yet may not be named. Men seek after it and are impelled to choose it. The sign of transcendence creates movement and *the* movement: it is a sign for coming and going. The sign of unity is cognate with the sign of transcendence. It contains the most powerful and wide-ranging resonance: the unity of God's people, the solidarity of man, the idea of solidarity against evil, the aspiration for the one true primal speech, the unity of knowledge and science and of the world itself. The potent idea of the one and the true, the truth of unity and the unity of truth, is a two-edged sword. Those who unite in truth and solidarity are divided from those who do not. Unity is a social wedge, cutting into the diversity of cultures and gods, creating division. It proclaims universal peace but that very proclamation creates conflict:

'My peace I give unto you . . .'

'I come not to send peace . . .'

'I pray . . . that they may all be one . . .'

'One shall be taken, and the other left.'

This is always true of the great movements of coming and going. Judaism, Christianity, Islam and Marxism are carriers of unity and creators of division. The one creates two and the one encounters the many.[1]

At the same time as I fastened on the sign of movement and of solidarity I looked sideways at the possibility of conservation which lies inside the idea of transcendence along with the more dynamic possibilities. There is no great radical idea which does not contain a power of conservation and which cannot be redeployed in the cause of conservation. Many people look for the *inherently* radical idea: there is no such thing. Some ideas are more radical than others but they all include a conserving potential. This is partly because they must at least conserve themselves, partly because society is impossible without the conservation of social energy, partly because all dynamism is linked to quiescence and latency. Great releases of energy depend on prior build-ups, reservoirs slowly brimming in periods of latency.

The conservatism implicit in transcendence is expressed in the idea of decree. The eternal lays down the unchanging law. So men are not only incorporated in a movement towards the beyond; they are bound by the decree of the eternal. Even as men are thrust into orbit they are battened down and constricted. The images of movement and of 'the movement' congeal into unchanging icons. They are confiscated by the urge to stablish something for ever. The historic trajectory, pointing towards the future, is slowly bent back into endless cycles of conservation. The social world revolves without revolution.

Yet just as there is no inherently radical idea so there is no unequivocal agent of conservation. The eternal decree can stablish and stabilize an order, but it can also bring all men equally under one banner with dramatic power and force. Once unite the idea of decree with the solidarity of man and with the unity of faith, and immense power is unleashed. Men

must submit to the decree, but they are bound together in one single submission, equal and united behind one supreme law. They become one army of the living God. The decree then becomes a promise and the faithful inherit the promises. The armies of Islam and of Cromwell were inheritors of promise. It was these armies which inundated the slow-maturing cycles of established civilizations.

So the argument has emphasized how stasis and ecstasis can both lie inside the idea of transcendence, and how the hope of universal unity breeds violent division. Now the language of social reality must be counterpoised with the language of transcendence. The social 'is' is confronted by the transcendent 'might be'.

What then is the language of social reality? It has a few key terms: degree, blood, the generations. Degree corresponds to hierarchy, blood to the local tie, and 'the generations' to tradition. Degree implies that there are more or less agreed channels of decision and of legitimacy. Blood means that the near and the known are normally preferred over the far and the unknown. The link of blood is the tie which binds. Loyalty belongs to the family or to a local group conceived as an extension of the family. The generational link is the family reproducing itself over time, not merely by physical reproduction but by cultural reproduction. What runs from generation to generation expresses the principle of inertia. It is continuity and tradition. So society is constructed on a principle of legitimate authority and ordination, on a principle of proximity which is usually a real or fictive blood tie, and on a principle of conservation or inertia. These are the necessary conditions of social existence. Take but degree away and you unleash the universal wolf.

> How could communities,
> Degrees in schools, and brotherhoods in cities,
> Peaceful commerce from dividable shores,

> The primogenitive and due of birth,
> Prerogative of age, crowns, sceptres, laurels,
> But by degree stand in authentic place?[2]

Unless charity begins at home nobody understands the nature of obligation. Unless culture is reproduced nothing can be predicted and nothing can be done. Nothing expected nothing done. Of course, the slope of hierarchy may be slight or steep, the boundaries between near and far, or brother and alien, may be permeable or impermeable, and predictability may be limited. Nevertheless society is rooted in degree, blood and tradition. It depends on acceptable channels of power, on graduated obligation, and on foreknowledge of what is likely to happen.

Any religion will code this language of social necessity. *This means that it will generate a sacred weight around the channels of power, the pattern of obligation and the understood ways.* Confucian religion is one of the most perfect coding devices for translating social imperatives into sacred order. It stabilizes the whole structure of familial obligation and of superordination. A man is set in a magnetic field of harmonious social force. The social 'I' lies at the centre of a complex web of deference and reciprocity.

The tie of local reciprocity will normally attach itself to a place: the boundaries of the group have a spatial expression. A society usually exists in a territory. Often this territory shares in the sacred character of the group. Both the tribe and the land can be seen as marking the limits of the truly human, defined against the unknown or threatening semi-human outsider. The attachment to place and territory is not necessary but there is a tendency even for migrating groups to move round the same cycle of places. Gypsies move along the known ways and retrace the old paths. The diaspora never forgets the land from which it came. How shall we sing the songs of Zion in a stange land? How shall we forget Etchmiadzin?

Degree, locality, the local and limited tie, tradition. And the highest, most intense expression of these degrees and ties is likely to be in the warrior band. The brotherhoods of blood come together in blood-brotherhood. Blood defines with whom you shed blood, and whose blood demands revenge or recompense. The company of warriors is united in shared sacrifice. The band of warriors is so important because the attempt to reverse the social necessities of the local tie and of degree must either convert the brotherhood of blood into an engine of holy war or subvert the very idea of violence. The point must be developed later.

If this is the logic of natural social religion what then is the logic of transcendent faith? How do we go beyond the nature of society? How do men leave their little local platoon and defect to the army of the living God? Perhaps Christians reading these sentences already experience some discomfort. By using such phrases I expect to arouse considerable unease. Some readers may be unhappy with the military metaphors. Others may be unhappy because my language implies a rending clash between our ordinary natural affection for home and homeland and the demands of universal faith. The pacifists will not like the warlike language; the patriots will put local loyalty before universal obligations.

Christianity is about the One, about unity and the one thing necessary. It strives to create one unified sacred space which, because it *is* one space, can be described either as wholly sacred or wholly secular. When the logic of division is overcome the vocabulary of division ceases to be applicable. 'When that which is perfect is come, then that which is in part shall be done away.' The part is less than the whole, and expresses a principle of distinction. The result is a vocabulary and a geography of distinctions: holy land from profane land, holy place from profane place, holy man from profane man, holy city from profane city. That vocabulary contains the

notion of partition. The partition may be drawn around part
of the temple or of the sanctuary, or it may be a boundary
around the holy land or the church. It may be a social and
physical wall around the monastery. Partition is enclosure. I
have used spatial metaphors because the ideas of unity and of
partitions have this spatial reference. When we walk into a
church or other sacred building we cross a partition at the
moment of entry. Other parts of the building will be divided
up or set apart. We are encountering physical signs of social
partitions. The physical geography is a metaphysical and a
social geography. It tells us we are not yet one flock and that
God is not yet all in all.

Perhaps I may select some key signs of this unity. One is the
sign of a celestial city in which there is no temple. The writer
of the Book of Revelation explains that where God is fully
present in plenitude of light and power a temple is
superfluous. Another sign is the breaking down of the middle
wall of partition. The middle wall partitioned the temple
between the outer court for Gentiles and the inner court for
Jews only. By extension it signifies the distinctions
engendered by the law and ordinances, and all separation
between man and man, and man and God. Paul explains:

> For he is our peace, who hath made both one, and hath
> broken down the middle wall of partition between us;
> having abolished in his flesh the enmity, even the law of
> commandments contained in ordinances; for to make in
> himself of twain one new man, so making peace.

The theme is clear: peace, unity, the abolition of the division
sign, the creation of a single space. Another sign is just a
dramatic illustration with respect to hierarchy: the new man
of the new testament is to be 'a King and a priest unto God'.
Where everybody is King and priest the partitions of hierarchy

are abolished. The sacred building, the sacred nation and the sacred castes are all set on one side.

The confrontation of universal with particular, of equality with degree, could not be more total. It cuts at every principle of social nature and challenges the continuities of the generations. Such a momentous shift does not occur all at once and all kinds of influences will be fed into it. Yet there was a moment when all the multiple confrontations were dramatized: the first century of the Christian era. Natural religion was challenged in the family, in the sphere of authority and in the idea of the continuity of generations. Those who join the family of the redeemed must leave the natural family: the power of generation must become the power of regeneration. In the natural Gentile world men exercise authority one over another but in the spiritual family the master is the servant. The radical brotherhood drops everything to find the Kingdom of God. Leave your nets: follow me.

So Christianity is about radical contingency and risk. The root idea of the Christian religion grows around the vulnerability of God: the threatened child and the wounded man. God is at risk but men live by scriptures, by the protection of identities, roles, rules, families, communities. They live by law and belonging. All these things are relative goods. It *is* right to honour parents, to pay tribute to Caesar, to accept the obligations of ceremonial. Yet the demands of Caesar and the family are secondary to the divine imperative. There is only one thing necessary: commitment to the rule of God. Everything that ties the soul to the securities of the world, much riches, much goods laid up for many years, the cares of the morrow, the claims of the family and the dead, the demands of the body, must be set aside to do the Father's will. All human categories are relative to that: the law, the powers that be, holy places and sacred authorities, the usual

rules of reciprocity and acceptable violence, the conventional concepts of who are the good men and who are the bad men. In the end there is only faith, trust and love. For the rest let the dead bury the dead. This is the treasure that is in heaven and it is its own reward.

Here is the tension between the logic of Christianity and the logic of our social nature. Social life depends very much on the continuities provided by families and by traditions. It rests on rules which appear absolute, authorities which appear binding, on holy places and temples that tie and focus the sacred bond, on *cosmoi* and *nomoi*.[3] Society is based on accepted hierarchies of virtue and of power. It is these crucial axes of social organization against which Christianity sets a query. Natural religion clothes the requirements of social organization with sanctity. This means that Christianity is a form of secularization. The contradictions of Christian iconography and ecclesiology derive directly from the clash of radical secularity with natural religion. Christianity relativizes and undermines the whole structure of holy laws, holy priesthoods, holy places and holy lands.

This outright war of faith and natural religion cannot continue for long. There has to be a compromise between transcendence and the social givens. The war is recorded in the New Testament, and the compromise is recorded in the history of the Church. The idea of unity is an eschatological hope and it generates a tension which is expressed in a duality: church and world. The apocalyptic discourses scattered in the New Testament witness to the colossal violence of the confrontation between grace and nature. The thirteenth chapter of St Mark's Gospel is one instance; the whole Book of Revelation another. The Book of Revelation is a manual of spiritual war between the redeemed and the idolators, the Lamb and the Beast, the new Jerusalem and Babylon. It is undergirded by the idea of unity: *all* nations and tribes and tongues stand before the throne of God. Hence the division

into warring combatants: the partisans of faith and the armies of the alien. It carries forward the fundamental opposition in the gospels between the children of darkness and the children of light.

The compromise of the church carries forward this dual structure. Moreover this compromise is not just a set of *ad hoc* accommodations gently yielding hope up to the resistance of the given. The attack itself requires that hierarchy is reinstituted. Equality is rooted in the acceptance of hierarchy. The new brothers require new fathers.

Consider the situation of the radical brotherhood. They have been called out of every tribe and every tongue to be a new and holy nation. This in itself creates a much tighter frontier between church and world than the frontier between the Jewish nation and other peoples. A community of faith is not demarcated by natural ties or by a territory, but by the sharp edge of commitment. Moreover that cutting edge must be maintained. If the distinction between church and world is lost the power of grace will be assimilated to the realities of our social nature. This means that the revolution must be conserved within the ranks of the brethren. The new order demands the brethren be placed under orders. A united brotherhood requires discipline and has therefore to be placed under the eye of fathers-in-God. Sociologically, brothers give rise to fathers just as much as fathers give birth to brothers. The discipline of the brethren will necessarily inhibit the flow of the natural affections since these easily encourage a relapse into the old natural structures of tribe and family. The liberty of the Sons of God demands the sharp inhibition of natural affections.

Eventually a complete structure of spiritual brotherhood and fatherhood will appear counterpoised to the structure of natural brotherhood. This in turn will undergird the basic distinction between church and state, sword spiritual and sword temporal. Thus the impulse to unity which aimed at

the abolition of partitions will have recreated a complex geography of demarcation. That geography will mark off the territory symbolically claimed by grace from the territory conceded to social nature. As time goes on, of course, the sacred hierarchy will collude more and more directly with the secular hierarchy, leaving the confrontation mostly expressed either in the realm of symbols or in the monastic or the sectarian spirit. At the same time that expression in the world of symbols is not just an armaments museum displaying discarded and impotent images of rigidified revolution. The idea of unity has been implanted, though carried in the notion of catholicism, that is the universal church. The broader loyalty is carried in a more limited confine. And the idea of a distinction of realm between the world of faith and that of secular power represents a revolutionary incursion on human consciousness. It separates faith from the *status quo*. It invites the conclusion that matters of faith are not in the keeping or jurisdiction of the secular power. This symbolic separation and autonomy of faith is a submerged platform in human consciousness, a point of departure which has to be established in the symbolic realm before it has any chance of making an explicit appearance in political reality. Symbols are platforms required for take-off. Thus John Wesley's offer of universal grace for all can presage universal citizenship for all.

So we have a paradox: the aspiration to unity and the abolition of partitions has to be protected by the distinction between church and world and between church and state. This runs parallel to the paradox that the hope of equality is kept in being by the discipline of hierarchy among the brothers. And the possibility of revolutionary change has to be conserved in the cycle of liturgy. Each new possibility has to rest on its opposite in order to remain in being; unity on duality, equality on hierarchy, change on conservation. This is why revolutions are so intensely conservative.

At this point we must return to the warrior band. The bond of war expresses the tie of blood in the most intense form. It was suggested that this bond either had to be converted into a holy war to establish God's universal decree or else had to be inverted by the refusal of violence. This choice of holy war or non-violence has to be related to the sheer intensity of the confrontation recorded in the New Testament.

That confrontation expresses itself in the language of warfare.[4] The Church is a liberation army, offering Christian liberty to those who take upon them the helmet of salvation and the breastplate of righteousness. Its militant language is really an attempt to deploy the vocabulary of physical war in the service of spiritual war. Blood is used to signify the means of life and not the consequence of murder or battle or assault. The blood of the murdered son of God gives life, whereas the blood shed by the murderous sons of men deals death. It is that life-giving blood which reunites all mankind: men are now able to recognize that they are indeed of one blood. More than that, the sign of blood costs the battle between grace and the resistance of sin. There is no redemption without cost: the abolition of the partitions has to be through blood and suffering.

So the warfare of the natural man is taken over by the Church Militant. This is done through the most basic inversion of values in the New Testament: the weakness of God is his power. Vulnerability is the power of God towards men. The curse is the benediction; the criminal is the saviour; the disgrace is the grace; the crucified is the King. All the minus signs are turned into plus signs. The master who is servant becomes the criminal who is King. In this sign conquer.

However, this breakthrough has had to use the language of ordinary war in the cause of spiritual battle, and such language is still soaked in its original associations. In any case, violence is still a necessary and inevitable part of the

social order. This means that there must be a continuous dialectic whereby the sword turns into the cross and the cross into the sword. The sign will carry double and contrary meanings. And this is precisely how the new potential crosses the line of sociological prohibition: by carrying several meanings, or by bearing an ambiguous meaning. The cross will be carried into the realm of temporal power and will turn into a sword which defends established order. It will execute criminals and heretics in the name of God and the King. But temporal kingship will now be defended by reversed arms, that is by a sign of reversal and inversion. Every sign in the armoury of temporal legitimacy will now carry the reverse implication.

An illustration of this dialectic of symbols can be found in the hymn 'Vexilla Regis': 'The royal banners forward go'. Here we have a poem celebrating the progress of the cross as a triumphal march. So the imagery of battle is redeployed in the service of spiritual war. Indeed, the hymn was originally sung as the relics of the 'true cross' were taken into Poiters in procession. Yet it was precisely this processional hymn which was most popular amongst the crusaders; and they carried crosses as instruments of war. (This suggests how we might see Christian processions. Every procession in church is a demilitarized slow march behind the device of a sorrowful king.)

Another illustration, to which I turn again later, is provided by the cross which dominates the US Air Force Chapel at Colorado Springs. At the centre of the huge arsenal is a chapel built of stained glass spurs like planes at the point of take-off. The cross inside is also a sword. Looked at from another angle the combined cross and sword is a plane and a dove. The plane is poised to deliver death rather than to deliver *from* death and the dove signifies the spirit of peace and concord.

Liberation theology can run into contradictions just as

sharp as those which affect civil religion. Radical theology can make the cross a sign of the suffering endured by the despised and outcast, but it is not easily deployed as a sign of guerilla warfare and proletarian victory. So theologians turn to Moses and the exodus from bondage. Moses rings the liberty bell and sends the People to a promised land. Moreover, once *en marche* the impetus of militancy is very difficult to halt, and liberation theologians will find themselves behind what Ioan Davies has nicely called the 'militarized version of organic solidarity'. They will be partisans of societies which are organized as armed camps. This is an odd fate for the hope of liberation and is even more paradoxical than the fate of 'civil religion'.[5]

This same dialectic affects the concrete use of violence in another way. Suppose we recollect the impulse to unity and see it as including the universal establishment of peace: men shall 'study war no more'. Yet temporal power is inherent in all social organization. The result is that the aspiration towards universal peace is realized only as a formal gesture within the priestly sector of the Church. For example, the imposition of universal military service has fallen short of requiring ministers of the gospel to bear arms. So the gesture is highly paradoxical. First the original aspiration belonged to a thrust against all partitions, yet the distinction between clergy and laity is precisely such a partition. Second, the original aspiration was designed to achieve equality and yet the limited witness for peace contained in this formal gesture is rooted in inequality. Of course, many people would conclude that the symbol should be abolished to establish equality. I would conclude on the contrary that this would abolish an important resistance buried very deep in the sensibility of any civilization informed by Christianity.

Let us pursue the dialectic of unity and duality of grace and social nature. It was argued earlier that the boundary of the one church acquired a sharper edge than the boundary of

Israel because it was a community of faith dispersed in a wider world and confronting that world. This is the paradoxical effect of unity in faith and love: the single company of the loving and the faithful becomes a hard wedge lodged in the wider society. This company sees itself as the carrier of Christian liberty to a world which is enslaved. It is moving as an alien body into the massed forces of alienation. To mix the free and the enslaved together would be to imperil redemption. Hence the hardness of the casing.

But with the arrival of establishment, an alternative logic is available which still derives from the impulse to unity, though of course reinforced and activated by political consider-ations. If men are to be one in love then the Catholic Church should allow no one to remain outside it. There must be no residuum. Those who stand outside should be compelled to come in. Church and society come to form a common order and the hard edge of the Church is almost co-extensive with the hard edge of society. So the company of love forces everybody into its ranks, and those it excommunicates are deprived of every kind of communication. In this way, the company of love becomes a vehicle of compulsion and expulsion.

By a parallel logic, the Communist Party sees itself as creating universal solidarity, and this in turn brings about the duality of struggle. Since the enslaved in mind remain alienated even after the party is established they are demoted to the status of second-class citizens; the vehicle of equality thus gives rise to inequality precisely because it cannot dilute the redemptive potential of the party elect. It then restricts rights of entry and exit from the liberated territory. A man who wants to cross the boundary of the society is *ipso facto* crossing the demarcation line between truth and falsity. Care for his soul suggests that he should not be allowed to embrace falsity. Hence he must be compelled to stay on liberated territory. This is the modern form of the way in which the

great movements of solidarity constantly 'compel them to come in': Faith, unity and love have a very curious link with inquisition and with violence.

The dialectic of unity and duality works itself out in successive transformations. Once that dialectic is set up it waits for a structural opportunity to realize itself. The huge generator at the root of a world religion has mighty transformations hidden inside it and these will be elicited by social context. A social context is an aperture through which a transformation starts to move, often slowly at first, but then widening and moulding the aperture, displaying a wider and wider range of potential.

The mightiest transformations strive to achieve uni-fication. They aim to abolish the partitions and create one single open space. Then they encounter a limit, a structural blockage, a resistance. This limit creates a new partition or at least produces some sign that unification has encountered a *Ne plus ultra*.

If this should appear mysterious, let me illustrate from early Christianity, Calvinism and Marxism. Early Christianity tries to make God all in all and to set up the Kingdom on earth as it is in heaven. Heaven and earth are combined; angels and men are agreed. God is in Christ reconciling the world to himself. This is atonement. But the Kingdom does not come, and a symbolic line has to appear separating first advent from second advent. The glory of God remains behind a screen; and God has not fulfilled the whole cosmos. The Book of Revelation portrays the tribulations which arise at the limiting boundary and describes what it would be to cross the frontier. As men come up to the frontier they fall on silence: there is silence in heaven. The last word cannot be spoken. Once that word was spoken, the mystery of God would be finished, and men would see face to face. Ever since then, the partitions in God's house have said that the last word cannot be spoken: the Amen is not totally unveiled. He moves

behind screens and is revealed under veils. One of the tasks of theology is to trace the ways in which these lines, limits and veils are breached and re-formed.

Calvinism is just such a breach. It aims to establish the Lordship of Christ and to put all human community into submission to Him. Logically God is to be co-extensive with the godly community. This means that one of the crucial lines and limits written into Catholic Christianity has to be breached. The line drawn around the monastic orders must be abolished in order to offer full commitment to all. The two-tier system of commitment has to be broken down. But it immediately reappears in the concept of the Elect. The Elect are marked off within the mysterious purposes of God, so the line still exists, yet it is out of sight.

At the same time, the image of God is broken because images limit the divine by giving divinity a particular form. A broken image opens up infinite space. Yet the limit reappears inside that space as a blank white wall. Here is the wall on which the image cannot be drawn. It conveys a double message: the infinite is here, the infinite cannot be known. All the limits have this double message: yes/no. The 'no' is contained in the 'yes' and the 'yes' in the 'no'. The same is true of the limit of silence. Quaker aspiration aims to make all life sacramental. It rubs out the edge of the sacramental element and so crosses the old limit. It breaks out of the steeple-house. But the last word cannot be spoken. The old structures of the Word have been broken up by the Spirit and every man may now speak. The protective cordon drawn around holy word and ordained speaker is put aside. And suddenly, the Word cannot be said. For two reasons: the transcendent is a plenitude transcending all words; and in any case we have reached the limit. God's realm has been blocked off. All that can be done is to put another new protective cordon around the social boundaries of the sect. The Quakers break out of

the steeple-house and then partition themselves from the world.

Marxism aims to remove the blockage around the sect itself. It observes that human aspirations have been channelled into an ecclesiastical circuit which cuts off their potential. The official Church is a walled-off area in which hope is systematically alienated from itself. The Church can do this precisely because the hope is *real*: men actually reinforce the limit on hope because hope is genuine. They truly reflect a distorted world. They celebrate their own frustration. The equivalent, psychologically, is where we begin to take pleasure in our losses because we remember how tender our hopes actually were. The Church therefore is imprisoned hope. Not only that, even the most progressive Christianity has only managed to realize itself in the enclave of the utopian sect or the communistic community. The sect too draws a wall round to protect hope from dilution, but that wall is a limitation. It acts as a double-block, against the world infiltrating the little flock and against the little flock redeeming the world. Hence the walls around Church and around sect must be broken down, so that those inside may lose the limiting name of Christian (or Molokan or Doukhobor) and achieve the universal name of Man. The Church and the sect must be forcibly merged with the community, creating one single spiritual space in which alienation has been overcome. The ancient line between church and state must be rubbed out, because that line meant truth was distinct from power, the Word from reality. Now the word must come with power.[6]

Immediately, however, the limits reappear because the community as a whole is not co-extensive with communism and there remain huge pockets of alienation. The party forms inside the society, an elect distinguished from the rest. The stage of true, universal communism is postponed to an

undefined point in the future. Moreover, the supposed reunion of power and truth is eventually discovered to be power posing as truth. The true followers of Marx now denounce the socialist state as a vehicle of alienation in its own right and the state responds with the apparatus of inquisition and the accusation of heresy. So there is now a double partition: those who run the new unified church-state and cast out heretics, and those who affirm the old truth and denounce the church-state. The open unified space is now a set of competing partitions, each proclaiming that a limit has been reached: either socialism has not really arrived, or the heretics have not been finally exposed and converted. Or to put it in theological terms: 'the end is not yet', the mystery of God is *not finished*.[7]

Notes

1. This pressure of unity assists social control within Christianity, Islam and Marxism: no one must be allowed to break the solidarity of the proletarian carrier of truth or to divide the universal Church of God or disrupt the Islamic brotherhood. All conflict can be defined as imperilling salvation or revolution. This is why revolution is so conservative.
2. *Troilus and Cressida*, Act I, Scene 3.
3. These notions are persuasively set out in P. Berger, *The Social Reality of Religion*, London: Faber and Faber, 1969.
4. For a very helpful treatment of the Christian use of military images cf. Gerald Bonner, *The Warfare of Christ*, Leighton Buzzard: Faith Press, 1962.
5. For an illuminating discussion of civil religion cf. R. K. Fenn, 'The Relevance of Bellah's "Civil Religion" thesis to a theory of secularization', *Social Science History*, Vol. 1, No. 4, 1977. With reference to societies organized as 'armed camps' it is interesting that the Church in East Germany has protested against the militarization of adolescents, and has done so by appealing to

'peace' propaganda of the Communist government cf. also R. K. Fenn, *Toward a Theory of Secularization*, University of Connecticut, Society for the Scientific Study of Religion, 1978. This provides examples from the field of law. One of the best statements of liberation theology is L. Boff, *Jesus Christ Liberator*, New York: Orbis Books/Monograph No. 1, 1978.

6. For an excellent treatment of the relationship between Christianity and Marxism cf. Dale Vree, *On Synthesizing Marxism and Christianity*, London and New York: Wiley, 1976. Also cf. P. Hebblethwaite, *The Christian-Marxist Dialogue and Beyond*, London: Darton, Longman and Todd, 1977.

7. Since writing this chapter I have come upon a sociological account of the earliest Christianity by a New Testament scholar: Gerd Theissen, *The First Followers of Jesus*, London: SCM Press, 1978. Though I would wish to criticize this both as to the use of sociology and historical evidence the general outline is consonant with the argument put forward above. I have also had the pleasure of reading John Bowker, *The Religious Imagination and the Sense of God*, Oxford: Clarendon Press, 1978. Some of the points made in my argument are also in Professor Bowker's work within the frame provided by information theory.

3

Holy Virgin and Holy City

The previous chapter was concerned with the logic of universal love as it contends with our limited natural affections and with the necessities of our social nature. It discussed the confrontation between equality and degree, between universality and the local tie, between revolutionary regeneration and the continuities which run through all generations. The drive to unification gives rise to a warfare between the partisans of unity and the reality of diversity. And moreover unity creates duality: the Church faces the world, the spiritual sword is distinguished from the temporal sword, the spiritual orders of holy fathers and brothers-in-Christ are counterpoised to the social order of ordinary parenthood and filial obligation. The universal spiritual family takes on the local natural family.

So the thrust to unity is expressed in a duality: spirit and nature, church and world. One side of that duality, the spirit and the Church, carries inside it a store of transforming potential. But that potential has to be protected. Universality has to be located in a particular vehicle and the vehicle must have a sharp cutting edge. Equality requires discipline, and discipline demands authority. The radical charge of equality and universality is maintained by hierarchy and particularity. The radical fraternity is marked off from the world and is obedient to the father-in-God. The revolutionary sect maintains a sharp boundary with the rest of society. Sectarian

teachers discipline the lax and expel the recalcitrant. This is the double-lock which I referred to earlier. The social boundary around the vehicles of redemption keeps the potential safe by heavy insulation.

Moreover, as has been argued, the line which demarcates liberated from unliberated territory symbolizes the resistance of the world to God. Both church and sect draw lines in symbolic space. The very existence of such lines indicates that the perfect has not come and that men still see through a glass darkly. At the same time they point to God because they distinguish the perfect from the ruined. One side of the demarcation stands for hope and the other side for resistance. The limit speaks of the unlimited. Typically the limiting line runs *through* the body of the Church and *round* the body of the sect. For example, there is an ecclesiastical line dividing priest from laity, and that is because the priest can re-present Christ. He has privileged access to the holy place and unveils the elements of perfection and plenitude. The priest works in an area which is partitioned off in order to hold back, preserve and protect perfection. The partition is a paradox because it speaks about the power of the perfect by placing a cordon around it. This is how the Church provides an interim defence against God. And rightly so, because a God allowed everywhere would soon be coextensive with whatever is.

Truth, perfection and equality of access are cordoned off and expropriated by the priestly caste. This is one reason why priesthood is simultaneously exalted and reviled: it provides limited access to the idea that mediation has been abolished. It provides access and controls access. This double function of opening and closing, representing hierarchy and denying it, sets up a potential tension. The failure of priesthood to represent Christ means that priesthood will be identified with Antichrist. The binary distinction is the conceptual womb of anti-clericalism. Part of the intensity of anti-clerical feeling is based on resentment at the expropriation of the divine

potency and the radical potentiality. Anticlericalism is, in part, disappointed religion.

The line which runs *through* the Church is the line which separates the sect from the rest of society. Just as the sacramental element is a colony of divinity so too the sectarian enclave is a colony of divinity. The edge of the wafer, the wall of the monastery, the social boundary of the sect each protect the idea of perfection. The edge, the wall and the boundary simultaneously mark a limit and proclaim a possibility. The sectarian boundary may be articulated in a variety of ways, each of which codes a message to the outside world and constitutes a social experiment and a potentiality. And one of the reasons why certain sects have no sacrament is because the boundary of the community has replaced the outer margin of the wafer. Other sects distinguish between ruined and perfect by more graduated boundaries and this enables the sacrament to be restored as an inner fortress of divinity protected by the outer concentric rings.

The margin of the sacred within the Church and the outer margin of the sectarian boundary are alternative forms of storage. The divine is held back in order to be protected. There is a build-up of potentiality inside the sacred dykes. Power grows by inhibition: it depends on the careful structure of limits. But those limits are *too* tight, *too* constraining. The realization of power then depends on a breakdown of the structure. The edge frays and the radical concepts which were previously inhibited are now put on social exhibition. For example, the radical potential protected and inhibited by the boundary around Quakerism had to be released by evangelical incursions over the border in the nineteenth century. Almost every advance thereafter had a Quaker element in its original deposit. The same process can be observed in the Bohemian Brethren from whom a significant element in modern education derives.

When the potentials dammed up in the Church and in

the sect slowly begin to brim over the edge, a dynamic is set in motion, which is related to the unifying impulse, and therefore to secularization. It turns on the relationship between grace and law. It begins, usually, in an attempt to tighten up the observance of God's law and to make His word come with power. The dull images start to shine, the somnolent rituals are shaken alive. Men strive to be perfect, even as their Father in heaven is perfect. Then the Law begins to totter. Men aim to replace their heavenly father and claim his prerogatives for themselves. This means they are released from the chain of command and are fulfilled with grace and heavenly benediction. This can show itself in a variety of ways: in self-worship or worship of the collective. Then the images are torn down and the word of God burnt up in the flame of the spirit.

This is only one sequence. There are several branching options all consistent with the logic of revolution. The word may first come with power and then fall on silence. Or it may break up the moulds of ordinary language and become communication in tongues. The burning of the books, the breaking of the images, the espousal of silence, the speaking in tongues, all push away from constraining particulars towards the universal. Each conveys a fullness and at the same time speaks of a limit. It will depend on the situation whether silence signifies the withdrawal of God or the ineffable plenitude of the divine presence, or both. There is an underlying structure of transcendence and limits which broken images, broken speech and unbroken silence define and convey.

So far discussion has been concerned with processes of storage and release. Storage means that the transcendent is held back in sacred space, located in sacred elements, sanctuaries, churches. Release is the breaking of these boundaries and the search for a unified space. The static is overcome and the dynamic unleashed. However, storage and

release do not negate each other. They exist rather within a complicated dialectic of vertical and horizontal, heaven and earth, present and future. Storage precedes release, but release quickly establishes a new geography of partitions and begins again the process of storage. This interaction of storage and release can now be illustrated by taking two dynamic symbols, the virgin and the city, showing how they create aliens who rapidly settle down as natives. The idea of the perfect city disturbs the natives but it also allows aliens to imagine that they are about to arrive, or even to suppose they have already arrived. I want to show how central images of hope for the future are also images which can guard and maintain the solid temporal satisfaction of the moment.

To deal with the idea of virginity and with the image of the Virgin some previous elements in my argument need to be recapitulated to indicate the underlying mesh of signs and symbols. The virgin must be linked to brothers-in-God and fathers-in-God, and therefore to the idea of the breakthrough.

Both virginity and the second birth are directed against the most vital links in social reproduction, the biological necessity of the family, reproducing culture from generation to generation, and the necessity embodied in the natural community. Virginity and the second birth pose regeneration against generation, and choice against necessity. They are the root principles of a peaceable brotherhood undercutting the biological brotherhood of the family and the ascriptive ties of natural community. The secret history of these root principles cannot be found in history books, but lies buried in the multiple implications of images. (Not even art history tells us what the figures on the dome and on the tympanum really mean. Ordinary history and art history only provide checks on what is put forward as the history of inner meanings and implications.)

'Wist ye not that I must be about my Father's business?'

'Who is my mother? and who are my brethren?' 'I and my Father are **one**.' These are key texts and it matters little whether or not they are proved conclusively to be the *ipsissima verba* of Jesus: the Church selected them as such and they are congruent with the clear logic of the gospels. That logic is exemplified in the idea of a eunuch 'for the Kingdom of heaven's sake'. This means quite simply that some men accept virginity in order to form a brotherhood outside the families and kingdoms of this world. And this brotherhood will negate the law of earthly kingdoms, because they are based on domination. The Gentiles live by domination, but it shall not be so among *you*: the Master of all is the Servant of all. The brotherhood negates the law 'in the members' and the law of the Gentiles. This is exactly the meaning of the Lord's Supper. The order of precedence is reversed: the master is as the servant that the servant may be as the master. The ceremony of feet-washing today codes this mesage, and it is interesting that you may find such a ceremony *either* in radical heresies or in the Maundy Thursday practices of very conservative churches such as the Armenian Church. The Armenian Church has conceded almost everything to the social nature of the natural community, that is, it is the ecclesiastical vehicle of Armenian identity. Yet inside that church is encapsulated a radical version of sacramental worship.

Brotherhood, whether realized directly in a sect or symbolically hinted at in the priestly brotherhood of a conservative church, pushes against hierarchy and continuity, against natural family and natural community. This is its *direction*. The maintenance of the brotherhood requires heavy control in the erotic sphere and this control must rest on stable discipline. There can be no long-term discipline without discipleship, that is roles which embody control and provide a base for supervision. Entry into the brotherhood demands an exacting resocialization. This resocialization is supervised by the agents of social control, but not in their

own right. A patron exercises control in his own right, but a padre does so as the representative of an idea. So the idea of brotherhood-in-God requires a father-in-God. Once you reject the human fathers in order to set up a brotherhood you need symbolic fathers to help maintain and ensure your rejection. So the régime of human fathers, ordinary fathers and city fathers and fathers of the people, will be paralleled all along the line by early fathers, father superiors, fathers-in-God and holy fathers. These will claim the authority of the *Pater omnipotens*, in whose name they demand obedience. This omnipotent father is then a further bulwark against natural sexuality. Loyalty to the universal father-in-God and to God the Father defends the radical association of sons against the pull of local community and local family.

This is not at all the conclusion of the matter. The radical brotherhood is the antithesis of the warrior band: it is devoted to peace and rejects aggression. This represents a feminization of the male psyche which overturns the ordinary patriarchal role structure in a fundamental manner. Since it *is* so fundamental it reinforces the need for a strong control system. Indeed, it will appeal to precisely the system of spiritual patriarchy noted above, the fathers-in God and the holy father. The antecedent association of female gods with release and eroticism will make it the more certain that feminization will be achieved inside a framework activated by images of male discipline.

Jesus Christ, the representative of the principle of sonship and the Founder of the brotherhood will be reassimilated back into this framework of masculine discipline. The inverted images will be temporarily frozen, so that the washing of the feet or the crucifixion are shut off and contained in a theological reservation. The Son will become as the Father: iconographically he will ascend into his father's place. The dome of the church, representing the whole infinite cosmos, will be dominated by a Christ in judgement, by the stern

Pantocrator. So instead of God becoming man or manhood being taken into God, the son will simply re-acquire the attributes of the Father. The sting of the death of God will have been removed and only the glorious resurrection will remain. This indeed is the overall tendency of Byzantine Orthodoxy: to recover the power of God and with it the power of the natural community. In the monastery of Daphni, Christ dominates the cosmic dome in the person of the Father. With Christ restored in the image of the Father rather than man restored in the image of the son, the radical brotherhood has been partly neutralized. You could say that the revolutionary image of the eunuch had been socially neutered. The revolutionary potential of the new feminine man now requires some feminine focus of psychic attention which will not reactivate sublimated sexuality and will simultaneously represent the principle of grace rather than the law. Thus the stern Christ must give way in some degree to the gracious Mother, *plena gratia. Ave Maria, gratia plena.* Indeed the cycle of redemption will acquire a complete complementary feminine cycle. The recovery of discipline forces the revolutionary potential to recover the *Dea Mater.*

But the divine mother, *gratia plena*, must herself remain ambiguous. At one level she will represent a partial recovery of the principle of love and grace and become spiritual 'queen' of the radical brotherhood. At another level she absorbs into herself the Triune God under the title 'Templum Trinitatis'. At yet another level she will be reassimilated back to the principle of the natural family and the natural community. The Virgin Mother will preside over the city and become patroness of its civic identity. Civic fathers will process in honour of Santa Maria della Salute, her church will dominate Oxford, Paris and Venice, her image will reign triumphant in Rheims and Chartres. The ordinary natural family will appeal to her as divine mother and exemplary mould of human motherhood. The family will be

reconstituted as the holy family. Once that has happened, the revolutionary impulse can only make gestures to the effect that both virginity and the family are good, but virginity is higher than marriage. Thus the original revolutionary thrust will have worked through several conserving cycles until it is defined as the *most* conservative of images within the ecclesiastical universe.

As I argued above this is a secret history which cannot easily be verified by the ordinary processes of historical inspection. The evidence is documentary and iconographic: St Bernard's discourses on the Blessed Virgin or changes in the hierarchy of images. In the sixth-century basilica of St Euphrasius, Poreč, there is a dome on which the Pantocrator has been displaced by the Virgin and the male saints by female saints. That dome is the first recorded instance in the Byzantine world of such a fundamental displacement. It is not evidence, but it is illustration. Or again, there is the more familiar example of Chartres Cathedral. Chartres represents the union of Mother and Son, the Queen and the King on her knees. There is perhaps a further paradox, originally suggested by Henry Adams, which can be noted only in passing. The Court of the Queen of Heaven, established at Chartres, mirrored a society where women were in many ways superior to men and where they had masculine characteristics, and men feminine characteristics.

Not only did the Virgin efface or frame her divine Son; she became the patroness of place and guardian of holy ground. Our Lady presided over the City. So here we find a natural link with the secret history of another potent symbol: New Jerusalem. The Virgin was identified with the woman crowned with the stars in the Book of Revelation and even as the New Jerusalem itself. She was to the New Jerusalem as the great whore was to Babylon.

We turn to the Heavenly City, New Jerusalem, for an image

of movement to put alongside the image of breakage. So far we have been concerned with images which set the universal against the particular, the perfect against the real. These images break with all the bonds of biological family and ethnic connection. And they also set the realm of God over against the City of man. Yet the breakages remain largely static. The structure of alternatives is set up and elaborated but not set in motion. Instead, it slowly plays back into the solidarities of place and blood and recovers the cyclic sense of eternal recurrence. The liturgy revolves for ever with the recurrence of the seasons. So new images of motion and change have to realize the potential stored in the symbols of breakage.

The image of the heavenly city can guide the hopes of mankind as men seek to leave the city of destruction. It makes men aliens in their earthly habitations and calls them to set off for an unknown stored in the future. The image of the heavenly city guards the pilgrim people like the pillar of fire, going ahead in the alien wilderness until they have sight of the promised land. *'For here we have no abiding city, but we seek one to come.'* Men become pilgrims to the celestial city, travelling alone as did Bunyan's Christian, or banded together in companies.

I want now to explore that search for the city to come and also to show how there is once again a play back into ideas of holy land and holy place. Just as the images of breakage returned to preside over solidarities of place and kin, so the images of movement returned to preside over the complacent sense of cultural achievement. Once men begin to establish a New Jerusalem in the wilderness it is not long before they are 'at ease in Zion'. Once they identify a human culture or a people's mission with the holy city the meaning of the city is reversed. The Boers trekked twice into the wilderness and finally trekked into the cities. They aimed

to rebuild the waste places but were too soon at their ease in Zion. The city of John – Johannesberg – became new Babylon, the sign of partition and apartness.

The image of Jerusalem has many sides, and these must first of all be enumerated. The first image embodies the idea of return, that is, of movement backwards. To advance we must return. Jerusalem must be restored and the exiles must return to Jerusalem. This is the theme of the Book of Lamentations just as it is the theme of 'The Waste Land' and 'The Rock': 'The Ways of Zion do mourn' . . . 'Men must forever rebuild the Temple'. Close beside this image of return rides another image of return: back to the Land. There are here two returns: the recovery of the holy soil of Israel and the recovery of a holy life close to the soil. The second return is easily deployed against the whole idea of the city. Men who build new communities in the country – Kibbutzim, monasteries, co-operatives, utopian experiments – are closer to each other and to God. So it is important to set the picture of Jerusalem in the company of two other pictures: the paradisal garden, where mankind lives in harmony, and the waste place or wilderness which will one day blossom as the rose. The urge to restore Jersalem runs parallel to the recovery of the paradisal garden and the restoration of the waste places. To go back is to go forward. All things return to perfection in Him who is their origin.

The second theme also connects gardens and cities. It is put forward by monks, sectarians and utopian pioneers. Monks, sectarians and utopians create fresh movements and break new ground.[1] They part themselves from the world in order to be the leaven in the lump. They try to live all their life in the chancel or in a specially created Zion. For sectarians and for monks, the greater part of the world must be abandoned as a waste place and Jerusalem built in a small, protected enclave of heaven. The walls of this little Jerusalem must be firmly maintained. Utopia demands a protected frontier with the

world and proper boundary maintenance. It may be that a few seeds of hope will blow over the monastery wall: and the sect may regard itself as a first experiment the results of which are later made generally available. Meanwhile, however, the sect is a limited plot and the monastery is a secret garden, the planting of the Lord, a partial regression to man's first innocence.

These communities create powerful longings in the minds of those in the world or shut up in the corruption of the secular city. Even the images of advertising minister to this urge away from the corrupt city. There is an isle of blessedness lurking behind advertising: the subliminal has underground links with the sublime.[2] The weakest variant is the ordinary man's longing for home and garden. But poetry is filled with this desire for an enclave of truth set up in the contemporary wilderness. Wordsworth, Hopkins, Yeats and Eliot have this in common.

> I have desired to go
> Where springs not fail
> To fields where flies no sharp and sided hail
> And a few lilies blow

'I will arise and go . . .' 'I will go down to the sea . . .' The theme of Paradise and the return from 'this our exile' is very deeply embedded. It lies equally behind the concepts of advertising and the philosophical notions of alienation. The alien is the alienated, deprived of his true citizenship, parted from his authentic selfhood, separated from his own works and productions. No great revolutionary movement can miss this dynamic component, and almost every contemporary unease or discontent embodies it. The monks who built their houses in Rievaulx or Tintern or Fountains founded wells of hope on which the imagination of the future could draw. They laid foundations for images of recovery, retirement and

retreat, as well as images of the earth as a universal garden.
Their Jerusalem and their Paradise constituted the alternative
society.

Quite close to this monkish impulse lies the utopian idea of
the garden-city. The phrase comes, of course, from a book by
the Quaker, Ebenezer Howard, *Garden Cities of Tomorrow*.
The movement toward urban regeneration in the nineteenth
century fed partly on utilitarian concerns, like those of Edwin
Chadwick, and partly on ancient traditions of the ideal city
and the paradisal garden. The Quakers, Howard and
Cadbury, the Congregationalist, Titus Salt, the agnostic,
Robert Owen, the Christian Socialist, Raymond Unwin, the
Catholic, Pugin, all stand in a tradition of urban revolution.[3]
So too does the New Towns Movement which came to
fruition after the Second World War. The various schools all
used a common litany:

> From Hull, from Halifax, from Hell, 'tis thus
> From all these three good Lord deliver us.

Indeed, the tradition of ideal civic order and the perfect
garden could have the most diverse consequences, far from
the modest homeliness of Letchworth or Welwyn Garden
City. The palace of Versailles combined civic order and
paradisal solitude and was in its way yet another version of
'the city of the great King'. Versailles was a garden city of
yesterday. I would not want to rest too much weight on the
heavenly city of the eighteenth century, but it remains one
distant derivative of Jerusalem.

The third theme is the identification of some particular city
as the universal city: Eternal Rome, Byzantium, Third Rome.
These cities are New Jerusalems, liberated and restored to
true brightness. All nations shall flow to them and all roads
lead to Rome. Here also there is a dynamic element. Each

new Jerusalem turns out to be the antetype of Jerusalem. Disillusion renames Rome and calls it Babylon. A so-called holy city becomes a paradigm case of destruction and failure. Some other city has to become the beacon of hope. Hence the sequence running from first Rome to second Rome to third Rome.

The fourth theme is very similar: the building of a new and righteous city, which may or may not be called Jerusalem. Sometimes this is conceived by Renaissance or Enlightenment thinkers as a city of peace and harmony: Christianopolis, Palma Nuova, Karlsruhe, the Rome of Sixtus V. Or it is the city of brotherly love, Philadelphia. Blake set forth the idea for England just as Simon Kimbangu set it forth for the Congo. Jerusalem is to be built in England's pleasant land, or raised up in Zaire. When that happens the saints will come marching in. Let me quote from an account of Kimbangu's New Jerusalem at N'Kamba.

N'Kamba became the new Jerusalem. The emergence of Simon Kimbangu as a prophet endued with the power of the Holy Spirit was the new Pentecost. 'Through the events in N'Kamba God our Father and His Son Jesus Christ have come to us.'

'When this happened the hills of Satan also arose', the counterpart of N'Kamba-Jerusalem which, like the earthly Jerusalem in Palestine, is situated on a hill. What is meant by the hills of Satan are the attacks of the colonial government and the missions, which declared their hostility towards Simon Kimbangu and his followers. They were jealous that Jesus had given His power to the Africans and had manifested His new Jerusalem in Africa.'[4]

But all such earthly Jerusalems are disappointments, whether set up by enthusiastic sectarians or liberal intellectuals. Those

liberal refugees who founded New Ulm in 1856 as the basis of a utopian ethnic community were to become its status élite, monopolizing its social and cultural life.[5]

The fifth theme is the idea of the invisible city and of the invisible church. This idea loosens the bonds which tie men to terrestrial potentates, whether they be sacred or secular. It provides a foundation for protest and dissent, an interior castle and a transcendent point of reference. We are everywhere and always citizens of another country and nobody can deprive us of that citizenship. 'Our citizenship is in heaven.' Martin Luther puts it perfectly in 'Ein' feste Burg':

> And though they take our life
> Goods, honour, children, wife,
> Yet is their profit small;
> These things shall vanish all
> The city of God remaineth.

The sixth theme is closely related to the fifth: the search for the interior castle is a journey, or as Bunyan put it in a *Pilgrim's Progress*, a pilgrimage from this world to the next. Christian moves from the City of Destruction to the Celestial City and is attended on his way solely by faith and hope. He moves with the sacred objective inside him. His Ark is the covenant relation with God. God has no special place except the universal Word of judgement and release. God has no special time, because all time must be redeemed. The journey is never finished in time and can be consummated only in 'The Saints' Everlasting Rest'. This means therefore that sacred time and space are unified and the medieval partitions for a brief consistent movement torn down. This is why images are destroyed alongside partitions. The puritans break the image in order to break new ground and open up unified space. Geneva is the new creation exemplifying that unified space.

Pilgrim, isolated and alone, is also a new creation, walking towards the city by the power of adoption and of grace.

The medieval idea of the pilgrim has the same thrust but controlled within the old structure of partitions between sacred and secular. It is yet another version of the search for the celestial city which still remains tucked inside a world of liturgical cycles and divided spaces. The medieval pilgrim goes into orbit even though the trajectory moves round and round between a native city and a holy city. As Victor Turner has pointed out, the travelling pilgrim has been thrust into liminality. He is both native and alien, moving between one condition and another, shifting through gradations of sanctity. He departs for a holy period to visit a holy place (Santiago, Conques, Canterbury, Cologne), presided over by a holy relic; perhaps he visits the holy land in a holy year. Thus the movement towards unified space is halted, converted into a steady circulation through divisions of space and time, holy and profane.

The final conception of Jerusalem refers to Heaven, the great feast and the Beatific Vision. It is the reward of the saints and the vision of blessedness. Life is an exile and here we live in Babylon. But every now and then the trumpets sound 'from the hid battlements of eternity'. That sound makes all men alien because it calls them home. We are hounded and haunted by perfection and one day the trumpets sound for us.

> et ad Jerusalem
> a Babylonia
> post longa regredi
> tandem exsilia.

This is a scale of images, or, if you prefer, a scale of perfection. Like Jacob's ladder it reaches from earth to heaven, from the city of the eighteenth-century philosophers

to the idea of beatitude. Some of the notes on the scale are points of rest, while others are restless. The music of symbols must combine the restful and the restless. This combination must now be explored showing conserving potentials in radical ideas.

The argument earlier illustrated an alternative symbolic structure created by spiritual fathers, spiritual mothers and spiritual kin, and sketched the way radical symbols were redeployed to defend the positions against which they were originally launched. The same is true of the city and the sacred landscape. Christianity rejects the old Jerusalem and creates bands of alien pilgrims seeking a new city. But eventually they decide to build Jerusalem in England's green and pleasant land, in Salt Lake City, in the Bahai Temple by Lake Michigan, or in N'Kamba, Zaire. Quite soon there appears a new sacred landscape. The godly company of pilgrims on the move becomes a settled nation, with its own holy land and political mission. New Jerusalems have been built everywhere: New Amsterdam, New York, New Haven, Philadelphia. These holy cities and holy nations divide the world between sacred homeland and the opposing hills of Satan.

Switzerland is just such a case. Freedom's mountain redoubt is 'this other Eden', and to be a Swiss soldier is a sacred duty. Outside lies peril, evil, chaos and secularity. The princedom of Wales has been converted into a sacred territory, a holy land newly created. The initial movement of Welsh consciousness dotted the countryside with echoes of Bible Lands: Zoar, Hebron, Ebenezer, Little Bethel, Bethlehem. Sleeping Merlin and the living Christ together defended the shores and frontiers of Wales. The Welshman in Patagonia or Paddington is forced to sing the songs of Zion in a strange land. England, too, is full of sacred plots and holy corners alive with Arthurian promises and dreams. Avalon in

England and Avallon in France are mysterious numinous landscapes, only half hiding their secret life. The idea of one special holy land is banished only to return in a thousand disguises. When the RAF put a bombing run on the sacred Lleyn Peninsula of North Wales in 1937 it aroused the first violent expression of Welsh nationalism; when Polaris entered Holy Loch on the west coast of Scotland it had to be ceremonially exorcised by a Catholic priest. Incursions on holy land are equivalent to rape and blasphemy.[8]

Every land builds its sacred city and sanctifies a holy of holies, specially dear and unique to itself: Rocamadour, Santiago, Canterbury and Glastonbury. It need not be a city of course. It can be a holy island, holy mountain, holy stone, embalmed body or sacred image. In the tiny independent bishopric of Andorra, for example, the sense of identity focused on the image of the Virgin, and its destruction by fire in 1973 was accounted a national disaster. The Virgin stood for God and country: she was the sacred guardian of place, the protector of the city. Both radical signs, the Virgin and the city, colluded as agents of identity, of locality and conservation.

All the radical symbols exhibit this conserving potential and allow the sign of partition to describe divisions in social space. The alternative societies represented by monks and sectarians all maintain strong boundaries round the redoubts of Zion. They are based on the principle of the social or territorial enclave. The medieval pilgrims likewise moved inside a structure of divisions between holy city and profane city, holy time and mundane time. Even the Puritan pilgrim ceased to be a lonely dissenter and was slowly converted into a character type to which conventional citizens were expected to conform. The Protestant Ethic became a stereotyped cultural item. Yet the new creation of a unified space still trailed some permanent radical consequences: a universe

under one sole arbitrary and sovereign deity could become a universe under one sole mechanistic principle, to which all things in the heavens and the earth might be reduced.

Luther's invisible city and invisible church were from the start signs of division, separating the holy from the profane. The result was a permanent and deepening distinction within culture between sacred matters and secular matters. The sacred was saved, but only by isolation in a distinct closed area, denied almost all dialectic with social reality as a whole. The invisible city turned into a fortress of churchly pietism and of the inner man which left the world to the princes and the powers. Protest became Kulturprotestantismus. And the optimistic variant of the invisible city which flourished in Anglo-Saxon cultures did not fare so very much better. True, the principle of lonely protest and dissent was much better established, and a dialectic was set up between the world of holy things and the world of social reality. Separation was not identical with insulation: the spirit crossed the boundary and made forays which claimed the Kingdom of man for the Kingdom of God. But optimism too easily saw Jerusalem lying round the next bend of the historical road, and England or America nicely and providentially stationed *en route*. The theme song might have been:

> City of God, how broad and far
> Outspread thy walls sublime,
> The true thy chartered freemen are,
> Of every age and clime.

Happily truth and freedom have already achieved a preliminary lodgement in the Anglo-Saxon world. The sacred had discovered yet another temporal emplacement, a guaranteed fortress of truth.

Yet in spite of all the potent returns of locality, hierarchy and inertia Christianity still points to the unification of sacred

space, both by looking forward to the abolition of the secular and by creating a map of sacred and secular which contains a transformational grammar. It distributes sacred space and time in such a way that a determinate set of transformations is set in train. Sacred space cannot in fact be unified, but the aspiration to make God 'all in all' underlies each successive transformation.

The crucial image is a New City in which there is no Temple and no cult. The presence of God eliminates religion. The key text is in the Epistle to the Hebrews:

> But ye are come unto Mount Zion, and unto the city of the living God, the heavenly Jerusalem, and to an innum-erable company of angels, To the general assembly and church of the first-born, which are written in heaven, and to God the Judge of all, and to the spirits of just men made perfect, And to Jesus the mediator of the new covenant, and to the blood of sprinkling, that speaketh better things than that of Abel.

In other words you are on the verge of destroying all the partitions which separate the sacred from the profane. Once only the high priest was allowed entry to the holy of holies; now every man stands directly before God. But notice the implications for religion: what is made universal cannot be distinguished. The end of partition destroys sacred and secular *together*. The hierarchy of spiritual functions is destroyed along with the hierarchy of sacred space. Holy priesthoods and holy places disappear. So the universal achievement of Christianity would mean total secularization.

It has not happened. It remains the impossible possibility. Every attempt at a clear, unified sacred space only revives a covert social geography of new partitions. The visible edifice of the physical temple becomes the spiritual body of Christ, but the physical church then reabsorbs the spiritual body,

and puts partitions across the interior between sacred and secular. One may, like the Quakers, make the whole of life the Eucharist, or you may like the Puritan make every moment a pilgrimage. One may, like some modern theologians, abolish the walls of the physical church, or declare the sacrament a universal meal embodying human solidarity as such. But immediately new partitions are created at the border between those who have accepted the universal and those who remain locked in the particular. It is precisely this border which has been erected between Christianity and Judaism.

'Ye are come unto Mount Zion.'[9] But not quite. Every religion acknowledges a partition set between the time and space which has been redeemed and that which remains recalcitrant. The high priest may enter the holy of holies, but it is silent and empty. Christ may have entered the holy of holies but there is a period of silence before his final appearing. The Jews may return to Jerusalem, but the temple cannot be rebuilt. The difficulty is religious as well as practical and political. The Messiah has not yet come. Indeed there are two possibilities. Either the Messiah has not come, or he has come but the power and the glory remain under a sign of humiliation and weakness. The golden gate through which the Messiah will come in triumph stays blocked up and opaque.[10]

Notes

1. Cf. J. Whitworth, *God's Blueprints*, London and Boston: Routledge, 1975; and M. Hill, *The Religious Order*, London: Heinemann Educational Books, 1973.
2. This is brought out in Wanda Langholz Leymore, *Hidden Myth*, London: Heinemann, 1975.
3. I have drawn here on P. Nuttgens, *The Landscape of Ideas*, London: Faber and Faber, 1972.

4. Quoted in M.-L. Martin, *Kimbangu*, Oxford: Blackwell, 1971.
5. This is nicely detailed in N. Iverson, *Germania USA*, Minneapolis: University of Minnesota Press, 1976. A neat parallel from a century earlier is detailed by Gillian Lindt in her study of how Bethlehem became Bethlehem Steel: *Moravians in Two Worlds*, New York and London: Columbia University Press, 1967.
8. The 'violent' explosion of Welsh nationalism was largely symbolic. The blowing up of an RAF hut injured nobody and was carried about by a small group which included a pacifist Baptist minister.
9. Perhaps the idea for the present book came when an Australian Jewish guide in Jerusalem began to walk towards the clear open space of the Dome of the Rock and accidentally 'quoted' the words from the Epistle to the Hebrews.
10. The golden gate in Jerusalem cannot be opened until the Messiah comes in glory.

4

Marring, Breaking and Bruising

Let me begin by using conventional images and signs about the 'power' of Christ. The psalm which the Christian Church chooses to sing on the Feast of the Ascension is:

> Lift up your heads O ye gates and be ye lift up ye everlasting doors and the King of Glory shall come in.

Christ has risen and has entered in to the heavenly places. Christ, says the 'Te Deum laudamus', 'hath opened the Kingdom of heaven to all believers'. So the road is open and the way cleared and the place prepared: 'that where he is we may be also'.

These images of the Feast of the Ascension convey power and triumph: 'The Kingdoms are become the Kingdoms of our Lord and of his Christ, and He shall reign for ever and ever.' The Christmas lesson points in the same direction: 'Of the increase of his government and peace there shall be no end.' The Creed takes up the refrain of Scripture: Cuius regni non erit finis. At that moment of triumph Christ delivers up the Kingdom to the Father, to whom belongs the Kingdom, the power and the glory. But what has happened to that power? What is its nature and its name?

In the earthly city of Jerusalem the tower of the Church of the Ascension is directly aligned with the Golden Gate, through which the Messiah will come in glory. Nevertheless,

the Golden Gate remains blocked up. The alignment of that tower with that gate and the blocking of the gate together comprise a geography of signs. We have almost lost the capacity to read such signs, but they are central to a Christian understanding of how the power of God relates to the city of man. The spire of Ascension declares: Christ has entered into glory, yet the gate of the earthly city remains blocked up. The Scripture for the moment of Ascension ascribed to Christ the words, 'All power is given unto me . . . and lo I am with you alway even until the end of the world.' And at that moment 'he was parted from them'.

Entry, blockage, presence, parting. Something is assured. Something is missing. There is a break, a gap between the glory conveyed by the ascension and the hidden glory. The hidden glory can only be understood through the Christian understanding of the power of God. What is the power of God? The Scriptural answer is plain: 'The cross, the power of God to usward.' Christ is taken into glory marked by 'triumphant scars'. The scarring, marring and bruising are the source of power. St. Paul declares this is the only thing in which a follower of Christ may glory. He may make no other boast.

These, of course, are the ordinary worn images of Christian piety. Their familiarity dulls and obscures the meaning, so that they seem like evangelical formulae which conventionally accompany an appeal to be converted and believe. They appear very far from the realities of the social world, mere psychic triggers affecting only those ripe for a conversion experience. Such terminology is Bible-talk, rehearsed by those with a taste for rolling around huge and curious phrases. Yet when translated the phrases say: an essential step has been taken and we have a way through. We can follow this way only by recognizing that the power of the divine image lies in the breaking, marring and bruising. The power of wholeness is brokenness. Moreover, there still remains a blockage. The

power is realized 'in part'. We 'know in part and we prophesy in part'. The whole creation waits for the 'manifestation of the sons of God'. So the wholeness is there, achieved, complete and finished, yet we stay confined within the limits of the creatureliness. The power and the glory are partial. God is not yet 'all in all'. The mystery of God is not finished. 'Verily Thou art a God that hidest thyself.' Deus absconditus.

The new city, in which there is to be no temple, and no distinct company of the believing is a matter for faith not sight. Indeed the believing must mark themselves off in this era or dispensation, otherwise they will blunt or lose the vision of peace, oneness and unity. Unless bounded and distinct they cannot contain and retain the sense of the single city without divisions or boundaries, in which 'all nations, tribes and tongues' are at one. For the time being they remain aliens, their passports marked by the impress of a heavenly country.

> My soul, there is a country
> Far beyond the stars,
> Where stands a wingèd sentry
> All skilful in the wars:
>
> There above noise and danger,
> Sweet Peace sits crowned with smiles,
> And One born in a manger
> Commands the beauteous files.

It is a distant and a guarded perfection. This is why it is talked about mysteriously, in terms only half grasped, by men who roll around vast phrases, larger than themselves. Such pious language is not used merely out of pious preference.

How do we return from pious image to social reality? How does this sign of unity, and at-onement, relate to 'the world' and the signs around us in that world?

To make a proper return we must observe the crux of the problem in the mundane sphere: secular power. We have to look at some forms of worldly potency: dominions, dominations, powers, potentates. The proper study of divine lordship concerns human lordliness. We cannot understand the power of the ascension and the might realized in weakness except by scrutiny of ordinary everyday mightiness. Only the language of human power enables us to understand the alternative language created by faith and hope.

This will take us back to the issue of warfare and universal peace. For example, we can observe the US Air Force base by Colorado Springs, arguably the place where more mightiness has been amassed than ever before. In the centre of the base there is a temple, divided internally into denominations and religions, and divided externally from the surrounding campus. The temple is raised, distinct and bounded. It is set off. Inside, the mysterious gap conveyed by Christian images of blockage, opacity, partiality and hiddenness is made beautifully and brutally explicit. It is explicit because the architects of the temple builded better than they knew. Here then is a strange encounter of the modern, military power of ascension with the peaceful ascension of the triumphant Christ. How does the encounter work out?

The Christian sign is a cross: power by suffering, wholeness by brokenness, making by marring, the redemptive encounter with the violent wills of men. 'They did with Him whatsoever they would.' In the chapel you will find that the sign is in its usual, proper place over the altar of sacrifice and over the table where God is freely offered up and freely offers himself for humankind. But the cross has been turned into a sword which is also a plane in flight. The sword which is also a plane is being sent on a mission. It is to do a special kind of missionary work. The converting sign of Christianity has itself been converted. Ite missa est.

Here we have the spiritual power of conversion en-

countering the social power of reversion. The cross is once again a sword. More than that it is a holy sword, which means not only that the cross has reverted to the sword, but that the might of the cross has been subverted by mere might. The travail of crucifixion is now the travail of war – war conceived as crusade. The victory of the holy cross is understood according to the old temper: as victory. Even the images of peace are expected to guarantee physical deliverance. So when Christians encounter Christians they unfurl the cross of St George or St Dennis and expect to win by saintly advocacy. The Byzantine Emperor trapped in the Church of the Divine Wisdom appeals to his protectress for deliverance. War memorials assimilate sacrifice in war to the redemptive sacrifice of love.

The architects have done a neat conversion job, because the atoning blood, bringing all men together 'under God' is now the divisive and bloody sword. But that is not the end of the matter. Alter your point of vision and you find the sword is also a dove, flying skywards in the spirit of peace. The dove-like plane returns from its mission across the angry flood to presage and announce the bow of mercy set in the sky. Those who have entered the bounded barque of salvation and stand in the nave of Christ know the spirit of peace and mercy. The nave itself is shaped as a hangar to contain and express the upward thrust of the peaceful spirit. Go: in peace.

So, the subversion of the Christian sign is not total, because the ascending and descending plane is also the ascending and descending dove. Ascent and descent are the characteristic activities of the spirit. Angels ascend and descend Jacob's ladder stretched between earth and heaven. The Scripture says of Christ: 'He that descended is also He that ascended.' The downward and upward movement are locked together. Christ is taken up into the heaven of heavens and the spirit of love and peace descends to sit on the head of all his disciples. This is how it comes about that the secular ascent and descent

of the US Air Force can be reconceived as part of the mission of peace.

But in another sense love is not truly in the ascendant. The gap remains. The spirit of peace and love can be claimed precisely for the purposes of war. The dove with a branch in the mouth serves to cover up and obscure the realities of *realpolitik* not merely in the US but everywhere. Nation now speaks peace to nation the better to pursue the aims of war. Peace itself is converted into a propaganda weapon. Christian aspiration to peace constantly suffers redeployment in the interests of violence and domination and the propaganda of peace is the best weapon to cover up and cover over genuine conflicts. Even the idealisms of peace obscure the realities of conflict and the stark choices imposed upon man by social nature. This way and that the dove coos peace where there is no peace and flies malignly over the scenes of human desolation.

More than that, the cross itself allows a Christian passivity quite distinct from the active and redemptive encounter with evil. Because some form of authority is inherent in all living together the power of redemption becomes a Christian subservience to a particular order. Such subservience can be a form of passive obedience or can be sometimes imprinted on the soul. The stigmata of the cross then imprint stigmata on the minds of men, enabling them not only to accept things as they are but to rejoice in their losses. This is not at all the same as a joyful acceptance of all the costs of redemption, but a masochistic pleasure in the power of the social order to invade the deep recesses of the soul. This in turn arouses an imagery of blood which saturates the psyche and twists the means of redemption into a suppressed violence turned against the self. Indeed, both the redemptive encounter and the malign organization of the psyche can coexist together: the healing stream mixes with the sanguinary flood. There then arise huge images of unrealized violence, complemented

by eloquent evocations of a crucifixion of man which is also the death of God. In the pictures of Matthias Grünewald, the pitted, pitiable face of God is also a humanity wracked by pain and despair. The same motifs appear in the distorted hymns of the Moravian Brethren: the healing and the despair fused together. Even the conquest of violence can be turned to conquer the soul with violence. Yet at that point the healing may still occur, penetrating as deep as the losses and the despair.

> There is a fountain filled with blood
>> Drawn from Immanuel's veins;
> And sinners plunged beneath that flood,
>> Lose all their guilty stains.

Out of his side 'came there blood and water', says St John. This is the high and dangerous imagery of white and red.

> See, see where Christ's blood streams in the firmament

> Oh my blacke Soule! . . .
> Oh make thy selfe with holy mourning blacke,
> And red with blushing as thou art with sinne;
> Or wash thee in Christ's blood, which hath this might
> That being red, it dyes red soules to white.

Here is the terrible salve of the human condition pictured in the violent images of the Book of Revelation, where the redeemed are robed all in white because they have been washed in the blood of the Lamb. That is why the great upheavals of Christian history have such constant recourse to the Book of Revelation, revelling simultaneously in the strong tears and crying and in the gift of the heavenly city where there are no more tears. The tree of horror and the tree for the healing of the nations are the same.

None of this is avoidable: the Son of Man goeth as it is written of him . . . it needs be that offences will come. The hope of peace which calls peacemakers blessed already has the cost marked out for it. He set his face steadfastly to go to Jerusalem. There 'He was crucified also for us under Pontius Pilate.' Power encounters power: the immolation of love follows. He ascends his cross by the free laying down of his life and he descends from his cross at the sorrowful hands of others.

The crux is the issue of power. Here we touch the heart of the matter, since the Christian sign is not a cross for nothing. The act of redemption attracts one inadequate image after another. Frame upon frame is called up from the past to contain the mystery of atonement: judicial comparisons, the expulsion of the scapegoat, experiences of payment, placation, sacrifice or buying back from slavery. They all cluster around the tree of redemption trying to cover part of the sense and mediate the experience of mediation. How to convey the idea of the heaviest cost which lifts the heaviest load? How to celebrate and mourn the spectacle of life in death? How to understand the point of unity in the extreme manifestation of division between man and man, man and God? How to realize strength perfected in weakness? The available frames cannot contain atonement because nothing fits the idea that it 'behoved' him to suffer and to die. We ask why that of all things should be fitting.

Here we have a lack of fit. We do not know what to make of the scandal arising from the true nature of power poised against the nature of true power and the pc. .r of truth. Plainly this truth cannot be demonstrated. It is a showing not a proving, with no weapons of logic or enforcement.

Let us place the forms of human power against the form of divine weakness. By human and social nature men are joined together in blood brotherhood, either through kinship, which may be fictive, or by participation in the warrior band.

They defend their native fields and native lands and in so doing they mingle their blood together under the strict necessities of war. Their blood union is the most powerful redoubt of human consciousness and social solidarity. It represents the solidary good of mankind massed in the camp of evil, that is, domination and fundamental division. This is not to define military courage and blood loyalty as themselves evil, but to show their implication in all that pertains to domination and divisiveness. If military courage and the call of blood were straighforwardly evil they would be less powerful.

Nevertheless, it is this call of blood and the call for blood which dictates the nature of the great reversal. The war of man with man is death, either the confrontation of warring brotherhoods or the primal sin whereby Cain murders Abel. So love must take upon itself the dire necessities of our nature, giving but not taking blood, to bring about life, peace and unity, not death, war and division. These are the great contraries which meet at the point of atonement and life.

In this struggle of mighty opposites all the symbols of conquest have to be captured for the cause of Peace. This is why the Peace Army, the Army of Salvation, brought into being by this free act of redemption, must be militant and triumphant. Of course, when the Church colludes with the secular power this spiritual militancy tips towards triumphalism and also theocracy. Men are then 'forced' into Christian liberty. Every resource of language and sign hitherto devoted to the warrior ethic must be taken over. The spirit of love must commandeer all the old images.

So Christianity acquired the language of holy war as a kind of dangerous booty, which must be taken over and yet may get out of hand at any time. If faith recoils from this operation because it is too dangerous then the central redoubt of consciousness remains unreduced. The bright swords have to be put up and replaced by the sword of a new spirit and a

helmet of salvation. Warriors shed the blood of others to defend and save those of their own blood and kindred. The saviour must give his blood to make of one blood and kindred all the nations of mankind, and to reverse the primal curse of Cain.

> Put up your sword'. . . 'They that take the sword shall perish by the sword' . . . 'I, if I be lifted up, will draw all men unto me' . . .'His banner over me was love.'

As was argued earlier, the whole panoply of brotherhood-in-arms must be deployed in the warfare of the cross. Faith must capture the insignia of war in the cause of peace. Everything must be put in subjection to Christ who by delivering himself up made even captivity captive. Indeed, the new Israel has to commandeer the imagery of the captains and the hosts of the old Israel. Every Christian is a Gideon, alert to the menace of Midian. The peace army has sight of the Promised Land from Pisgah, must cross old Jordan, must put to flight the armies of the alien and build up the gates of Jerusalem. The Christian 'girds on his thigh the spirit's sword' and takes on him the whole panoply of God. Christ becomes

> Captain of Israel's host and Guide
> Of all who seek the happy land above.

The Son of God goes forth to war and the church militant moves like a mighty army. The Word is like a two-edged sword.

> What though a thousand hosts engage
> A thousand worlds, my soul to shake
> I have a shield shall quell their rage,
> And drive the alien armies back,

Portrayed it bears a bleeding lamb;
I dare believe in Jesus' name.

The word 'engage' in this hymn of Charles Wesley carries the
meaning of a duel and the word 'portrayed' is taken from the
vocabulary of heraldry. This is Bunyan's Holy War.

But there are difficulties. Men continue to live in the old
dispensation of power and violence. Clovis, King of the
Franks, hears the story of the crucifixion and says, 'Would
that I had been there with my Franks'. The Anglo-Saxon poet
writes 'The Dream of the Rood', and sees the Saviour in the
role of conquering hero. The old language of battle frames
the warfare of the cross. It takes a thousand years before the
sign of the suffering God is deeply implanted in the Christian
soul. The power of the cross becomes just power. Images of
triumphant potency invade the realm of Christian symbols.
Eventually the king of heaven takes his place alongside the
kings of earth. Heavenly kingship reinforces earthly kingship,
and their icons mutually support each other. At Ravenna in
San Vitale, Theodora and her court appear in the choir. The
empress with diadem and nimbus carries the golden chalice
towards the altar. The language of spiritual warfare capitu-
lates to the language of ordinary war.

Joshua became Jesus, and then Jesus once again became
Joshua. On the one hand, the vocabulary of war is captured
for peace, and on the other hand, the language of spiritual
warfare capitulates to power and violence. The thin line
separating spirit and nature, spiritual sword and temporal
sword, becomes both the sign of the thrust to unity, and the
frontier which marks the limited conquests of the spirit.

The disputed zone where grace confronts nature shows
how far hope has penetrated and how much it has been held
back. Over much of that disputed zone it is clear that the
redoubts of hope have been remilitarized, using the costly
advance achieved by peaceful militancy and spiritual

combat once again in the cause of secular war. The psychology of discipleship is handed over to the control of military discipline. Devotion powers the engines of force and oppression.

It is a question of power and sovereignty. Which kind of power is to be triumphant? Whose image and superscription? Granted the immense and continuous resistance generated by our social nature Christians do not entirely forget the question, 'Who is to be master?'

This, after all, was the first question asked of them as they advanced peacefully into the Roman Empire; where does your ultimate loyalty lie? Whose sacramentum, whose oath have you taken? Sacramentum means oath and that meaning cannot be entirely forgotten. The blood of martyrs keeps that memory alive and writes it in. But as we have seen the meaning cannot be entirely maintained either. The Christian Church is forced by social nature and circumstance to remain poised between the stamp of martydom and amnesia.

Enormous images of secular solidarity rise up to obliterate the Christian image, and huge idols mediate a sanctified tie of secular potency: the brutal triangular icons of Henry the Eighth, the sacred blazoned estate of Louis the Fourteenth, the multi-million banners inscribed with the image of Mao, the Japanese Emperor gloriously arrayed in huge outstretched clothes. Thomas More pits himself against the brutal image of kingly potency, the elders-in-presbytery declare Christ sole head of the Church, the Huguenots become desert martyrs rather than accept the royal edict, the 'hidden Christians' of seventeenth-century Japan are crucified. And other Christians attempt to solve the problem by complete withdrawal from the nexus of social power and military violence; the Bohemian Brethren, the Mennonites, the Society of Friends. But there is no final solution, either by martydrom or withdrawal.

So the crux of Christianity turns on power: the potency of

love and sacrifice and refusal to grant ultimate authority to secular potentates, even when arrayed in sacred claims or the verve and power of 'the people'. Christ offers a different kind of power, through an offering of himself and his spirit. The sign of that spirit is precisely the sacramentum, the oath, both the sacrament of baptism where he is enlisted as Christ's 'faithful soldier and servant' and the communion where he takes Christ's life into himself.

Within the communion all the themes are brought together in images of intense concentration. The holy meal celebrates the solidarity of the faithful, fully incorporated by grace in the body of Christ. It is a distinctive meal because that body is not the same as the social body or the citizen body. The time is not yet when there is no need for a separate different company of faith and for a celebration which marks out the special character of that faith.

The meal is an offering of God in man to man. Man takes that offering and holds it before God as a sign of reconciliation, which breaks the barriers between man and God, man and man. All the barriers are removed as manhood ascends into God even as God descends, enters into man and takes manhood upon him. There is a constant intertwined double helix of ascent and descent, rising up, offering up and entering in. By this offering, entering and rising, men are made whole. They are restored in and through the marring and bruising, and unified in the act of breakage and fracture. The marred body of this death is the risen and glorified body, cross and glory, death and resurrection conjoined.

In Christian imagery all by dying in him also rise and ascend in him. It is a corporate descending and rising in the power of the spirit of peace. In this spirit they are one and he by grace totally present in all. They become 'one new man, so making peace'.

5

Embodiment and Plenitude

At various points so far, and again later on, the exposition
leans towards the sociological mode. Now in this particular
chapter the exposition leans towards theology. It is necessary
now to state the fundamental code in which the Christian
message is carried. Since the code comprises a huge and
consistent repertoire of images it can only be stated by
recourse to those images. The *Imago Dei* demands its own
appropriate language. How then does Christianity create and
break its particular image of God?

Christianity plants colonies of divinity: the monastic cell,
the elect company of the saints, the New Jerusalem, the
sacramental element, the incarnate God. All these are
embodiments of a new order. They are all new cells
implanted in the social body to overcome the cancer of evil
and the ravages of sin. The monastic cells and the sectarian
cells divide and subdivide, each carrying a variant message
of health and salvation. The body of Christ breaks into
thousands of fragments, each newly created and bearing the
divine signature. Each cell and each fragment of the body is a
new creation, realizing a fresh genesis and anticipating a
divine order.

Such is the resistance of sin and society that most of the new
cells are converted into prisons, confiscated and redeployed
as redoubts of the old order. They are counteracted and
neutered, or isolated and quarantined, 'made of none-effect'

or made effective in the reverse direction. Nevertheless the divine image and signature is not entirely obliterated and the confiscated meanings stay embedded in the citizen body. They have been incorporated, but not destroyed. They are a potential inserted in the old structure, waiting to be activated.

The monastic cell is the edge of hope pointing towards a universal kingdom. But the edge must be protected in case it should become blunt, frayed and smudged. The colony of grace needs to create a membrane of rules to protect grace itself. The universal healing hope must be bound up and held in suspension. Hope must not be compromised by premature dilution. Every time hope is compromised the protective membrane reforms, harder, knottier and tighter: Benedictines, Carthusians, Cluniacs, Trappists. The diffuse light has to be bent down to a narrow focus, and has to contract to mark and burn a particular spot. So the universal illumination must concentrate on a particular spot, and be contained in a particular body. This is the reverse sign: universality contracted to a span, the rule of God recognized only in the colony. The liberated territory is placed under guard. Men draw protective boundaries around these lands of promise.

Not only will the monastic cell become a prison and a close guard be set round liberated territory. The flow of grace must also be controlled, held back and built up. This seems strange when grace is clearly for all. Charles Wesley speaks of the plenitude of saving grace. The New Testament speaks of an inexhaustible richness. The Book of Common Prayer knows grace as full, perfect and sufficient. The prophet Isaiah invites men to come and buy what is without money and without price. And yet this all-sufficient grace is crammed into a tiny space, railed round and rationed. It is free but you touch it at your peril and may even handle it to your damnation. The concentrated essence is a tiny capsule, slipping through the channel of consecration, passing through the patient hand of

the priest and melting in the mouth. So it is circumscribed and very tiny: a protected but miraculous seed. The miracle of the feeding of mankind is economical, and allows the weight of divinity to be carried in a crumb. It is the tiniest unit multiplied by infinity: infinity in a grain of sand and eternity in an hour.

So here are two principles, the protective rail around grace, and the carrying of the universal in the tiniest possible unit. The incarnation itself obeys both principles: the vulnerable single body of Christ bears the weight of divinity, and that divinity is hedged about. To the early Christians God was in Christ and that single affirmation constituted the exposed frontier of hope. The doctrine of the incarnation was for them the crucial junction of the divine and the human and the crucial juncture in time. The incarnation was the double frontier: bringing eternity to birth, giving mortal and visible flesh to the immortal and invisible God. God was here and now, the essence exposed and uncovered in an existence: the Ancient of Days but two hours old.

This is the reverse sign: fullness realized in privation; even in privacy and secrecy. One paradox folds into another: the universal realized in the particular, the perfect undergoing privation, life and immortality brought to birth and achieved in death. However, that is only the beginning of the paradox, because the particular is carrying a universal potential. 'God was in Christ', declared the New Testament, that 'God may be all in all'. Christ was the first-born of many. All mankind was to be united in Him and thereby taken into God. The tiny exposed colony of the divinity carried the seed of the whole kingdom. Perfection was realized in little in order to fill all things. The image is of filling and fullness. Redemption is restoration: the recovery of the human face and the remaking of the world. 'If any man be in Christ, he is a new creature.' This is why the very idea of Revelation is *newness* and renewal. It is the altered aspect and the altered prospect: a new heaven

and new earth, a new creature and a new creation. 'Behold, I make all things new.'

Here one must pause. The Christian religion seeks plenitude by the path of privation and the unity of all through the obedience of one. For Christian faith Christ is the first cell from which the universal growth may take off. This means the incarnation must be protected, just as the sacred element is protected. The core element is the truth of God in Christ: not just a message but an embodiment. 'For in him dwelleth all the fullness of the Godhead bodily.' This hope was imprinted over and over again in the worship of the Church. Christians saw themselves as members incorporated in the body of Christ, and thereby united to God. The link is incorporation, embodiment.

This is why an electric fence was and is set round the incarnation. The fence simultaneously protected the embodiment of God in Christ and the incorporation of all the members in the Head. Every creed, every rite, every hymn was dug around this emplacement. If that particular were not safeguarded then the universal was lost. So there was on the one hand a faith in the universal, man initiating a universal feast celebrated by a universal church, and on the other hand a deeper and deeper entrenchment around the divine colony, separating it from the world, the flesh and the devil. The creeds were the entrenched clauses of the constitution, the Eucharist a general thanksgiving that the clauses had not been breached. The Christian Thanksgiving Day celebrated the constitution of the new order. The margin of the sacrament, the entrenched clauses of the creed, the distinction between church and world, are one single line protecting the frontier of hope and the rights of incorporation.

The New Testament is about power: potency and potential. One power is abolished to establish another; the thrones and dominations come under the shadow of judgement. But the potential is contained under the reverse

sign: weakness. It claims that God chose the weak things of the earth to confound the mighty. Weakness is vulnerability. The divine presence can be touched, handled and disposed of. God is exposed, placed at human disposal. If that language is too heavy with orthodox phraseology, too mythological, we can say that the movement of love invites affront and betrayal. The potency of love is not protected by guarantees against rejection. It is an offering and a gift. Grace is understood as a gift, offered *ex gratia*. The relationship of members one with another is conceived as free giving and free receiving. God exists, consists and subsists in the mutual relationships of love. It is his nature and his name. He is realized in relationships. It is the prepositions 'in', 'through' and 'by' which speak most powerfully of God.

These relationships are familial, which is why the name of God is familiar: Abba, Father. The movement of love attempts to create the universal family and to mend and restore the broken relation. Blood is the sign of the broken relation, signifying simultaneously brotherly unity and brotherly enmity. Blood is the life which joins man together and the death which they deal out to each other. Abel and Cain are blood brothers: Cain murders his brother Abel and the blood of Abel cries out.

The broken relation has created a negative sign between men. They no longer 'understand' one another and are condemned to Babel. The broken relation must be re-established and understanding restored. This can only be done by love accepting the cost of the negative sign and cancelling its meaning. Love cancels the negative and recovers the relation. Alien becomes brother again; the foreigner suddenly speaks in a language we understand. The power of love can only reverse the broken relation by paying the full cost in vulnerability. It must be exposed to betrayal and to final loss. Love has to accept the possibility of death. Thus true love is realized in death: only by the openness of

love to death is the black legacy of murder reversed and overturned. Love turns evil to its own purposes, by openly admitting and accepting the possibility of rejection and frustration. In the end the embodiment of God is a total exposure: exposition and deposition. The vulnerable child and the wounded man are one and the same appeal. Neither has any power to command; both have the power to 'save'.

To save simply means to be at one and to share in atonement. It is God in man who makes possible the atonement of men with each other. The New Testament uses mysterious language here: to atone, to cancel, to restore. All of these words mean the recovery of true relationship by love and the overcoming of death by life. The prodigious power of the negation is turned to good account. Death and hatred are simultaneously reversed. Man that is doubly hurt is doubly healed. God in man rises over death and evil, making even captivity captive.

The embodiment of the divine and the redemptive death of love compose one single faith directed to one single end: the restoration of the human face so that each man is able to recognize every other as his brother. Redemption is recognition: seeing again, noticing that which was always there for the first time. The restoration occurs at the point of deepest breakage. The image of man is redeemed as the image of God is marred; man is reunited to God in the moment of dereliction: 'My God, my God, why hast thou forsaken me?' The split and the union are simultaneous.

The same is true of the embodiment of God in the elements of bread and wine. The act of breakage is the point of communion. The fracture of the body is the healing of the body, and the body of Christ is brought together by being torn apart. Life is poured out and therefore remains unexhausted and inexhaustible.

The elements are taken from nature and unite the bread and wine with the body and blood. The substances of the

natural world are taken up with the meaning of redemption and transubstantiated. Bread and wine and the whole world of nature have been infected by the curse and the negation. Now the unifying impulse strives to bring everything into subjection to the power of love. Heaven and earth are together to be filled with majesty and glory. Every created being is to shout: 'Gloria in Excelsis'. This is the cry of angels and archangels and all the company of heaven.

> Sing, hevin imperial, most of hicht!
> Regions of air mak armony!
> All fish in flud and fowl of flicht
> Be mirthful and mak melody!
> All Gloria in excelsis cry!

The breaking of the tiniest unit is the release of a locked up power capable of filling the whole cosmos. At the moment of breakage man dips in to share the feast with his fellow man and the whole world is pointed towards redemption. The New Testament looks forward to a time when God fills all things. And it also declares the fullness of deity is already with men. It is both present and to come. So in one sense the elements are all veiled, shut off, even expropriated, so that we cannot truly see ourselves or others. We remain prowling aliens dangerously approaching a concealed potentiality: a *deus absconditus* who hides himself and who has been hidden away from us, alienated.

Yet in another sense, we appropriate. We possess and are possessed. We take and eat with confidence because nothing can separate us or alienate us. Of course, we have no right, but we claim the gift and we appropriate the benefits. We do not *presume*, but we do trust. The veil of the temple is broken and Man has entered into the holy of holies where he sees face to face. The veiled and broken elements contain the fullness of Deity. Just as a single broken body contained the fullness of

the godhead, so the broken element sustains the plenitude of glory. *Pleni* sunt coeli et terra gloria tua: heaven and earth are *full*.

> He for our saik that sufferit to be slane
> And lyk a lamb in sacrifice wes dicht,
> Is lyk a lyone rissin up agane,
> And as a gyane raxit him on hicht;
> Sprungin is Aurora radius and bricht,
> On loft is gone the glorius Apollo,
> The blisfull day departit fro the nycht:
> Surrexit Dominus de sepulchro.

PART TWO

EMBODYING THE SIGN

TELL ALL THE TRUTH

Tell all the truth but tell it slant,
Success in circuit lies.
Too bright for our infirm delight
The truth's superb surprise;

As lightning to the children eased
With explanation kind,
The truth must dazzle gradually
Or every man be blind.

<div align="right">Emily Dickinson</div>

Deos facturus qui homines erant, homo
factus est qui Deus erat

<div align="right">Augustine</div>

Creative Word and Formal Incantation

It is impossible to say, in general, whether rite precedes word, or word creates rite. But it is perfectly possible to say that for Christianity in particular the creative word comes first. The Lord gave the word: great was the company of the preachers. The preachers respond to an authoritative voice. They experience a constraint which unleashes their tongues. They have coals of fire set on their lips because they 'have seen the King, the Lord of Hosts'.

This then is the Christian sequence: now I see, and therefore I speak. From this sight and this proclamation issues a community of faith. Somebody perceives the world in an altered light, as other than it seems. The great biblical paradigms are Moses and the bush on Sinai, the disciples and Jesus on the mount of transfiguration. Both incidents convey alterations of perspective: the ordinary touched by otherness. Mountains increase the range of vision by providing a new angle and unblocking the doors of perception. They are scene shifters.

The fresh image and newly minted word have to be reproduced. A new coinage has been issued which requires circulation. The 'express image and brightness' has to be dimmed and solidified to become part of ordinary exhanges between one man and other. Reproduction and exchange demand standardization. New coinages cannot circulate without a standard form embodying the received image. So,

it is not a simple case of routinization, whereby the new is handled over and over again till rubbed smooth and almost indecipherable. Rather the power of the new coinage depends on the acceptance of a common standard of worth and an agreed formula for exchange. What is passed on and around is inherently normative. A coinage which is constantly questioned cannot move about or permit the free commerce of persons.

Norms, standards, formulae, routines: these exist to stabilize the molten wax of vision and pass on the imprint. What is the nature of this imprint? To some people, of course, the religious imprint is merely a set of rules which are legitimated by a higher authority. This aspect is certainly present, since God is easily cast in the role of a secular potentate. But equally important is the fascination exercised by a complete and rounded image of the world as it might be. Religious visions are not so much rule books as compelling, inclusive pictures of transformed selves and altered worlds. They are projects which pull men into their orbit. Believers are sucked forward and transported into a powerful pattern which incites them to make it real. Thus the norms and formulae are themselves impregnated with dynamism. The act of stabilization known as liturgy discloses a future possibility by imprinting the compulsive, compelling norm. This norm is not *an* order but a new *kind* of order.

Religion is less a rule book than a set of spells by which people are bound in a certain direction. A community is held spell-bound by an image, transfixed by a verbal incantation. The spell contains a strange mixture. Potent spells are never pure.

This needs illustration. Suppose a man is impelled and compelled by a pure vision of free, equal and loving exchange between Father and Son, or, to avoid sexist overtones, first person and second person. This vision fixes a potential and imprints a possibility. However, transforming faith must also

bear the full counterweight of dominant social forms. Text must incorporate context. The hope of unconditioned, free response has to take in the power of contemporary patriarchy and serfdom. Without incorporating some of the weight of established forms hope becomes weightless. The spell-binding potency of hope arises precisely because the immense counterweight of established forms has been hoisted into the ambit of a new kind of movement. The resistant, repressive weight of primordial givens is tipped towards a new field of force. This does not mean that the huge blockages immediately begin to travel in the direction of the new movement. Not at all. But they have been tipped and positioned in such a way that they are no longer dead resistance. The spell moves the immovable by the re-deployment of inertia.

This process is not identical with the dialectic of creative word and reproductive routine. Nevertheless the two processes work together: reproductive routines carry forward the counterweights incorporated by hope. Hence the spell turns ambiguous. Men are simultaneously bound forward by the spell and held in bondage. They are arrested by hope. The vision incarcerates. The human form is frozen in a liberating posture. The slow incantation of liturgy is a petrifying stare, binding over the helpless escapee. The bond of community and the binding force of the past both hold the image of liberty in place, preventing any breath of hope or movement.

The stony stare which turns liberating images into petrified corpses is unavoidable. All journeys to freedom pass through an enchanted garden of spell-bound ideas. Activity has to be arrested in a timeless heaven of exemplary form. Mere flux is without form and void, whereas what has been arrested defines and persists. Christian martyrs and political heroes have to be 'held up', that is, fixed, defined, placed and put beyond flux. Ideals crave over-definition since that is a precondition of survival.

Liturgy is a way of holding things *up*, a stronghold which protects the treasure and creates the standard. The truth is buried in the ground like gold at Fort Knox, but (like coinage) it embodies the standard which allows free exchange. Every form of transport depends on reproduction and the renewed standard. Translation, transport, transcendence, transfiguration, transubstantiation – everything that passes through – depends on the received, the reproduced, the recorded, the recognized. Liturgy is transport through an act of recognition. I re-cognize the image and so I can know it in a new way.

Liturgy is performed in an enclave called 'the Church'. It is the way the faithful carry on in a special place, which is known as 'the Church'. Christianity creates special institutions and special places. Sociologically, one can say that Christianity is differentiated from society at large. Indeed, this differentiation is a social process whereby the Church was once almost coextensive with society and has since become more and more distinguished from it.

What now is the situation of liturgy in a church which is able to claim only a sector of contemporary life? Granted the vast repertoire of word and image donated by liturgy to Western society, in the past, what now is the state of Christian practice? The word 'practice' is used intentionally because it includes two distinct elements: the performance of 'practices' and the idea of applying a theory in social practice. How the broad social practice of Christianity works out must be left to the final part of this book. What follows concentrates on the practice of religion, in terms of celebration, remembrance, proclamation, and every invocation of the transcendent in act, image, word and musical sound.

6

Profane Habit and Sacred Usage

For many people, perhaps for most, liturgy is habit tempered by affection. Liturgy is use: what people are used to. It is recollection: the way things were done at St Etheldreda's or St Lawrence's or St Mary's. Use is usage.

Usage implies familiarity and things which can be taken for granted. At some time, maybe, in early adolescence (or in late domesticity) a person has friends who attend church services. He likes a girl; or she likes a boy. The youth leader has a personality. The discussions in the club are warm and stimulating. There is somewhere to go: friends. There is a role to be accepted as server, chorister, bell-ringer, fund-raiser or secretary. One way or another people are networked and liturgy can be part of those things which go on in the network. Liturgy is one of the known, accepted and acceptable activities which make up the pattern of group activity. It may even be part of the definition of a group, so that the St Mary's crowd are set apart from the crowd at St Etheldreda's.

So each quirk and oddity and each familiar known way together enter into a definition of self. Even sacrament becomes a badge and the members of the network wear the same badge with a difference. The result is an odd mixture of universal and particular. On the one side the sacred rite links the local congregation with the wider scope of the Church at large. On the other side the quirks and quiddities give a

special character to a local, particular sentiment. People cling to the signs of their identity and their history.

The sacramental feast is a personal and communal rite, which acts as an efficacious sign. The sign activates a history, a membership and a selfhood. A particular kind of invocation evokes a memory and a continuity. As the rite returns, turning and returning with the rhythm of the year, so the continuity of membership and of memory is maintained. It is like the order of seating for a meal at home and the ritual act of carving the meat. The Father carves. The liturgical order belongs to these familiar rhythms and ways of doing things. All the buried selves of innumerable yesterdays are reactivated in the order of worship.

These buried selves are brought alive in the present by all kinds of associations. Liturgy is about associates and associations: people remembered, and sights and sounds recollected. Such things can be very simple: the remembered opening of a gate or the creaky movement of a door. It can be the sound of a bell or an organ. Just the act of repetition is enough. The words 'saying after me' are sufficient to unite all the buried selves in 'those things which we do at this present'.

These associations are potent not only because they reach back into the recesses of self but because they can unite several sides of self in a single act of recall. 'Our Father, which art in heaven, hallowed be thy name, thy kingdom come.' Lips move along a familiar groove which contains resonance of home and school as well as church. The act of repetition is a summons to complete attention.

A prayer is like a table chanted in school. Children enjoy the rhythm of repetition, letting once two is two, twice two is four sink in simply by running through the groove again and again. This is why the Japanese are so much better at Maths than the rest of the world. They learn by rote. To some people these ancient chants seem mechanical and thoughtless: mere vain repetitions. They see chanted prayers as so many scales

standing between the child and real personal music. Musicians and mathematicians know better.

Chants, scales, tables and repetitions are ways of freeing the attention by making a lower hierarchy of habit purely automatic. An absolutely familiar sequence allows the mind to stand outside for a moment: in suspension, in recollection, in interpretation, or in ecstasy. At one level the saying of a collect can be somnambulistic. The ancient syllables are part of a waking dream. At another level the collect touches a profound level of recollection. A man is enabled to re-collect himself. He stands recollected. The words have acted like a tuning fork to bring all the disparate modes of being into a unifying harmonious world.

This is where rhythm is especially important. A familiar rhythm has the power to lift the mind out of a groove and also totally to absorb the attention. A collect is groovy, capable of simultaneous capture and liberation. The balance of phrases and thoughts creates an active stillness. This means that the slightest disturbance of the balance of thought and phrase is destructive. It is as if you were listening to the slow movement of Bach's double violin concerto and a beat was added or taken away. It is like a persistent click in the groove. Signal is lost in noise. The mind returns to the level of surface tension. It buzzes with helpless fury like a wasp against a window. The free movement which rhythm makes possible has contracted to a nervous spasm.[1]

So the movement of the mind depends on rhythm and constant repetition. This is as true of charismatic worship as of the completely prescribed liturgical score. The extempore cadenzas of the charismatic movement are almost all written out beforehand. Phrases and gestures follow each other in familiar sequence. Above all the sermon is a fixed mosiac of quotation. There is a basic repertoire of texts which punctuate the exposition of the Word and these act as marks of identification and identity. The quotation acts as a

hallmark or as an invisible thread in the note which separates true from false. It certifies the exchange rate between speakers and hearers. To quote is to let people know where they are and who they are. Without a repertoire of quotation the people would be lost and the preacher would lose his way. The set pieces are the preconditions of extempore worship. To be out of time, ex-tempore, you must first know how to be in time. Quotations are the *notae* of the Church: the necessary notes of authenticity.

Formal prayer is quotation, just as tables and scales are quotation. Quotation lies very close to cliché; the ecstasy of quotation easily descends to the boredom of cliché. The main problem of public worship is boredom. However, there are two kinds of boredom which differ from each other as much as quotation differs from cliché. One kind of boredom derives from straight lack of stimulus. The preacher's mind is an anthology of cliché: the conduct of prayer and praise is lifeless and insensitive. This kind of boredom leads to wandering. The housewife sits and wonders what the price of turkey is going to be for Christmas. The other kind of boredom is a mid-point between the contingent dislocations of everyday life and the shift to ecstasy. A musician moves patiently through a score, committing it to memory. This is an act of appropriation. The score is both fixed and open and he has to transfix the notes in order to transfigure the music. A priest moves patiently through the Eucharist fixing the underlying pattern more and more deeply in order to allow for transfiguration. He practices his religion over and over again. Without that boring, stereotypical practice no illumination is possible. Boredom is the infrastructure of illumination.

Here perhaps we should discriminate. Illumination comes in various kinds. One kind is the condition of being lit-up. To be lit-up is to be stoned out of your mind. When rhythm is transformed into an insistent hypnotic beat the rational

faculty is overwhelmed. Another variety of illumination is enlightenment. To be enlightened is to achieve an integrated wisdom. A man recovers ancient simplicities altered and transformed by experience and discipline. Very simple sayings are reappropriated in a new sense. A third variety of illumination is union with the ground of being: the beatific vision.

None of these kinds of illumination seems to me the primary objective of public worship. The first lies too close to fixation and the 'fix'. The second and third imply the existence of levels of wisdom and being which are perhaps rather rarely achieved. They verge on gnosticism. By illumination I mean the kind of interior quiet which assists attention. Prayer and praise are a form of attention. Most people do not go to church expecting the beatific vision any more than they expect to be informed. They go in order to attend and be attentive.

Attention to what? Certainly not to a series of empirical propositions or to a train of logical implication. The language of faith is not propositional. Existence cannot be forced and crammed into propositions. Existence is framed in images, linked together by tables of poetic affinity. Common prayer is sharing common images. These images are dense, concentrated reserves of meaning and implication, centring around suffering and hope, forgiveness and judgement, birth and re-birth, death and resurrection. They work by personal response not rational understanding.

This means that a man entering a church is receiving signs and signals designed to alter his world. He sees the ordinary elements of his experience, height and depth, bread and wine, fire and water, city and garden, transubstantiated. These altered elements are signs of longing which connect memory with expectation and link his personal experience to a universal context.

Signs and signals are conveyed in poetry. Poetry is

irreducible. It cannot be cut down to some other form of statement, clearer and more valid. Moreover it is closely linked to poetic form: repetition, incantation, balance and the precise ordering of words. This does not mean that poetry cannot be translated, only that the power of the image is incarnate in specific form and expression. A poetic idea is not a generalized notion indifferently susceptible to any number of expressions. Poetry has a local habitation and a name. People enter into the local habitation and know it by that name. This is particularly true of liturgical poetry which is shared quotation, known by heart. Liturgical quotations have an integrity which is wrecked by even the most minor transpositions. Indeed the most damage is caused by the most minor transpositions. A major translation would be a work of re-creation, whereas minor transpositions simply tamper with achieved form. The mind cannot attend because the rhythms which make attention possible have been disrupted.[2]

But what about the clarification of obscurity? What about those who are uneducated? There are several misunderstandings behind such questions. There is no difficulty about uneducated people learning quotations by heart. One generation after another of the unlearned has apprehended religious truth through liturgical poetry known by rote. Rote and rite are closely connected. They are the things we have by *heart*. Nor does it matter whether or not the full range of meaning is grasped immediately. The full range of meaning cannot be grasped anyway. A poetic statement is not a fuzzy archaism to be cleared up by a modern translation. It is an induction into a historic world of meanings, an offer of a range of alternative visions. These exist alongside modern statements in their own integrity and in their own right. To tamper with that integrity is to ex-communicate other worlds and cut off the cumulative resources of meaning. It is like reading the works of T. H. White to children, and turning every phrase into basic

modern English. Of course T. H. White cannot be grasped immediately and that is why he is a good author to read and above all to re-read to children. He offers the possibility of other worlds and new languages alongside and beyond their own. At the beginning of *The Sword in the Stone* White pronounces a curse on all those who try to cut down his meaning to what can be easily apprehended. There is nothing so fascinating as a glorious nugget of half-apprehended meaning, and the hint of additional sense. It incites enquiry and invites mastery.[3]

One need hardly say that modern liturgical reform has been largely conducted on principles utterly opposed to those just put forward. The reformers have ignored the role of rote and rite in establishing and defining selfhood. They have damaged the rhythm of verbal incantation and thereby interfered with the very possibility of attention. They have wrecked the powerful rime. They have closed off historic worlds of feeling and acted as though congregations were incapable of picking up alternative visions and meanings. For adult individuality they have substituted childish communality.

They have tampered with achieved form without any attempt at a serious translation in modern terms. They are, in the words of Mary Douglas, colour-blind signalmen. There are three further characteristics of modern changes which are worth noticing and challenging. They are an intrusive moralism, often with political overtones, a curiously explicit insistence on spontaneity, and a thrust to obligatory communitarianism.

Moralizing is not in itself anything new. There is a long Christian tradition of telling people to be good. But modern moralizing has some special characteristics. In the first place it is thoroughly dissociated from the idea that men are miserable sinners. One of the objections to the Book of Common Prayer has been the unflattering way in which one is

obliged to refer to oneself. Moreover the unflattering language makes no distinction between the healthy, the mildly maladjusted and the positively pathological. Everybody is made to sound as bad as everybody else. This leaves very little room for moralizing and allows no option but forgiveness and salvation.

If on the other hand men are basically well-intentioned then the scope for moralizing is greatly extended. Man's good intentions can be appealed to and deployed for excellent causes. The Church can then become the home of good causes. If resistant and recalcitrant individuals still exist they are presumably fit objects for psychotherapy. Insofar as people in general seem to retain hints of corruption this can be attributed to the effects of the 'structure' and the 'system'. Indeed, everybody can be seen as a casualty of the system. The pathological cases can be viewed as the serious casualties and the rest as examples of minor damage. The pathological cases are beyond exhortation, but those suffering from only minor damage can be exhorted to do something about the system. Thus moralizing switches from individuals (who are pretty good on the whole or would be so if not distorted by the system) to the malignancy of society in general. By a further mutation moralizing turns against the idea of social structure as such.

The changes of approach just indicated raise difficult if not insoluble problems, but the switch from the malignancy of our human nature to the malignancy of our social nature has important consequences for liturgy. In extreme versions it would appear as if the very fact of social structuring is the essence of 'sin'. This means that repetition and patterning are the primary manifestations of the curse. Since I have argued earlier that they are the primary sources of selfhood and identity and the preconditions of attention and transcendence there is clearly a central clash of viewpoint here.

Those who think that the fault lies in the very idea of

structure will be in a state of chronic fear lest any elements of ritual continuity should establish themselves. They will see social roles, and especially religious definitions of roles, as forms of imprisonment. Habitation and usage will be the marks of the Beast. Men will be truly themselves only when shocked out of their habits, including their clerical habits. So moralizing is roughly equivalent to shock. Any firm and settled form of speech will be regarded as a confinement restricting the emergence of underlying authenticity. Jerks are good for you.

Perhaps not many people hold this extreme view but it was quite popular in the educated middle classes of the sixties and it contributed to the pressures against the traditional forms of worship. This is the point at which to go on to look specifically at the cult of spontaneity which had diverse sources apart from the extreme view just mentioned. The major source is the idea of self-expression and the potent opposition proposed between the language of self-expression and the language of common identity. What perhaps should be stressed is the way we are currently suffering from a hang-over originally induced by currents of thinking in an influential sector of the intelligentsia which drew either on the chronic fear of structure *as such*, or else exaggerated the opposition between selfhood and communal organization.

For those addicted to the cult of spontaneity ritual form was condemned as the religious equivalent of good manners. Ritual restraint was the authorized version of psychic repression. Form and restraint were equally divisive because they provided ways in which the true self might be held back from authentic contact with others. A form was not a facility, but a rigid barrier to communication. And language was the paradigm case of a structure which inhibited the expression of the self. So many people tried to speak as if sentences did not exist. They tried to convert language into a series of

ejaculations, or else eschewed language in favour of touch. One of the impulses to speech in tongues lay precisely in a preference for ejaculation over structured speech.

Thus many people set off on a voyage of mutual invasion, whereby language was used to break through the defences of the self. Provided the defences were down, the boundaries breached, and the distinctions of form erased, selves would relate harmoniously. Some T Groups worked on just this principle and conducted concerted attacks on the conventional boundaries of the self. They therefore institutionalized the cult of spontaneity. Needless to say more people were damaged by these invasions of their private space than were assisted to openness and authenticity.

Institutionalized spontaneity is important because this too affected the Church. Once the implicit understandings undergirding the old ways were disturbed or uprooted every activity acquired a new explicitness. The ritual rubric became much longer. A priest who wanted to initiate spontaneity had to explain exactly how it was to be done. People had to be warned against any relapse into habitual ways or manners. In this respect changes in language could be regarded as very useful because they constantly disrupted habits. The disruptive effect of linguistic innovation was valued just as highly as the opportunity for modernization, if not more so. Anything that jerked people out of understood, implicit activity was supposed to assist the emergence of true, spontaneous consciousness.

This was linked to a renewed stress on the power and influence of the holy spirit. The holy spirit is often invoked in times of upheaval because inspiration is conceived as the source of the wind of change. Whenever people want to alter something they claim to be hearing the voice of the spirit or to be actually 'in the spirit'. This allows *Zeitgeist* to be represented as *Heiliger Geist*. Once the Holy Ghost is lined up behind the forces of progress the hapless resisters are left with

no legitimate defence. The Spirit breaks in and that means that He breaks up the ancient moulds and overflows the archaic channels. He *is* true spontaneity and therefore irresistible.

The cult of spontaneity uses physical contact as a way of breaking into the protective space between members of congregations. So the pew in church is treated like the desk in school: an obstruction cutting down the free flow of spontaneous contact. People must be encouraged to tear down the obstruction and cross the barrier. Solitariness becomes sin. A girl or boy in school alone with a book is an offence against existential openness. A man or woman alone with God or just thinking or existing *in foro interno* is an offence against the pressing demands of his fellow human beings. God's house has to be rebuilt on an open plan with each cubby hole exposed to public view. Corners are offensive. Personal meditation is disallowed. Everybody is opened up on first name terms and made to feel at home in the holy club.[4]

I use the phrase '*made* to feel at home' because this capture of private space is an organized invasion. No doubt there are some people who like it; no doubt some of the invaders simply want to be friendly. But whatever the intentions cosiness became mandatory. The 'kiss of peace' for example was just such a mandatory gesture. Unhappily the usual version of the so-called 'kiss' is a shake of the hand. Shaking hands is not usually a sign of vital encounter but it became incorporated in the rite as an obligatory sign of spontaneous goodwill. It is the ecclesiastical version of the group-grope.

The 'kiss of peace' is not in itself important but it does serve to illustrate the paradox that authenticity is backed up by obligation and public pressure. The incumbent makes it incumbent. Moreover mandatory openness can be linked to cosy communitarianism. This in itself is not new: scouting for boys included a healthy godly variant of hearty good

fellowship in which everybody was expected to join. But hearty intrusions could usually be avoided in the major rites of the Church.

The modern, revised standard version of heartiness combines various strains. One is the nostalgia for *Gemein-schaftlich*, primary face-to-face relationships. Another is straightforward bonhomous good fellowship. Yet another is the slow but tangible movement away from a civic church to a small semi-sectarian cell. And finally there is the call of the commune, which appeals to the clerical intellectual as the antetype of suburban churchmanship.

None of these strains need emerge very strongly but there is generally a tincture of all of them.

The shift to sectarianism is much accelerated by the variety of usages and by the fact that some are exclusive to the regular church-going sector. The changes in the Lord's Prayer mean that people half outside the Church no longer know what the faithful are up to. The ordinary church-goer has to be very well-up in the latest altercations if he is to be at his ease in some church other than his own. Series Three, for example, easily becomes the personal property of a small and cosy in-group. For example, at midnight communion, a woman entered my local church in obvious distress. Her lips tried to find the familiar words and ancient consolations. But there were no comfortable words to hear or to say. She had stumbled into the semi-private rite of an episcopal sect.

W. H. Auden's comments in the *New Statesman* for 29 June 1973 are very apt.

In one version of the Lord's Prayer they have 'Our Father who art in heaven'. Why? Nobody can ever have thought the pronoun *which* meant God is neuter. Then they open the Nicene Creed (but not the Apostles' Creed) with *We believe* instead of *I believe. We* may be alright for children,

but an adult has to accept personal responsibility for his faith.

Auden has laid his finger on the attack on individual responsibility and the preference for childishness.

One major change is the shift away from vertical relationships towards horizontal ones. God is seen as the midpoint of a social circle not as the apex of a pyramid of being. The people are seeing God as they face each other. This emphasizes face-to-face control and places the locus of law in the magnetic field of human relationships. The people of God do not face towards an external point but create that point at the interface of their common life.

There are gains and losses here. There is less stress on the authoritarian externality of God and this is a gain. On the other hand it is very easy for individual conscience to be absorbed in collective consciousness. Conscience appeals to a point above the heads of the crowd. Of course conscience is initially generated in a group since moral awareness is a creation of interpersonal relations. The very word 'conscience' suggests this. All the same independent judgement belongs to the notion of distinctive unique individuality. If the idea of the unique individual is weakened the idea of conscience is weakened with it. Conscience needs to clear a private space in which to take its bearings. It needs to have a point of reference outside the confluence of public eyes.

Not only is there less emphasis on the authority of God but also less overt emphasis on the distinctive role of the priest. Authority figures, human and divine, are out. That in itself is presumably an advance: Christianity is about sonship, not about paternalism. All the same there are some difficulties. Authority is a necessary part of human relationships and hierarchy an inherent element in social organization. If

authority is not now symbolized in the sphere of the sacred it either has to appear naked or to hide behind the fig-leaf of communal legitimations. Authority either speaks in a tone of plain assertion or else pretends to be the voice of the people. *Vox Dei* becomes *Vox populi Dei*. Those who speak on the authority of the people are often more pressing in their demands than those who speak on the basis of traditional authority. At least traditional authority is circumscribed by traditional limits and ancient let-outs. Traditional authority, especially when exercised in modern conditions, usually allows a great deal of private space for personal dispositions and individual options. Popular authority is often oppressive because so all-encompassing.

Suppose that your reformer wants the people of God to stand in a circle facing each other rather than in rows facing the altar. He intends in this way to show that God is in the centre of human concerns and that we are all joined one to another. He sees the circle as communitarian and democratic whereas a line of worshippers facing east implies authority and externality. But the line facing east may just as well signify open-endedness. A priest with his back to the congregation may signify that both he and they are subject to the divine transcendence and judgement. Equally the circle has symbolic disadvantages: the people of God are all turned inward with their backs to the world. If they are a circle, how can they be *en marche*, *en route*? They have lost their orientation and the external point of reference to which they may move and to which all things tend. A person pulled into a circle is exposed to the immediate and continuous inquisition of other eyes. His defensible space is overwhelmed.

There is now quite a lot of evidence about the importance of defensible space in ordinary living and especially in the home. Yet the circle, so widely insisted upon in God's house, is a very deliberate attempt to cut down the space within which an individual may protect himself. Contemporary

preference defines individual integrity and the integrity of personal space as mere crabbed and furtive defensiveness. This is only because the proper rights of individuality and individual responsibility are confused with the improper claims of rampant and competitive individualism. All such shifts are pointers towards the new collectivist ethos and the diminishing of individuality. Did the reformers but know it they are engineers not of community but consensus.

Similar confusions affect the penchant for standing rather than kneeling. There is nothing inherently progressive about standing unless kneeling is thought to signify immobility or regarded as the religious analogue of social deference. But kneeling can just as properly signify ecstasy: a kneeling man is removed from the static categories of man erect. A kneeling man presents the human figure in a new light which both extends the world and humbles it. A change of posture is a change in the angle of vision.

What a symbol or figure means at any one time is largely a matter of context, more especially the context of those things which are thought to stand counter to it. You cannot simply make a symbolic change which then permanently defines those new things you wish to say. When you make a change the old signs soon begin to receive part of your new meaning. Once that happens the ambiguity of new sign and of old sign becomes clear. Thus a protective space around a man may signify the isolation which is accorded authority or a decent sense of privacy. It may signify rank or the respect properly accorded to human beings as such.

Signs cannot speak everything at once. They will only give voice to some of the possibilities and will cut out others. This is one role of silence: to refer to the possibilities which have been cut out. This is also the role of music: to present the full range of possibilities in terms whose content cannot be verbalized. Whatever signs are selected they will leave God in his transcendence and convey in this way or that the

brokenness of the human state and condition. The brokenness may be conveyed in partitions between man and God or in signs which speak of the inadequacy of signs. The fundamental sign, *the* Christian sign, says Yes and No simultaneously: the power of God in weakness.

This is not, of course, to defend the kind of legalism which operates by external fiat and which has deformed the Roman Church from time to time. But it is abundantly clear that the shift to populistic claims to authority, invoking the people or the people of God, are scarcely less demanding or all-embracing. This is true even of the mild slope of authority between cleric and laity. The clergyman may cease to claim a special area for himself. He may abolish the high altar, ignore the altar steps, remove the distinction between nave and chancel, and face his people as part of one united circle. Yet when he speaks he nevertheless insists and requires. He may define himself as a resource-person or as an enabler, but he cannot avoid insisting on that definition. He may divest himself of the clerical garb but he cannot so easily divest himself of the role of leadership. And the communitarian ideology may actually reinforce his leading role. The new mode requires more explicit authority than the old.

One paradoxical facet of liturgical reform is worth emphasis. The changes are initiated by clerics and defended by them. Partly this is because liturgy is one of few areas where expertise is largely confined to the clergy. But it is also because the changes embody more explicit commitment. As was argued at the beginning the average layman is a creature of habit, and his feeling for liturgy is habit tinged by affection. It is based on associations: people known, things remembered. The clergyman wants something more than association: he wants community.

That community looks a long way back and a long way forward, to the primitive church and a new society. The Eucharist is equally the memory of an axial past, celebration

in the present, anticipation of the future. But a great deal depends on the precise balance of these elements of memory and hope. Perhaps this is a proper point at which to conclude. Liturgy *is* a complicated balance of elements. What is the relationship of horizontal to vertical? What is the balance of spontaneity and rule? Where shall the line be drawn between communal participation and individual private space, or between group consciousness and personal conscience? How far is liturgy personal and meditative, how far political and activist? To what extent is it a treasure-house of past being and ancient resource, or an ideal mirror of our present state or an anticipation of a transformed future? How is the *theologia crucis* combined with the *theologia gloriae*, the signs of suffering with the hope of glory?

Notes

1. This is one reason why the recent vandalization of the collects is so harmful. It is the precise balance of phrases and the exact sequence of words which makes attention possible. George Steiner has some comments which are relevant here, because they underline the relationship between diminished words and diminished meaning. 'The writer of today tends to use far fewer and simpler words, both because mass culture has watered down the concept of literacy and because the sum of realities of which words can give a necessary and sufficient account has sharply diminished'. 'Compare the vitality of language implicit in Shakespeare, in the Book of Common Prayer or in the style of a country gentleman such as Cavendish, with our present vulgate.' G. Steiner, *Language and Silence*, London: Faber and Faber, 1967.
2. One notable distraction is the repulsive phrase 'And also with you' which the Anglican Series 3 has borrowed from the new Roman rite to replace 'And with thy spirit'. The rationale is quite unclear. Perhaps the reformers thought the unwary might suppose the priest was addicted to hard liquor. Elsewhere, however, they have altered 'ghost' to 'spirit', presumably

because they thought a misunderstanding about hard liquor less harmful than a misunderstanding about holy spooks. Other alterations are not so much objectionable as pointless. For example: 'whose property is always to have mercy' has been changed to 'whose nature is always to have mercy'. Can it really be that in a 'scientific' age 'property' is regarded as an unfamiliar word? Or are we being preserved from the idea that God has a piece of real estate known as 'mercy'? Such pinpricks are, of course, quite minor compared with the dislocations of rhythm in the great liturgical poems, like the Te Deum. The ICET translation of 'Te Deum laudamus' begins 'You are God, we praise you', which is pedantically more or less correct, but liturgically and poetically null and void. Cf. M. Perry, *The Paradox of Worship*, London: SPCK, 1977, Ch. 4. Even worse is the banishment of the marvellous sentence beginning 'It is very meet, right and our bounden duty' in favour of a piece of bombast which priests try to shout because it possesses neither shape nor natural stress.

3. When I was an adolescent my minister, the Reverend Rudland Showell, asked me to say what I thought wrong with the service of holy communion. Not having any real views of my own on the matter I trotted out the idea that archaic words were difficult to follow. He then asked me to go through the text listing obscure words and phrases. I discovered there were none, except for the phrase 'his one oblation of himself once offered'. He then told me what it meant and I thereby learnt something new. Words like 'bounden', 'prevent', 'property', 'meet' and 'heavenly benediction' are verbal delights which fascinate children, like 'yum yum' and 'fe fi fo fum'.

4. In the course of personal conversation, Victor Turner has pointed out to me the dialectic between subjective meditation and the massive objectivity of the rite before the new forms tried to pack everybody into a unified, collectivist circle. For poignant and pungent comments cf. Mary Douglas, *Natural Symbols*, London: Cresset Press, 1971. It is significant that the most distinguished of contemporary anthropologists should have commented so unfavourably on certain aspects of contemporary liturgical reform. Cf. also a helpful comment on the Eucharist in R. Firth, *Symbols: Public and Private*, London: Allen and Unwin, 1973, Ch. 12.

7

Mundane Speech and Divine Word

This chapter is an aside about preaching. Like so much preaching it is pious opinion glossed by sociology. The style differs therefore from what comes before and after and may be omitted by those who wish to stay in the same vein, or fallen upon with relief by those who do not.

Clearly preaching is not so socially important as it once was. The sermon is no longer a major source of communication. The flow of communication runs through other channels, like television, radio, newspapers. And the number of people who tune in to this particular channel is relatively small. The English audience figures are no more than four or five million.

Very few people declare themselves enamoured of sermons. They are regarded as boring interludes between one part of a service and the next. The very word sermon suggests severity and unction. Someone who sermonizes is supposed to deliver a severe and righteous comment at length and in stilted prose. The sermon shares this unfair press with the lecture and the political speech. To give somebody a bit of a lecture is to speak rather loftily about principles. To speechify is to harangue with the maximum of rhetoric and the minimum of content.

So the sermon, the lecture and the speech share the same condemnation. It is probably worth asking why. The sermon should not be discussed entirely in isolation. Many

tendencies which affect the Church are part of tendencies that affect the whole society. If the Churches are under pressure it is worth asking to what extent *all* voluntary associations are under pressure, whether religious or not. And if the sermon is unpopular then it is worth asking whether speeches and lectures are equally unpopular. Indeed the question might be: what has happened to voluntary associations and to the role of formal speaking? The issue concerns the local chapel, whether religious or trade union, the local party, the local WEA or Co-op Women's Guild. And it concerns a style of public talking: the speaking man addressing his fellows.

So far as the chapels, parties, guilds and associations are concerned I think it reasonable to suggest they are in decline. It is precisely because local party or branch meetings are so sparsely attended that Trotskyites can take over the local constituencies or hard-liners dominate union policy. The old educational associations and libraries have been largely absorbed in formal educational provision under the aegis of large-scale bureaucratic organizations like universities and polytechnics. People do not gather together any longer for entertainment arranged by the Pleasant Sunday Afternoon movement. They watch the television instead or go out for a drive in the car. All these changes have been going on for some while and they involve familiar common char-acteristics: a shift from local to national networks and a change from active participation to passive entertainment, both of which contribute to a withering of local civic involvement.

So the occasions when people come together locally and address each other formally on matters of political, religious or educational concern are diminishing. Of course that statement should be qualified. Rotary is probably flourishing and the Buffaloes. No doubt people lean back at the end of a well-wined meal and tolerate a few drink-sodden remarks from the Rotary President. The Mayor rises during the civic

banquet for a vote of thanks and a joke or two. Yet another qualification is necessary. The open, middle-of-the-road bodies may be declining but the small sectarian groups are slipping into some of the vacant space. The political sect and the religious sect flourish. These offer total participation. They demand total commitment and offer an all-encompassing, all-absorbing world-view. The Mormons, Witnesses and Socialist Workers Party expand in the vacuum left by the old-fashioned voluntary associations. In these groupings and grouplets passionate poring over the revolutionary text largely replace political or religious preaching.

So the chapel and local party hut are caught between the fervent participatory style of the sects, offering closed worlds and closed minds, and the slack and flaccid style of popular radio and television entertainment. The one offers the closed mind and the paranoid cell, the other offers the padded comfort of the television room and no mind at all. Of course, this is an exaggeration. There is quite a lot of information disseminated on television but very little prolonged discussion or argument. A programme like Mastermind, good and clever though it is, has absolutely nothing to do with the serious activity of the intelligence. Serious exposition is constantly chopped up into tiny pre-digested segments. A debate is a series of short, sharp gladiatorial exchanges with the focus constantly shifting from one personality to another. Issues are posed in terms of glaring alternatives put forward by rival specialists in colourful abuse or self-display. Of serious argument there is scarcely nothing. An occasional programme featuring Steiner or Marcuse only proves the rule. This could be illustrated from personal experience. Some while ago the author was asked by a producer to draw up a list of 'punitive personalities' who could be wheeled on to represent the right-wing viewpoint in a series of discussion programmes. Moreover the time-span of attention to any

single sequence of thought is a maximum of five minutes. Nor is there much understanding of what constitutes a debatable issue. It does not always occur to producers that distinct issues should not and cannot be nudged and fudged into a simple global confrontation.

I give these examples because the same tendencies operate even on religious programmes. Television is crucial here because so far as the local churches are concerned the context of expectation is set by television and by the religious programmes as an extension of the broad ethos of televised entertainment. As a matter of fact the religious programmes are sometimes much better than the rest in that enough space is occasionally allowed for serious thinking, and the screening of deep powerful imagery. Dennis Potter, for example, was allowed half an hour, in an absolutely outstanding programme. He did it, however, under the unnecessary aegis of a conversational manager, in this case one of the best, Colin Morris. Too often however there is a puppet master and a series of brief responses conjured from a set of puppets. It is perhaps significant that the audience figures over recent years show a shift to those ITV religious programmes which have no serious content and are an extension of show-biz.

The shrinkage in the allowed time-scale of attention is even visible on radio. Most programmes about issues now consist of cut-ups. An interviewer goes and talks to about twenty people and then slices their opinions up into a shifting mosaic of impressions. Nobody knows what these people really think: they have become a discrete set of opinions. It *can* make good listening but there is little attempt to let views be known in their integrity. Indeed for a time viewpoints seemed persistently tailored to fit the broad left-centre consensus of received liberal opinion. If people outside this middle spectrum were allowed a hearing they did so as accredited oddities, the permitted spokesmen for peculiarity.[1]

So far as religious programmes are concerned there are gestures towards participation and democratization that often end by illustrating the same malign tendencies. For example, the old-style programmes of community hymn-singing now include brief interviews with people who speak from their own personal experience. This can sometimes be touching and moving. Nevertheless a person is swooped down upon by the camera and invited to disgorge his existential commitment in twenty or thirty seconds. It is the old tradition of witness speeded up into the allowed gobbets of television consumption. Everybody has that exploitable facet of personality which can be flashed across the minds of the watching millions before it fades off again into the dark. This is the principle of expendability taken to its ultimate conclusion. Producers rarely last more than a few years; those they produce last for a few seconds. They do not lack talent, but they mostly obey the imperatives of the medium.

I have spent so much time on the tendencies of passive, centralized entertainment because it provides the dominating context within which the political speech, the lecture and the sermon have to operate. Before I sum up these tendencies let me refer to the approved changes in *manner*. The television manner relies on the fireside chat. The politician performing on television does not set out his wares formally, but sidles up on the listener. He insinuates himself. He does not stand and deliver an argument and illustrate it; he exudes a series of impressions. Like the rest he manipulates images.

What all this means for formal speaking is too clear. The sermon, the speech and the lecture are condemned for their protracted time-span, for their intellectuality, for their formality, for their seriousness.[2] They are also condemned because of the lonely eminence of the speaker. People increasingly agree with Queen Victoria and prefer not to be addressed like a public meeting. (The major exception is the span of attention and seriousness allowed to music.)

Thus the contemporary preference is for bogus partici-
pation and the approved form of religious communica-
tion is the quick subjective 'witness' in a rapidly swallowed
capsule. This seemingly accords very well with demo-
cratic theory. Religion is opinion and feeling, and the
only distinction between feelings is authenticity. Does it grab
you or does it not? So religious commitment is up for grabs.
The television dredger delves in the mass and comes up with
one or two shining stones. Alternatively there is the other
variant of democratic theory which stresses confrontation
between straight alternatives within the limits prescribed by
consensus. Here the model is the party system in which
opinions are bundled up in rival sets and then put on
contrasting display.

So what price the lonely eminence of the speaker? The
physical form of the pulpit and the stance of the preacher are
diametrically opposed to the approved contemporary style.
The preacher becomes a man set apart, either by his office or
by his learning or by both, and enters a separate area above
the heads of the congregation and there speaks *in nomine
domine*. He does not lean back in a priestly chair to puff his
pipe and make a few insinuations about how you might cast
your vote. He expounds or he should do. He does not put out
a quick take of authenticity. He appeals to the attention and
asks for an *act* of attention. Indeed there is something more
participatory in the preaching style than ever is possible in the
media. A man confronts a group 'live' and asks for active
attention: let us for a few minutes consider so-and-so. He
defines a theme and they narrow their attention down to a
specific point. Not always, but sometimes.

Of course, some kinds of free church style overlap the ethos
of the media. The free churches were pioneers in the business
of moving outside the authority of office or learning and
appealing to feelings by the exploitation of personality. Some
free church preaching is just the degraded fag-end of the

exploitative style: subjectivity appealing to subjectivity. The classic preaching styles retained an element of objectivity and this inhered either in learning or in an assigned role. It depended on persons set apart in areas set apart. A man 'entered the pulpit', opened his Bible and engaged in a serious act of exposition.

The restitution of this authority is neither possible nor desirable. But it was at least *honest* in that the source and locus of authority was plain. The preacher stands in the pulpit. The headmaster stands on the dais. The party leaders stand behind the rostrum. This is power made manifest. It would indeed be fruitful to follow through the changing symbols of power and apartness in these three areas. The pulpit has been lowered or abandoned: the preacher speaks in the midst of the people. The headmaster's dais has been removed and the address to the whole corporate assembly has been largely abandoned. The fate of the political rostrum is more complicated. In democratic societies political persuasion works in the insinuating or confrontational style mentioned earlier; but the real sources of mass bureaucratized power still line up behind the rostrum. The leader shows himself to the people robed in the clichés of party dogma. He reiterates the ancient truths, and appeals to the repository of revolutionary or conservative tradition. He deploys a specialized eloquence.

And so does – or did – the preacher. Preaching is a form of eloquence. It uses specialized tones, rhythms, accents. Here lies the problem of preaching. The preacher stands analogous to the politician and union leader and he deploys a specialized eloquence in the context of a particular kind of authority. The analogy is not flattering. The politician addresses the faithful and receives the due reward of his eloquence, but those who watch the proceedings on TV dismiss his performance as an irrelevant harangue. There is a disparity between role and utterance. It feels flatulent,

gaseous, self-righteous, puffed up. Nevertheless the power is real. The power of the pulpit is not. Once upon a time the main channels of social power flowed through pulpits and 'In the name of the Lord' was as much in the name of the lord of the manor as in the name of God. Then power shifted to the leaders of voluntary associations, notably the free churches or moral pressure groups, the leaders speaking to meetings or to crowds. This too has gone: other media of communication have left those channels dry or silted up. The pulpit no longer sums up the local or national community, nor does it express the sentiments of lively voluntary associations.

The point can be put too strongly but the remaining form of political eloquence rests on massed centralized bureaucratic power in union or party. Religious eloquence lacks this power base: it no longer speaks for the civic or communal sense nor does it address itself to a lively active association of dissenters. In sociological terminology it has lost its roots in community and it has also lost its role in voluntary association. There are plenty of exceptions, but that has been the historic trend. Preaching seems to have been a moment in the process of democratization. It belonged maybe to the Franciscan appeal to the new masses in the late medieval city and the Protestant appeal to the masses in the early capitalistic city and the industrial city. Those cities now belong to history, and with them the hall churches of the friars and the Central Halls of the Methodists.

So what does preaching become under modern conditions? It follows the trends, haltingly, sometimes regretfully. Most obviously preaching degenerates into opinionation. The man in the pulpit 'shares' his religious opinions with the man in the pew. Perhaps he begins with a witticism to relax his auditors. Then he delivers some wry observations on the current state of the world. If a socialist he will note that the New Jerusalem has not arrived; if a conservative he will play *laudator temporis acti*, things are not as

they were. Maybe he will pick on some event and muse aloud whether perhaps one might not see the hand of God in it. One never knows. God works in a mysterious way. Perhaps the minister has been reading some psychology or sociology which he wants to 'share' with his congregation. Or something happened to him the other day on the way to the pulpit.

All too frequently the result is a poor clerical essay: a mixture of anecdote and opinion. The clergyman plays the role of a one-man 'Any Questions' followed by 'Any Answers'. It is not surprising the questions and answers are not very good. If people have to produce a regular essay on the state of the world then the level will not be particularly high. The sermon turns into the clergyman's digest of the *Guardian*, *The Times* or the *Daily Telegraph* or the *Reader's Digest* according to taste. The relation to Christianity is often tenuous and is suggested only by an initial blast-off from a text or biblical story. If longish sermons are preferred the story can be embroidered by exegetical material out of the standard commentaries. This is how people have come to distrust eloquence. The linguistic clothing is too big for the intellectual scarecrow inside. Some preachers repeat the old large phrases through sheer inability to stop. They turn sermons into mosaics of soteriological cliché, horrible analogues of the speech on the party rostrum. Other preachers adopt the methods of the fireside chat, emulating the insinuations of the party political broadcast on television. The man in the pew often finds he has to endure a flatulent pulpiteer or else a purveyor of vacant chat. Both of these lose one central characteristic of the sermon: the use of the quotation. Quotation arises out of a profound acquaintance with a scripture and liturgy. Indeed, it rises out of a profound acquaintance with a single version of that scripture or a liturgy. Quotation is embedded in particular forms, memorable sequences: it is sentences or phrases which are

quoted, not notions. Quotation is the reference back to the normative source as embodied in the classic form. Quotation is now destroyed, partly by the proliferation of innumerable variants, both of liturgy and of Scripture, and also by the division between flatulent pulpiteering and fireside chatting. On the one hand pulpiteers compose mosaics of quotation: they do not know how to relate text and context. On the other hand fireside chatterers are all context: they have lost contact with the norms of faith and with the common, understood poetry in which faith resides and by which it is understood.[3]

The danger of opinionation is that a clergyman's opinion need not be intrinsically any more interesting than anyone else's. His observations on the world have all the eternal validity of News at Ten. If he has been reading psychology or sociology then he is judged by the normal canons of those academic disciplines. These canons are not all that rigorous but they can be breached. Is the reading correct, the evidence rightly assessed, the reasoning rigorous and logical? Everybody has ideas on such matters and a few people have what they regard as professional expertise in them. The clergyman may garner his opinions with learning and care: the point remains that they are opinions. They do not justify the prelude: in the name of the Father and of the Son and of the Holy Ghost. Nor are they improved by having a label stuck on them 'ratified by Scripture'. Of course, when the parson was a man of exceptional learning, indeed the only man of learning, his opinions at least had the backing of the academy if not the certification of the Holy Ghost. This too is gone. A clergyman is now a man as other men. Not even the popular defence of sincerity will do. We do not excuse a foolish politician on the grounds that he means well. We prefer him to be hypocritical and correct rather than sincere and misguided. In any case, we assume the hypocrisy. It is part of the job.

The priest or the minister can descend to the level of

religious journalist: our religious correspondent. This is an excellent level but like most journalism it is destined for the trash can. It is no wonder people write to *The Times* and demand the right to answer back. The pulpit is not the place for discussion, but what is delivered from the pulpit naturally engenders a demand for a come-back. He (or she) observes and the congregation observes; he is sincere, maybe, and they are sincere, maybe. Why should they listen to his observations anyway. Would it not be better to ask the choir to fill in with a motet or a chorus? At least the average choir sings better than the average congregation.

There is no restoring of lost authority or the centrality of the parson's social role or the superiority of his learning. Nor is it possible to recast the parson as the exegetical expositor of a sect, unless of course the Church is willing to decline to the status of a sect. If the Church were a sect the religious functionary would be the expositor of an indisputable truth to which his hearers were by definition totally committed. They would be sheep and he would be shepherd. They would gather together in small enthusiastic circles and pore over the text, and he would be the first in expounding the revolutionary doctrine. It would not be a preaching situation. There would be a fixed global view of the world and our brother Silas or Carlos would be pre-eminent amongst those who had absorbed it and could re-present it with force and conviction to the true believers. Maybe the Christian Church was once like that: the exegete said 'This is how we see the world and you may like it or leave it.' The Christian Church is no longer that kind of organization.

No doubt the sectarian option has its appeal: let us regroup and form a small united cell against the intrusive world. Part of the appeal of conservative evangelicalism lies here: the closed group returns to agreed simplicities. Many people desire it: certitude is more comfortable than complexity. But in the long run it is no more possible to go

back to the sectarian womb than it is possible to restore the social or priestly authority of holy church. We can live neither by the authority of the role we occupy nor the guaranteed certainty of what we say: neither priestly robe nor bible-backed certitude can save us. We have to live by the nature of what we say and that is very problematic. It is a question of religious discourse. What is that discourse? The future of the sermon forces attention on to the fundamental issue of religious language.

The minister would be safer if he could be isolated in a form of discourse, or a form of life all of its own. There are sophisticated defences for this view. You can argue that there is a religious way of talking just as there is an ethical or aesthetic or scientific way of talking. But there is no criterion by which we can separate off religious talking in a quarantine of its own. No doubt God-talk is about God, but you can't just talk about God, not if He is the kind of God depicted in the New Testament. Talking about God is talking about man and about Jerusalem. If it were intellectually possible to isolate God-talk then we would have succeeded in castrating God-talk religiously. God-talk would have been reduced to bowing before the All or the Almighty or to exploring the interior psychology and aesthetics of mysticism. That does not go very far in the pulpit. 'God is great' is a good beginning but it makes a boring middle; and the interior life of the mystic suffers from inexpressibility. The old saying holds: if Mr X has experienced the inexpressible he would be well advised not to try to express it. St John of the Cross found it difficult; the Rev Mike Collins will find it more so.

The preacher must talk about God if he is to be a preacher at all, but he cannot restrict himself to God. He is willy-nilly committed to a natural theology, that is a view of nature, and to a social theology, that is a view of social nature. It is at a harvest festival that you will find out what a man's natural theology is. Usually it is a version of creative evolution:

evolution tinged by religious emotion. Often the emotion will be sentimental. There will be a generalized invocation of the Maker of all things followed by selective observations of the more prepossessing results of His activity. And it is at a civic festival that you will find out a man's social theology. Usually it is a version of liberal optimism: if only individuals would be nicer the complexities and difficulties of social organization would automatically be overcome. Or alternatively and more rarely the preacher declares. the world is a sorry place and those who think it could be otherwise ignore the universal corruption of sin. Neither of these will do.

This is the substance of preaching: God, nature and society, that is, theology, natural theology, social theology. The last is the least developed, but it is the arena in which opinionation is allowed the fullest scope. Of course, there is the possibility of prophetic witness and ethical denunciation. This is not entirely neglected. It is, indeed, attractive, because ethical denunciation is not logically entangled in matters of complicated fact. A prophetic witness is firm and strong and utterly unanswerable except in terms of a counter-denunciation.

There is a time to denounce, just as there is a time to cease from denunciation. Sometimes there are clear and present evils of poverty or oppression or exploitation which it is a Christian duty to combat. But things are not always clear or present dangers: ethical judgements are in practice trammelled up in very murky questions of fact. Ethical judgement ends up in the complexities and uncertainties of the world, just as God-talk is compromised by the complexities of the world. Simple ethical judgement is no way out of the difficulties of a social theology.

Religious language is about God, man and society, and it is also about history. These are the most controvertible areas of human discourse, leaving aside pure judgements of taste.

Indeed there are people who believe that God, man, society and history raise questions which are no more than issues of taste. If that were so then the preacher would be like a lecturer on wine-tasting: he would discuss the bouquet, absolutely divine, or how to make your religion a really desirable, worthwhile, significant experience. However, the preacher is bound to disregard this view. He cannot get out by reducing religion to pure aesthetics any more than he can get out by issuing moral judgements.

Theology is not science, social or natural. It is not ethics and not aesthetics. It is not separable into some strictly other discourse, wholly other, *sui generis*. One cannot say theology is theology and that is that. So how does the preacher talk at all? Might it not be wiser to obey the theological injunction: *not that, not that!* No doubt there is safety in silence or in transcendental meditation. But this is the mystical option yet again. It is right to keep silence before the overwhelming. But it is absolutely clear that the foundation documents of Christianity and Judaism preclude this option. Isaiah stands before the Cherubim and Seraphim and initially declares he cannot speak. But then he commits himself to a Word. The long struggle between Christianity and mysticism is not due to a rejection of mystical experience in itself. It is based rather on a rejection of mystical experience as providing the exclusive definition of religion. Man does not retire to the interior castle or live by illumination. He lives by the Word: *logos*, reason, embodiment.

In the beginning was the Word. The Word became flesh. It must be fleshed again. But how? That is something too large, too central for a coda. But here is religious language. Listen to it: two texts, one from the Old Testament, one from the New. In this unconventional sermon the texts come at the end: Psalm 39, and Chapter 2 of the Epistle to the Ephesians.

Behold, thou has made my days as it were a span long: and

mine age is even as nothing in respect of thee; and verily every man living is altogether vanity. For man walketh as a vain shadow, and disquieteth himself in vain; he heapeth up riches, and cannot tell who shall gather them. And now, Lord, what is my hope? Truly my hope is even in thee . . . Hear my prayer, O Lord, and with thine ears consider my calling: hold not thy peace at my tears. For I am a stranger with thee: and a sojourner as all my fathers were. O spare me a little, that I may recover my strength before I go hence and be no more seen. (*Book of Common Prayer*)

For he is our peace, who hath made both one, and hath broken down the middle wall of partition between us; having abolished in his flesh the enmity, even the law of commandments contained in ordinances; for to make in himself of twain one new man, so making peace . . . Now therefore ye are no more strangers and foreigners, but fellow-citizens with the saints, and of the household of God . . . (*Authorized Version*)

These texts are on the highest level of generality: one is concerned with a universal aspect of the human condition, the other with a universal transition. The texts set up a universal *context*: they define a limit and affirm a possibility. Limits and possibilities are the basic currency of religious language. This you must accept, this you can transcend. This is your constraint, this is your creativity. And these limits and possibilities are conveyed as existential awareness and as image, not as proposition. Religious language arises from and points to a condition of existence, and it conveys images of alteration. The breaking of the middle wall of partition sets up the idea of breakage: the blank wall of division can be broken down. This is transcendence: the Alter, the other, the alternative set against the image of what is. Religious language is not primarily a statement of what is or of ethical

judgement: it is an image of the tension between limit and possibility.

Notes

1. There is at the present time a new mobilization of opinion amongst people at large, which in America at least concentrates on violence. It is argued by some that there is a decline in violence on American TV matched by an increase in plastic sex. This issue of violence, or sex and violence, overlaps the questions raised by the left-liberal consensus on television in a very complex way. The appointed spokesmen for 'the creative community' believe they have a right to portray what they will and say what they like on the issues which they wish to put before the public. Many of these issues do happen to be very important. Yet the right to present important issues in an adult way is mixed up with the right to gore the public mind. Moreover, the right to discuss the crucial conflicts in our society is confused with the god-given assurance of the intelligentsia to monopolize the way these conflicts are presented. The intelligentsia decries authoritarianism but it takes on a teacher-pupil attitude to the rest of society.

2. America might seem to be an exception in that the media dominate the culture yet without eclipsing the sermon. However, it must be said that the content of American sermons is not usually impressive and the content of radio and TV religion is much more exiguous than in England. The general survival of the sermons in America needs to be linked to a broad analysis of relatively high practice, and that is too lengthy a topic to be indulged here.

3. Previous centuries sported their own versions of corruption. In the eighteenth century sermons were printed as if handwritten so that when the parson placed the 'manuscript' on the pulpit it appeared to curious watchers in the gallery as his own production.

8

Secular Communication and Holy Communion

First we must remind ourselves of the Christian vocabulary: breath, praise, grace, spirit, world, holiness, kingdom, power, liberty, faith, lordship, regeneration, redemption, revelation, damnation, glory. They are strange words drawn from ordinary secular experience but impregnated by a different spirit. They are familiar coinage made unfamiliar. They are given by the world but not given as the world gives. We know what a worldly kingdom is but we are introduced to a kingdom which 'is not of this world'. Somehow the ordinary sense has been expanded, transubstantiated. It has been altered: touched by an alternative, put in a different light. It has encountered the Alter, the Other, but that otherness is not wholly other. The words are still familiar coinage: sun, light, stars, heavens, seed, corn, sea, crowns, fatherhood, sonship. All these are familiar and part of the natural family of ordinary words. They are homely.

For those of us who live or have lived in the special enclosure called 'the church' the words are almost too familiar. We know them as a smooth and worn conventional medium, part of the accepted furniture of the sacred. They define the religious manner and we use a special tone when we speak them. It is a familiar religious tone designed to show that these ordinary things like sonship and fatherhood, grace and power, are also endowed with the extraordinary. We

speak differently to show there is a difference. We speak slower or we move to a monotone; we murmur in a curious rhythm which contains an invitation to dance which is not a dance. It is a quiet dance, touched by the movement of the spirit. The spirit moves and so do we: slowly in time, but not in ordinary time. Each movement is carefully timed, timely even though the temporal is invaded by the eternal. The familiar ordinary time is affected by unfamiliar time; the acceptable time, the end of time. We have put off ordinary wordage and adopted a Christian mode of address. Or rather we have been adopted *by* a Christian mode of address. We adopt and are adopted: in this grammar active is also passive. We move and accept movement; we place ourselves in a particular position and find that we have been displaced so that the world can fall into place. There is an alteration. The alternative way of being enables as to transform and be transformed. We know what form is and we know how to give form. We have created a form of activity, worship, that contains transformation. This grammar is about the way the familiar is transformed. transubstantiated, translated, transcended. It is in the active-passive: I yet not I.

So this familiar language is odd and we pronounce it oddly to remind ourselves of its oddity. The words are full of paradox: 'I yet not I', 'I am in the world but the world does not know me', 'the peace of God which passeth understanding'. Something occurs which is paradoxical by nature, forcing us to talk in contradiction. We use a counter-speech, deploy the same everyday encounters with an altered content. This counter-speech creates a counter-culture. We are children inducted into a counter-culture by the power of the words we use. We use the words actively but it is the Word which takes us into the culture. We *use* but we are defined by usage. We are altered and made distinctive and different by the words of our Christian culture and usage, by cultus and by use. We become a new creation by the power of the word.

That is an ordinary natural fact: every culture is defined by a linguistic use. A society is the boundary of those who are used to each other and know how to communicate. Communication is an ordinary natural word: Christians live in a social circle of communication just like everybody else. All society, all communication is created by the power of the Word: in all our beginnings was the Word. We know each other in our everyday usages and they make us who and what we are. So in this respect Christian community is the same as every other kind of community.

But the communication is different and so is the Word. Language and communication are ordinary, familiar and everyday. They are the substance of social being. But this substance is transubstantiated. 'Heaven and earth shall pass away but my word never'; 'The word of the Lord endureth for ever'. All language mutates and dies, but what we are offered in church claims to be a true and living word. How can the true word be present in the world and not received by the world? This is the *true* speech but not in some sense *received* speech. In what sense? In a spiritual sense? And what is a spiritual sense? What other sense can there be than ordinary sense – except nonsense?

This 'word' has to do with the senses certainly: things heard, seen, touched and handled. But it is not sensual. It informs the sensuous world but is not conformed to it. We know what conformity is, but this has to do with conformity to the alternative. 'Be not conformed to this world.' The world is deaf, dumb and dark: it does not comprehend the word, and does not receive the light. The message comes through the senses but it is in a new language for which we lack adequate translation. The language has an overtone which we recognize but cannot catch. We hear and touch, taste and see, but the word of grace remains evasive: 'that seeing they may *not* see, and hearing they may *not* understand'.

What is the word of grace? Grace is ordinary, natural and everyday. That which is *ex gratia* is freely given. An act of kingly grace sets a man free from the burden of duty or of punishment. It is an intervention from one who is higher. Certain acts of social inclusion are deeds of grace: we are brought in by the open offer of inclusion. We are constituted full members, not by virtue of what we have done or even by nature of what we are. There is a primordial givenness, and acceptance without money or price.

So what is God's grace? The ordinary and everyday points to it. Divine grace lies there by analogy and we know that it is something to do with acceptance and pricelessness, the open and the given. These are the experiences from which the mysterious language of grace takes off and on which it depends. It is a matter of analogy. Christian speech is rooted in analogy just as it is rooted in paradox. But an analogue is not an identity: there is overlap and difference, immanence and transcendence. The word is in our world but it is not conformed to that world or limited by it. It breaks into the limitations of our speech like a new tongue. The new tongue can appear to be nonsense: a form of drunkenness. It claims to be a universal language but it can seem to be mere inebriation. What transcends can only be partially understood. Therefore we cannot give a full account of the transcendent Word: we respond by analogy and by paradox. We resort to oxymoron: when I die I live, when I fall I rise. That sounds plausible. But it is equally likely that we are chattering in our sleep, emanating nonsense and thinking we are eloquent. The advent of the new language at Pentecost was interpreted by some as the emergence of the universal tongue, and by others as drunkenness. We know what an ordinary tongue is, but what kind of tongue is this? Christians answer that it is a charismatic language, the speech of grace. But what is that?

How do we have a tongue which is not a tongue, a

community which is spiritual as well as natural, a grace which is transcendent and immanent? This is not a Christian claim but a description of the logic of Christian language. Yet it does not really describe. It exemplifies. Christian speech can only be exemplified. What includes the transcendent cannot be reduced to a description. What goes beyond cannot be exhaustively subsumed in a naturalistic account.

But two things must immediately be admitted. One is that our use of a specialized tongue and a special tone to carry loads of meaning is dangerous. The danger for Christians is that this altered language comes to seem ordinary. It ceases to be the language of what they profess and becomes the lingo of their profession. The danger for those outside the Church is that this lingo can be interpreted as the manner of the pious. It is the convention governing God-talk and church-talk. The convention is used merely to mark a transition. At the door we talk this way, across the threshold we talk that way.

Or alternatively the man outside the sacred enclosure dismisses the inside lingo as nonsense. The Christian *argot* does not seem to refer to anything and does not belong to the world of turnips and carburettors. It has ceased to belong to those things we touch and handle, taste and see. The breath of spirit has vanished into air, into thoroughly thin and small air, and ceased to animate any tangible form or visible body. It has become merely verbal instead of an embodied word altering the substance of the world. It has lost body and image. This loss is very Protestant: the Word degenerates into words without tangible incarnation. So the Christian language can become a collection of prose counters, not a poetic and specific embodiment *hic et nunc*; in place and in time. The word can shrink to a verbal skeleton without flesh.

That is the first danger: that Christian language is a pious mannerism, a set of professional counters, signifying nothing, embodying nothing. It afflicts all our religious language; including that which masquerades in the guise of

modernity. The second danger is sleepiness. That danger is also an opportunity. This is because the religious way of talking is used to mark a transition from the world where things are substantiated to the world where they are transubstantiated. Indeed, the physical building of the church actually bears witness to the possibility of that transition. The separate building defines a difference. We shift. And as we shift we become sleepy. We pass subliminally to the sublime. We sleep-walk and sleep-talk. We are like children murmuring a poem comprised of huge syllables we cannot grasp. We are in a maze, amazed, as if we had lost the thread of what we were saying. This is because the words refer not only to the things that are and the limitations of the moment but to things that may be, latent possibilities. The words are full of latency; latent deity. There is a tension inside the language between the present and the latent, so that we cannot fully grasp what we say. We have gone to sleep in order to be awake to other possibilities, we have closed our eyes in order to see things differently, we have passed into a darkened language in order to find the luminous point. The very structure of speaking is veiled in order to allow for openness, covered and covert, to permit inexhaustibility.

So not only is the language both familiar and unfamiliar, but we have to become sleepy in order to see the familiar differently. Those who talk ordinary common sense may say we have been put to sleep, deadened: religious language says we have fallen asleep in order to wake, that we are dead to live. The monotone is a kind of slow breathing, the murmuring is a kind of sleep talk. Both carry us across the threshold. We do not take ourselves: we are carried across. To speak in this way is, once again, to exemplify religious language rather than to describe it. We use an analogy: sleepiness. We deploy a paradox: I die to live, I fall asleep in time to wake eternally. We employ the passive-active:

choosing and chosen, adopting and adopted, the free acceptance of invasion.

It is odd to hold what you cannot grasp and to use what you do not comprehend. To the political activist, of course, there is no passive-active voice. The passive-active is a way of making the active man passive: it arrests activity. Sleepiness is not the pathway to vision but the opiate which leads people to bow their head rather than get up and move. In Marxist terms the bowed head is passivity posing as receptivity. The dream has to be unlocked from the doors of sleep and made clear, public and obtainable. The Christian activist may agree with the Marxist viewpoint. He sees the sleepiness not as God's knocking time but as a veil drawn across man's real possibilities. The partition in the Church is precisely what hides the latent godhead from manifestation. The images and pictures and icons which should mediate possibilities have become barriers, the narrow opening onto vision has become closure.

And this is true: the necessary instruments of openness can lead to closure. The partition which says there is more to come may cut off potentiality. The transfiguration may be used to diminish and not to alter, because the figures of grace have been translated into a completely foreign 'other' world expropriated and removed from their proper contact with human potentiality.

This is for many reasons. One is that there has to be a long period of imprinting in which the visionary acid cuts deeper and deeper into the psyche. In terms of human history this long latency is very short, but to those who are part of the process it may seem very long. Another reason is that structures of communication and image cannot bear more than a slight part of the load. The full weight of glory has to be narrowed down to a tiny slit, to a small gap in the partition. Another reason is that as structures incorporate a small point

of glory they build the new weight into their own stability, redeploying the challenge as another protective device. But this is as true of political challenge as it is of religious vision. Moreover political animals too easily forget this is so, whereas it is part of the official memory of religion. When politicians cry, 'The dream is over,' and claim the reality is being brought on stage they are the creatures of delusion, obsessed by myth. There is no man more obsessed by false, deluded religion than the politician who declares that myth is now abolished in favour of reality.

We are saying that religion, more especially the Christian religion, is one way we image limits and potentialities; that it becomes part of the protective cover developed by social structure; that it incorporates a part of that potentiality in order to prevent a devastating explosion. When the power is incorporated it is then re-presented as a limit, something set over against men. Or to put it another way, the new instruments of power are expropriated and are used to confuse the difference between real limits and bogus ones. After all, there are real limitations in the human situation. This means that the dream-time which carries the vision forward, the slow repeated liturgical murmur about something else, can act to cut off as well as to uncover. The vision is slowly tipping towards a dreamy opiate, the mysterious opening door begins to close again.

So what is Christian language? It is a way of coding this tension of limit and possibility. First, we do not fully understand the words we say and the grammar we use because they contain more than can be ordinarily said. They include the potential of the dream-time as well as the limits of the wake-a-day world. Second, these words actually carry intimations of real brokenness and real limitation inside them: they express the frustration. The impulse is towards a unification: the breaking down of the middle wall of partition, the abolition of the rail between sacred and secular

or between church and world, the creation of a new, unified space where 'they may all be one'. But the recalcitrance of 'the world' means that we must still distinguish between church and world, and the limits of our situation means that we must re-build partitions.

Thus the distinctions that we make and the partitions we build are simultaneously acts of potency and of alienation. What has been made alien to us, foreign, is at the same time the other possibility lying inside what is. Unless we protect and demarcate that possibility it will cease to be identifiable and thus even to be possible. Alienation and potentiality cannot be finally disentangled: *o felix culpa*.

Third, the language of potential and limit is very general. That is not to say it is abstract. On the contrary: it is embodied and incarnate. There is an open texture about religious signs which will not allow us to make just one translation, and in particular is not patient of one specific political translation. The political activist wants to bring the dreamy texture down to earth in a closed form. He has to make this limited translation because he cannot act unless he narrows himself down to a programme. He will say: now is the time to abolish the partitions, to make church and world co-extensive, to turn Christian and civilizing grace into a revolutionary civil power. He will try to smash the double structure of Christian concepts, reuniting church and world, spiritual grace and temporal potency. That act will both release part of the damned up potential and also deplete the resources stored away in church and in culture. The activist will even try to eliminate the *double-entendre* in Christian language, and make the ambiguous clear and definite. He seeks a clarity that in the end destroys the idea of an alteration.

What is the *double-entendre* in Christian language: how does it enable our senses to hear in more senses than one?

Christian language is unified: and it is about unity. It

strives to create one radical brotherhood united in the bond of peace and in the power of the spirit. This means bringing men together in a single body. It also means breaking down the middle walls of partition.

This in turn will require the invocation of another world, not the present world, but one to come. The biological unity of the family will have to be extended to become a universal spiritual family. The temporal kingdoms of the world will have to be made subject to an eternal king. The kingdom comes, but it remains precarious, that is something to be prayed for and hoped for. Those who are awakened become citizens in this Kingdom, born again into a new society by spiritual adherence. In other words, the world of social nature – the local adhesion to the family, the ancient generational inertias of tribe, clan, tongue and kingdom are placed in subjection to the universal kingship of the spirit. This act of subjection is a violent rupture in human nature, dividing the old time from the present era, Old Testament from New Testament. It is also a rupture with violence. The new kingdom is to embody an authority based on service and deploy the resources of love. It will speak a new language.

This fundamental change must alter the meaning of the basic words in ordinary natural language, like war and peace, kingship and lordship, power and service, brotherhood and fatherhood, eating and drinking, body and blood. Each will acquire new meaning inside the old forms, and that meaning will reflect a new spirit. You have entered a spiritual warfare, not for the kingdoms of the world but for the kingdom of Christ. You have taken up the sword of the spirit. You have received peace given not as the world gives. Christ is a King but his followers put up their swords and do not fight for him. He is lord but he does not exercise lordship as the Gentiles exercise lordship. He who is greatest of all in the Kingdom is servant of all. All power is given to him, but it has nothing to do with powers or principalities. He is a son and the firstborn

of the dead, the firstborn of many, but he is not born of the will of man but of God. He has brothers, united not by blood but by obedience to the will of the Father. 'My brother is he who does the will of my Father in heaven.' My Father is not Abraham or Isaac or Jacob or Joseph: he is in heaven. That is where we truly belong: our citizenship is in heaven. The city is not made with hands: its builder and maker is God. Its inhabitants speak a new tongue and sing a new song. They inherit the city of God. They are, all of them, kings and priests unto God, dead to the world, alive to Him.

All these images have been invoked: war and peace, King and Lord, brotherhood and fatherhood, citizenship and inheritance, language and singing, to show how they alter, how they subvert or invert all the usual meanings. They invert and convert; turn upside down and change. Christian language is analogy, paradox, oxymoron, inversion, conversion. And it is set in the active-passive voice. Grace is the name of the altered load: it conveys the sense of the given. Grace is not an extra element or a coating of super-nature but the old sense which has been made incarnate and embodied in the old form.

But how does the loading of grace run up against the frontier of social possibility?

The new language must mount an attack on the frontier of social possibility. To make the particular universal means releasing the Fathers from their relation to a particular society and placing them in relation to all nations, tribes and tongues. That requires a rejection of the biological continuity of the chosen people and the new creation of a brotherhood based on choice not necessity, regeneration not generation. Those who belong to the brotherhood will be defined as those who do the will of the Father and who are born of the spirit. They will have a new method of defending the movement; peace and love not war. They will capture the language of warfare, for spiritual combat. And they will have

a new idea of movement: the notion of mobility across tribal frontiers, for example, the concept of the alien, who is travelling to a new city. A man who is going to choose to move must face alienation and also carry the covenant and the citizenship inside him. He will need a new language, transcending previous local languages. He must speak in tongues, the speech of those who are renewed in the spirit. To create unity faith must reverse babel.

All these requirements build up the symbolic structures of hope. One for example is virginity: the break in biological continuity centred in those who are eunuchs for the kingdom of heaven's sake. Another is second birth: the process of choosing and being chosen. Another is the Heavenly City: the point outside time and specific social space towards which the alien moves. The Christian will be a person of the way, a wayfaring man, remembering a garden and seeking a city.

These symbols, pointers and signposts encounter the frontier of social resistance. So strong is this resistance that two things happen. They are turned round and appear to defend what they attack and they also form a structure of radical symbols lying like bombs across the frontier of the socially possible.

So the Son is reassimilated to the Father. The Virgin becomes patroness of place and family and country and warring armies. The second birth becomes baptism, that is Christian circumcision, re-entry into the biological community. The heavenly city returns to space and time: Rome or Byzantium or Moscow. The alien appears as the native: the Pilgrim Father becomes a city father and sits at ease in his Zion.

Put it another way: the golden gate stays closed. When the golden gate stays closed this defines a social resistance to the triumphal entry of God. God can only enter the gate behind the symbolic device of weakness and sorrow.

Human hopes press against the boundaries and the radical

Christian tries to reunify space. In the New Testament this is prefigured in the idea of the broken wall of partition. For example, radical Puritanism tries to remove the partitions from time as well as from space, redeeming all time for God. But the 'blockage' reappears as a blank wall. The white-washed interior of the Church is a boundary forbidding the divine image, recognizing once again the frontier between the achievable and the transcendent. Thus the attempt to break down the partition produces a reinforced partition erected in another sector. The very concept of the arbitrariness of God is another partition, appearing at the intellectual level. You put a rail round the sacrament or you rail against the visible image of God. Each attempt at unification reforms the partition. Each partition initiates another attempt at unification.

But what about the weak, bounded, broken, limited symbols of 'fullness'? What of those things we have already, now, the transcendent future in the present: those things which break down the partition between present and future without breaking the boundaries that distinguish the ruined from the perfect?

The broken elements of bread and wine contain the fullness of the cosmos. But they are tiny, vulnerable and bounded. They are distinguished from the world like colonies of divinity. If they were not, everything would be divine and the government and Kingdom of God would be compromised. The boundary around the element is a limit like the boundary around the altar and around the Church. Of course, you can abolish any particular boundary. For example, the Society of Friends made all life a sacrament.

But the limit reappeared in the realm of language. Silence means fullness and it means the impossibility of embodying fullness. The ring around the altar, the demarcated edge of the sacred element, the blank wall inside the Church, the silence in the mouth, are all variations on the limit. They are

strictly implicated in the grammar of transformation. They are different ways of expressing fullness by the act of containment.

Broken, limited, bounded: this expresses the idea of incarnation and of sacrament. Just as the universal is carried in the particular so the full is carried in the empty, the strong in the weak, the unlimited in the bounded. It also belongs to a special language in which double meanings carry and complement the double structures.

For example:

the kingdoms of the world and the kingdom of God

the blood of our father Abraham and the blood of Jesus

the seed of Abraham and the seed of the gospel

the water from Jacob's well and the living water

the body of this death and the body of Christ

Kingdom, seed, blood, and water mean: life, life, more life![1]

Note

1. William Blake.

9

Human Sound and Sublime Vision

Here is a quotation from a review by George Steiner of Jacques Attali's 'Bruits', published in *The Times Literary Supplement*, 6 May 1977. George Steiner is putting forward an argument which he has made familiar, concerning the shift from the library to the shelf of records. He says:

> The reasons for this musicalization of sensibility lie very deep: in the hunger for substitute forms of religiosity or 'metaecstasy', in the insight that unlike books, which are read alone, which cut one off in their imperative of attention, music can be listened to socially, that it offers the attractions of simultaneous intimate and familial or collective emotion.

My theme is the way serious music has moved into some of the open spaces evacuated by institutional religion. In the course of the discussion a comparison is made with the way experience of nature has also acted as a modern substitute for religion. The issue must be approached by way of cultural history: how has the relationship of music to religion been conceived in the past?

The role of music is clearly connected with the theme of spiritual harmony. Music has been anciently associated, like religion, with calming the savage breast and healing the distempered soul. 'Art thou troubled? Music will calm thee.'

Men have apostrophized music as 'Du holde Kunst'. They have sought in it images of order and ecstasy. The power of harmony can make men whole, either by 'ordering their affections aright' or by releasing pent-up energies which might otherwise be destructive. The very idea of harmony is used as a general paradigm of right relationship and appropriate ordering.

Up to the onset of the modern era music has usually been conceived (in Luther's phrase) as 'the handmaid of religion', though it has also been regarded as dangerous and demonic. The association of dancing with sexuality has made ethical religions in the monotheistic mould quite suspicious of the powers of music, and intent on regulating them. So while music has been welcomed as a subordinate power, subject to a greater, it has also been suspected. A man may be taken out of himself but it does not always follow that he is thereby taken into God.

All the same music has been allowed to play the role of handmaid on conditions, and subject to regulations. Byzantine tradition enshrined certain tunes as perfect icons of the divine, and so froze them into a timeless heaven. Medieval theory accorded a good moral character to some modes, and a sinister character to others, so providing a musical analogue to the four humours. The Council of Trent set out norms of propriety, disallowing certain kinds of sensuousness and display and insisting on the primacy of the word and the rite. As is too well known, Calvinism was suspicious of music in church and prevented any musical expression outside the four-square psalm tune. This attitude did not however apply to music outside church, unless of course it was also inside a theatre. Lutheranism had few reservations about music, and it was only with the simultaneous advent of secular operatic intrusions and of pietism that a serious tension developed. A late instance of this tension is the 'Leeds Organ' controversy in early nineteenth-century Methodism.

These varied instances simply underline the special relationship between music and religion throughout the whole history of the Church, and the intermittent sense of rivalry that has led to the banning of an instrument or of a mode or of a style.

The Renaissance view of music drew more straightforwardly on just those Platonic and Neo-Platonic traditions which had lain behind the attitudes of the Byzantine and Catholic Churches. There was less moralistic suspicion and a more direct incorporation of music into philosophic systems. Music was part of that same underlying 'natural' harmony of relations which informed architecture. The mathematical co-ordinates of perfect spatial relationships also informed perfect aural relationships. Milton and Shakespeare both give eloquent expression to this view, as for example in the 'Ode on the Morning of Christ's Nativity' or in Lorenzo's speech in *The Merchant of Venice*:

> There's not the smallest orb which thou behold'st
> But in his motion like an angel sings
> Still quiring to the young-eyed cherubim

In most Renaissance conceptions music is not grudgingly admitted as handmaid to religion, but is itself one of the divine powers. But it is not yet a fully autonomous power, merely an element in the Pantheon, one mode of the divine activity.

> From harmony, from heavenly harmony
> This universal frame began
> From harmony to harmony
> Through all the compass of the notes it ran
> The diapason ending full in man.
> ('A Song for St Cecilia's Day', 1687)

Dryden writes at the point where new conceptions of music
are beginning to make their way alongside the ecclesiastical
and Renaissance view. The late seventeenth century is the
great period for Odes to Saint Cecilia, patroness of music,
and some of these embody a semi-classical view of music as
capable of evoking all the human emotions from love to
madness to bellicosity. But the late seventeenth century is also
the period when music emerges as entertainment. So we have
a shift from the idea of music as a wand evoking first this
mood and then that, exciting the mad and quieting the
beasts, to the notion of incidental pleasures provided by
sounds. In Vauxhall Gardens or Dorset Gardens the quality
met to parade and talk, and music provided an accom-
paniment to a polite saunter. Similarly of course with
attendance at the opera: lords and ladies visited the theatre to
be seen as much as to listen. Opera provided a spectacle just
as music provided an entertainment.

This same period is notable for other changes which may
be connected in complicated ways with the shift in the
approach to music. The most important change is
secularization: a slackening of faith into unobtrusive piety, a
rejection of all enthusiasm, the revelation of a cold
mechanical universe in which the spheres make no music.
The modality of thought moves from the theological to the
philosophical. A man might be – almost – openly atheistic.
Prose becomes measured, elegant, observational. The
mystical intimations of the natural world to be found in
Browne, Traherne, Vaughan and Herbert go underground.
Music and nature simultaneously lose their numinous gleam.
They cease to shadow the infinite universe. Perhaps Addison
stands at the exact juncture where old gives place to new:

> What though in solemn silence all
> Move round this dark terrestrial ball?

What tho' no real voice nor sound
Amid their radiant orbs be found?

In reason's ear they all rejoice
And utter forth a glorious voice
For ever singing as they shine
'The hand that made us is divine.'

These changes are very familiar but the link between them
and a new conception of music is little explored. It may be
that music lost its place in the sphere of the divine even as the
divine spheres themselves disappeared into outer space. It
may be that even as a man openly avowed his atheism he
also admitted his lack of musicality. Musical and religious
deafness are now allowed options. Dr Johnson for example is
a man of exemplary piety but appears to have no developed
musical sensibility. He is all sense and no sensibility. It may
even be that 'measure' defined a modulation from certain
kinds of musical intensity and tension which might evoke
visions and ecstacies to a more precisely ordered time, to a
controlled sensibility contemplating this or that within
discrete boundaries. For example Purcell's divine songs in
the 'Harmonia Sacra' are almost the last examples of an
intense religious sensibility. Handel's Chandos Anthems and
Foundling Anthems only one generation later are grand and
eloquent but the intensity has been elided and the emotion
smoothed out.[1]

This is not to say that all these changes happened
everywhere and at once or that they were not contradicted
quite quickly by very different tendencies. Christian
reservations about music, especially about music in the
theatre, continued to be expressed. Opera was not allowed
in Lent and this made a social space for oratorio. And John
Newton, evangelical Rector of St Mary Woolnoth, exclaimed
against 'Messiah' in a long series of sermons on the ground

that it distracted attention from the Redeemer. Composers themselves maintained a religious attitude towards music throughout the eighteenth century, not only Bach, who lived in a largely pre-enlightenment atmosphere, but also Handel and Haydn. Handel represented a massive shift from church to theatre, but there is no doubt about his piety or his Christian charity. 'Messiah' was performed again and again, as a contemporary remarked, to set at liberty the captive and to relieve the widow and the fatherless.

The years 1790–1810 are the time when the musician emerges as a prophet, writing music to accompany the march of revolution or of nationalism. On the whole, music has been and has remained the most religious and the least political and revolutionary of the arts, but 'Fidelio' and the 'Eroica' and Choral Symphonies are self-consciously prophetic documents. They embody the hopes and despairs of the revolutionary ferment. At the same time the musician also acquires the status of virtuoso and minor entrepreneur. He is released from a secure role amongst the service personnel of Kings, Electors and Archbishops and enters the service of the market. He depends more on the market and less on patronage. And he adds the character of 'star' to the office of prophet. As 'star' he appears before the audience and inaugurates the era of the public concert, appealing to wider and wider sectors of society. Insofar as he takes on the office of prophet he composes music which exemplifies a new kind of seriousness. He composes music expressing the new romantic awareness of nature, as well as 'absolute' music. The musical prophet addressed a serious bourgeois congregation in the terms of absolute music. There emerged a canon of serious music to place alongside the canon of scripture.[2]

Yet music maintained strong links with religion and some kind of connection with the Church. Beethoven wrote the Ninth Symphony, but that nevertheless invoked a free humanity standing united before God; and he also wrote a

supreme invocation of the Deity in the Missa Solemnis. Similarly Berlioz, who followed Beethoven in panegyrics for Napoleon, also composed the 'Te Deum' and 'The Childhood of Christ', in spite of being an atheist. Even in France, the most secularist of cultures, there was an institutional link with the Church in the French organ school and composers like Fauré. All the same, the weight of serious performance and composition now lay in opera, orchestral and chamber music, each of which marked transitions away from the Church. Opera was a shift to the theatre, orchestral music to the civic concert hall, chamber music to the salon and the drawing room.

The new prophetic character of sound was related to the new prophetic nature of sight, particularly the sight of nature. For the eighteenth century the natural world was a vista and a prospect. Nature was a landscape with figures, carefully ordered or set in nice disorder. God was displayed in the steady movements of the heavens and the great chain of being. He had designed his creations with exquisite care and nature was the book in which men might read the purposes of God. Every delicate natural mechanism illustrated his infinite intelligence. A flower might witness to the Creator in the delicacy and intricacy of its design; a cat might praise God in the variety of its movements. Nature displayed the Deity: 'Lord, how thy wonders are displayed Where'er I turn mine eye.'

Then gradually nature emerged as a power in its own right. The book of natural phenomena opened up a mystical union with God and conveyed a spontaneous moral impulse. The awefulness of divinity was translated into human awe before the mighty universe. The world had the aspect of the sublime and might attract man's free worship and communion. So nature became a domain where man discovered the religious impulse and acknowledged religious feelings: awe, communion, admiration, worship, renewal, healing, consolation.

This theme requires emphasis here because it was so strongly related to the emotions engendered by music and by ecclesiastical religion. Music, nature and religion were all sides of the same pyramid, reaching up to the same apex. Perhaps in no European culture was there such a union of feeling as occurred in England. Natural creation, revealed religion and inspired music worked together for moral and religious good. Indeed, the poetic images used to describe the religion of nature borrowed freely from Christian associations and musical metaphors. Thus Wordsworth in 'Tintern Abbey': 'So with an eye made quiet by the power of harmony and the deep power of joy, we see into the life of things.'

So Englishmen enjoy a special association of sensibility. The countryside can be their confessional, the concert their mass. The sacred rites of Catholicism and the psychic seriousness of Puritanism have together been channelled into the meal in the country and serious listening in the concert hall. A man begins as a Methodist and ends in the Bach choir. Music has become a kind of theophany, replacing the Word and even – if George Steiner is correct – replacing words. The universal church of sound is now a channel for feelings of exaltation, release, consolation.[3]

Thus music picks up signals of unfocused, inchoate, religious sensibility and the word is partially replaced by sound. The record begins to take over from the book, the concert audience – or the rock festival – replaces the congregation, and the quest for ecstasy displaces concern for dogmatic assent.

Music provides perhaps *the* major serious ritual performance of our contemporary society. It demands attention and commands devotion. The rites of the concert are tended with appropriate solemnity. Both the attention and the devotion have grown over the past hundred years. A Henry Wood Concert in the early days was often a relatively

light-hearted affair, and the concerts of the mid-nineteenth century were comprised mostly of short pieces and excerpts which made little demand on concentration or sensitivity. Now the conductor is celebrant and the soloists his concelebrants. The concert is a contemporary high mass for the modern bourgeoisie.

This was obliquely hinted at a generation ago by the music critic Eric Blom when he said that attendance at a concert should be counted as equivalent to attendance at divine service. The Church itself takes partial cognizance of the situation. If you are in Sweden and look around for evening service you will find it is literally evensong. Curiously enough this parallels almost the very first concert performances which were provided by Tunder's and Buxtehude's 'Abendmusik' in the Marienkirche, Lübeck. If you go to Guildford Cathedral you will find the sermon is periodically replaced by a motet. Perhaps some people still agree with Dean Inge that there is little to justify the notion that God enjoys nothing better than a serenade, but there is not much dissatisfaction with the change. Presumably Karl Barth's view attracts more support, which is that God finds Bach very acceptable when the angelic choir gives public performances, and delights most of all in Mozart for purely private occasions.

Barth's remark is indicative: there is a strong connection between musicality and religiosity. The concert constituency overlaps the church constituency. The slightly wistful unbeliever can see notes as God's Rorschach blots. Bernard Levin points out that to listen to really great music is almost enough to make a man believe. On the musical side there are conductors like Colin Davies for whom music is explicitly a religious and mystical experience. The number of major contemporary composers who have written major works either for the Church or on religious themes is very impressive. The briefest glance at the works produced by Stravinsky or Britten shows the proportion and the

importance of religious works. The proportion and the importance are arguably greater than in the romantic period or the classical period. We would have to return to the Baroque for comparable production and we would have then to take into account the organizational patronage exercised by the Baroque Church.

And this is in a time when the religious element in the other arts is small and has exhibited a decline. Only in poetry among the other arts are there appreciable signs of religious awareness, and that in itself must be significant. Religion is aligned with the sources of ecstasy: music, and to a lesser extent poetry. It is cut off from prosaic statement and ordinary verbal culture. It is odd that this is not more remarked on, and odd that nobody in the Church seems bothered. The long tradition of enmity and suspicion between clergy and musicians, religion and music ought at least to have some contemporary echo. Bell-ringers, church orchestras, organists have all tangled from time to time with the clergy. Bach's struggle with his pastor provided only one classic instance of the clash between music-maker and clergyman. But these personal and organizational enmities are minor compared with the underlying theological issue raised by the increasing assimilation of religious awareness to musical sensibility. Amongst a large number of people it is taken for granted that music is a theophany. They would automatically agree with Carlyle that music 'takes us to the edge of the infinite and bids us for an instant gaze into that'. Pater claimed that all art aspired to the condition of music. Now religion too aspires to the condition of music, and vice versa. If I may again refer to George Steiner, he argues that light, silence and music are the three modes of statement which press on divinity: where words stop 'a great light begins'.

Light, silence and music. Traditionally the Church has had no difficulty with light or silence. Light is one of the great

primordial signatures of God. In Him is light. God said: Let there be light. He *is* the true light. In essence light is divine and by analogy stands for divinity. In the Middle Ages Grosseteste, for example, elaborated a metaphysics of light. Similarly with silence: The Lord is in his holy temple, Let all the earth keep silence before him. But with music it is different. True, the psalmist exhorts people to praise God with the sound of the trumpet and the lute. This does not mean that music is in itself a channel of the divine. Similarly, the ransomed of the Lord sing a new song in heavenly Jerusalem, a city justly famed for its choirs, but that does not make music a theophany.

There is, after all, a difference between an interest in the mathematical perfection of musical relationships or in the supposed moral character of the various modes, and a response to music as a form of revelation. The Church took over part of the Greek theory of music insofar as it related to mathematical relations and the moral tone of the various modes. It did not attempt to put forward any notion of music as unveiling the Godhead. In the same way an admiration for the divine order is not the same as an emotional absorption in the divine power of nature. An appreciation of order and relation whether in music or in nature is included in the ambit of theology, but not the notion that they are the most direct channels to God needing no mediation of Word or Sacrament.

Since music and nature have now been reintroduced together it is worth remarking that both are relatively late in emerging as channels of revelation.[4] There are inevitably some early instances even in the middle ages. In Irish poetry of the eighth and ninth centuries there is a clear delight in the natural world, a sensuous pleasure in creation. That same feeling reappears in the Franciscans, more especially in (say) a poet like Dunbar. Dunbar explicitly links music and nature together: the regions of air are commanded to make

harmony. Everything is to cry 'Gloria in Excelsis'. But while a sensitivity to music often accompanies a religious awareness of nature it remains true that music waits till the Renaissance before it is fully acknowledged as possessing the power of revelation.

How then do we come to grips with the problem of an art which rises to its full development later than the other arts, which for a long time stands in an ambivalent relation to religion and eventually emerges as a major source of revelation in its own right? What *is* the problem of music conceived as revelation? Why is this revelation now so powerful that attending a concert or listening to a record has become for many people their only sacrament? Has this subjective ecstasy come to edge out objective dogma? Is it a stand-in for explicit beliefs? Is music complement or alternative? Here after all, is one of the greatest instruments of human ecstasy placed, like sexuality, in profoundly ambiguous relation to the Church.

Music, nature, sexuality: this perhaps taps the underground stream running through all the passages of argument. It is the problem of a potentially free flow that can wreck three systems. One is the sacramental system which preserves the power of God by acts of containment and designation. Sacrament concentrates power by designation. Another is the theological system which does not wish to compromise the divine perfection by allowing God's existence in all experience. Another is the system of morality and social control, which *must* designate certain areas of appropriate delight and other areas of illicit delight and therefore includes even harmless delights in its normative categories. After all it might be dangerous to leave some areas of experience uncovered. St Augustine is converted to the sound of music, but shies away from it in the service of the Church. Even further than that, the Christian revolution and the formation of radical brotherhood cannot be rooted in

indiscriminate delight, and in sensual or sensuous relaxation: like all revolutions it is rooted in discipline and discipleship. Eating, drinking and women and giving ear to sweet enticing melody all endanger the disciplines required to create the *koinonia* of universal brotherhood.

Yet, of course, it is just this eating and drinking, this union and marriage, this music heard and unheard, which fills the imagery of the Kingdom. The marriage feast, the wine, the dance and the song are the primary activities of the kingdom of heaven. As the Irish saint put it with crude and proper materialism: 'I would like to have a great lake of beer for the King of Kings.' These are signs of fullness and plenitude that makes the rites and sacraments of the Church look economic. So we are confronted by a paradox that just those things which signify plenitude and fullness must be renounced *en route*. They have to be placed at one remove, held at arm's length lest by indulging them now men never arrive at that state where true joys are to be found.

This then is the source of the ambiguity of music for Christian religion, as indeed it is the source of the ambiguity of dancing, feasting and drinking. But in one area, at least, part of the dangerous ambiguity of music has been removed. We no longer have an overarching system of social control backed by an inclusive metaphysical mandate. The ancient linkages between one sector of life and another have been so weakened that it is no longer so necessary to devise norms and rules which englobe the whole system. Free flow does not threaten total inundation. Whole sectors can be sealed off and made freely available for expression. Indeed, many revolutionaries complain precisely about the way in which a control system can be maintained at key points while others can be flooded at will.

So music is released from the sector of discipline and the taint of ambiguity, and begins to float freely. Dance is also released and sexuality is given partial freedom to roam

abroad on parole. Since religion itself has been reduced to one sector certain changes follow.

One has already been noticed: the musical sector takes off on its own and acquires the seriousness of a church and the status of a revelation. The concert hall is a nave with the musician in the chancel. Then the church itself is relieved of the task of moral and social control and begins to explore the traditional sources of ecstasy and of release with greater and greater freedom. It is no longer so tied in to the general control system that it needs to fear that the structure of society will collapse as soon as free flow is allowed. Indeed, being somewhat cut-off from the main power centres it begins to return to the ancient reservoirs of fullness and plenitude. It recognizes in the power of harmony just one of those ancient reservoirs.

It recognizes that music avoids and transcends the critical problem of language. The problem of language is that specifically religious speech can degenerate into the professional lingo of the ecclesiastical enclosure. This means limited availability: the images fall into disuse, the references grow obscure, the cadences become unfamiliar. Moreover people constantly enquire what *are* you saying: do you speak in a special sense? Are you muttering archaic, out-of-date science and philosophy? Are you indulging in magical charms, incantation or nonsense? Music relieves you of that problem. Nobody knows to what music refers: the logic of musical statements cannot be confused with the logic of statements about the world. It has its own world, but nobody asks whether that is this world or the other. It is itself.

That means that music is an inviolate enclosure in a way that theology cannot be. Musical ecstasy cannot be compromised by specificity or treated as a peculiar variety of discursive prose. Yet the sense of a transition is identical in music and religion. A man who enters the world of music is in transit: he crosses a threshold from the subliminal to the

sublime. He is inducted into a different time: a moment in time and out of time. He is abducted by rhythm, simultaneously captured and liberated. Music works like liturgy in the passive-active voice: you place yourself in the circle of enchantment so that things fall into place around you. You are sent to sleep in order to be awakened. You attend and are attentive. You achieve stillness inside the movement. A man listening to music has been centred.

Moreover he is in a circle of communication that is unlimited, at least by the patois of different professions or confessions or natural languages. The universal church of sound invites a universal allegiance. The interior of music is unified and consistent and the language itself is potentially open to all. So the concert offers unity within the self and a universal circle of communicants. I know perfectly well of course that there is a particular social constituency for music as there is also for religion, and that 'classical' music has a specific Western provenance but all the same it does provide the closest approximation which mortals possess to a shared tongue, outside kissing.[5]

The shared tongue links it to the charismatic impulse and the kiss of peace. Charismatic language seeks to reverse babel and to leap over the boundaries of role and the limits to communication. It hints at the universal speech which makes for unity and brings together all nations and tribes and tongues. Indeed, charismatic language overlaps music by breaking into spontaneous harmony. Charisma *is* the free flow of grace. Music and charisma together are the free flow of the spirit. Both work by rules, sequences, references back, but they take the person into a new ordering of social space and time.

This new ordering is literally ecstasy: being taken beyond the static. The ecstasy depends on the order. Without the understood rules and sequences no breakthrough of the spirit is possible. This is the constraint and the limit which is

at the same time a possibility. Music is represented by figures: mathematical relations and the figures of musical speech. Only on that rigorous basis of figuration is transfiguration possible. The musician works by golden numbers. The substratum of rigorous and precise relation shifts towards a potent ambiguity and the invocation of more and more possible worlds. Just as the spirit impregnates the coinage of ordinary speech and gives it a different exchange rate, so inspiration re-orders the relations of sound and makes a new creation. Music cannot be reduced to words, any more than Christian speech can be reduced to ordinary talk. Christianity has to do with a new time and with the invasion of the present by a new order. So alongside the word we have silence and sound, touching and dancing, to signify what cannot be said, to indicate the limits on the potentiality, and the potentiality incarnate in the limit.

> Illic, molestiis
> finitis omnibus,
> securi cantica
> Sion cantabimus,
> et iuges gratias
> de donis gratiae
> beata referet
> plebs tibi, Domine.[6]

Notes

1. I am talking, of course, about England. The revolutionary conservatism of J. S. Bach took the older religious tension far into the eighteenth century. Handel is actually a very complicated case as is made clear in P. H. Lang, *George Frederick Handel*, London: Faber and Faber, 1966. He does not have

Purcell's 'jarring, jarring sounds' (so disliked by Dr Burney), but alongside the sublimity of his powerful architecture there is a Purcellian chastity of line, which is English as well as Italianate.

2. Cf. W. Weber, *Music and the Middle Class*, London: Croom Helm, 1975.

3. G. Steiner, *Language and Silence*, London: Faber and Faber, 1967. On the role of rock cf. B. Martin, 'Symbolism and the Sacred in Contemporary Rock Music' in *Acts of the 14th International Conference of the Sociology of Religion*, Paris: CISR, 1977.

4. It may be, of course, that the intense Christian preoccupation with interior life largely disallowed naïve pleasure in nature up to the Renaissance. Burckhardt describes how Petrarch climbed a mountain and his eye fell on the tenth book of Augustine's *Confessions*: 'And men go forth to admire lofty mountains and broad seas, and roaring torrents and the ocean and the course of the stars, and yet forget their own selves.' J. Burckhardt, *The Civilization of the Renaissance in Italy*, New York: Mentor Books, 1960, p. 221.

5. 'Music is, in fact, "extra-musical" in the sense that poetry is "extra-verbal", since notes, like words, have emotional connotations; it is, let us repeat, the supreme expression of universal emotions . . .' D. Cooke, *The Language of Music*, London: Oxford University Press, 1959, p. 33.

6. P. Abelard, 'O quanta qualia' in H. Waddell, *Medieval Latin Lyrics*, Harmondsworth: Penguin Books, 1952.

PART THREE

REAPING THE UNMARKED SEED

But in the days of the voice of the seventh angel,
when he shall begin to sound, the mystery of
God should be finished.

> The Revelation of St John the Divine,
> Chapter 10, verse 7. (Authorized
> Version)

Illic ex Sabbato
 succedit Sabbatum,
perpes laetitia
 sabbatizantium,
nec ineffabiles
 cessabunt iubili,
quos decantabimus
 et nos et angeli.
 Peter Abelard

10

The Paradigm and the Double Structure

Religious thinking, more especially as realized in the major world faiths, is a form of collective logic, with its own rules and modalities. These rules do not merely organize sets of valid inferences and combinations but take up and express a unique attitude towards 'the world'. Attitudes towards the world are the ground out of which the varied religious logics may grow. They expand upwards and outwards, crossing branches from other roots, growing branches at odd angles, but retaining an organic relation to the one, particular, unique root. Once that is grasped all the varied possibilities, alternatives, combinations and recombinations are already implicit. The root is a universe of possible patterns, a complex latent paradigm, packed into a nutshell but containing almost infinite space. So complex is this paradigm that it can be analysed from a very wide variety of angles, as essentially this or essentially that, and none of these angles is entirely misleading. The genetic code can be read off in a large number of ways, precisely because it contains a universe of possible developments and combinations. But the richness and variety of branching alternatives is not the same as chaos, even though chaos may be incorporated as one possibility.

Religious logic lies somewhere between Lévi-Strauss's notion of 'bricolage' and the sharp, precise edges of ordinary logic. It is not a hybrid, with nuggets of real rigorous thinking embedded in mess, which we can clean off and examine

according to the rules of ordinary logic or empiric philosophy. If for example we examine transubstantiation in the spirit of Bertrand Russell it seems that the priest turns food into God by speaking Latin to it. Religious thinking cannot be isolated in that way. Of course, priestly intellectuals sometimes fit poetic images into an alien frame of ordinary Aristotelian logic. When this happens we have to loosen the frame and lift out the incarcerated over-organized interior.

Religious thinking takes off from a root and reaches out of a unique ground. It pushes against a specific conformation and develops a specific grain, dynamism, pressure, texture, colouring. The thrust is away from and towards. That thrust may be simple and direct or dense and multiple; clearly articulated or messy; extending by complex repetitions or organic transformations. Islam for example seems to me relatively simple and well articulated, and to extend by more complicated combinations of the original message. That at least appears to be the message of Islamic architecture: clear, unambiguous, repetitive. Such judgements are only estimates of relative emphasis and very general tendency. Suppose at least that different roots do display varied degrees of articulation, and cleanliness of line. Suppose, too, that they can proceed by reassembling basic units or by chemical transformations. Suppose even that they can splay out into a small range or a large range of alternatives.

Religious thinking is organic and it must be looked at as a whole. Just as any item of culture gains colour and meaning from its relationship to the total cultural environment so religious thinking works by multiple relations, each implicating the other and providing a vast variety of settings. A religion is a multi-dimensional set, growing and expanding by congruences, proprieties, affinities. A set of beliefs is a table of existential affinity. We need to grasp the whole and

the way different items are set. Indeed we ought not to think of 'items' at all, but of environments which alter as we move around, through and above them. To move through an environment in this way is to sense what range it allows and what range it forbids, to recognize gradually what is an alien intrusion and what is a subtle and unexpected congruence.

Every environment exhibits certain constraints and must invite a viable response to each of them. Indeed, there is an inherent pattern of costs written into those responses, so that an easy and elegant solution of one problem may require a difficult, even perhaps a tortured or tortuous solution of another problem. Any response which attempts a simultaneous solution of all problems will eventually collapse. Only a skewed response, adopting a tactic which attacks certain fundamental issues at the expense of others can succeed. Lack of skew is as fatal as too heavy a skew or the solution of too small a range of problems. Moreover, there will always be a waste element. At least some difficulties will have to be left relatively unreduced and unsettled.

For example, there are reasons why the logic of Christianity runs into trouble with the ineluctable problem of social continuity, and therefore encounters further difficulties with respect to the traditional unit of continuity, which is the family. A superficial approach picks on the Christian attitude to sex and regards it as an unacceptable or awkward item. In fact it is part of a general Christian difficulty over the reproduction of the *status quo*. Sexual reproduction and the reproduction of the *status quo ante* are allied problems, and any logic of regeneration will run into a fundamental difficulty over the basic vehicle of generation: the family and sexuality. This difficulty radiates out in innumerable ways, from the celibacy of the clergy to the relative absence of a satisfactory Christian family liturgy. This example illustrates how important and how inevitable are

points of cumulative strain and how important are the *omissions*. What is not said and not covered is as important as what is said and covered.

It also illustrates the ambiguity that may build up at the point of cumulative strain and the creative role that may be played by strain. Christianity in particular embodies a logic which builds up a rich destructive trouble for itself. The logic of Christianity pushes out strongly in certain directions and encounters heavier and heavier resistances which eventually constitute a social structural *ne plus ultra*. Such conflicts are not all creative, and some will and must end in waste, frustration and pure negativity. Or else they will exhibit mute tortured lessons or possibilities which can only be picked up or utilized or understood very much later or in very different circumstances. But most conflicts will include creative tensions which half-succeed in sliding under the net of social structural prohibitions.

There are structural boundaries and limits which push back the logic of a religion like Christianity. As the cumulative pressure builds up on that boundary, more and more thrusts are repulsed and they then constitute further barriers to advance. The inhibited thrust of a radical logic rigidifies at the point of resistance, and then turns into a reinforcement of the new, slightly altered boundary. When that happens the forces of the *status quo* and the radical thrust begin to acquire ambiguous labels: the new boundary can be regarded both as achieved revolution and as a barrier to advance. It is simultaneously both. Matthew Arnold's powerful image precisely describes the situation: 'where ignorant armies clash by night'. The children of light and the children of darkness each wear contrary masks.

When this has happened the logic of a religion acquires a new and resonant ambiguity. Moreover, those small advance parties which slide under the net of sociological prohibition must either use protective devices borrowed from the enemy

or disguise themselves beyond hope of identification. In other words, a thrust against legitimation will have to build up some legitimation of its own, probably harder, more explicit and more rigid, than conventional legitimacy. And the symbols which appear on the other side of the mined fence will bear devices which obscure the explosive charge they carry inside them. The partisans of purity and clarity will see such symbols as traitors, but they are time-bombs lodged across the frontiers of the possible. The face of change wears the stony mask of the *status quo* and can easily be mistaken for it. Identification would mean elimination. Radical change mostly has to move under false names and in disguise. Some disguises are of course rather transparent: nakedness and silence proclaim their message obviously enough though they have divested themselves of revolutionary uniform. The Cromwellians knew well enough that Quaker silence and Quaker nakedness carried on revolution by other means. They knew the state of nakedness impugned the nakedness of the state.

So the thrust of radical logic pushes against the complex mesh of structural prohibition. Radical sons reappear on the other side of the fence in the guise of stern fathers and the problem of Christian logic turns compulsively on the relation of father and son. Indeed once the son has crossed the boundary and has sat down by his father's side it is not clear whether fatherhood has been changed or sonship subverted. Or to put it another way: it is no longer clear whether radical thrust has been blunted or established practice altered. The relationship of regeneration to generation remains in any case problematic: regenerating sons and generating fathers are now both painted on to the great inclusive dome of religion and both are ambiguous. Religion strives to regulate, contain and harmonize the ambiguity, to relate change and continuity, subordination and equality, regeneration and generation. Thus a document like the so-called Athanasian

Creed becomes a locus of tension, the complex resolution of cumulative strain. There are few religious statements which carry such a heavy load of sociological meaning.

Not only are symbols multivocal but they work in all the media. I have already mentioned silence and nakedness. The absence of clothes or the absence of speech are symbolic gestures operating in different media, though they often occur simultaneously. Indeed, the opposed extremes of the *same* media can sometimes carry an identical message. To speak in a 'tongue' above all normal language may be to convey the same message as to refuse to speak. So not only are symbols Janus-faced but opposed symbols can carry identical meanings. Yet whether ambiguous meanings lie in the one symbol or identical meanings lie in opposed symbols, they tend to overflow several symbolic channels and create a complete multi-media environment. The tongues and the silence, the nakedness and the sober clothing, will eventually settle into a pattern which organizes life comprehensively. Every medium will be marked by potent congruences with every other.

For example anyone entering Notre Dame at the beginning of the thirteenth century would encounter a symbolic universe realized in all the media of sight, sound, gesture and conceptual thought. The gestures of priests and people, the disposition of bodies, the pattern of movement, the dance and theatrical development of liturgy, the splay and frame and intensity of light and shadow, the hierarchy, style and choice of figures, would all comprise a symbolic universe. The new theories of Abbot Suger, the new architecture of Notre Dame, the new pulse and tone of the music of Léonin and Pérotin would together articulate a complex relation of time and space. The congruence of elements can, of course, be pushed too far, and few universes have been both so unified and so dynamic as that of Paris in the years 1160–1220. At other times different symbolic sectors may

shuffle along at varied speeds, or develop complex alternatives and counterpoints: a Bach cantata played in a church by Fischer von Erlach is both in and out of time, a complement and a counterpoint. Yet the point about complementarity throughout many media is still worth emphasizing.

The argument so far can now be summarized. Religious thinking is a form of collective logic, built up on congruences and affinities. It spreads upward from a unique root and has to cope with certain ineluctable constraints and limits. As it pushes against the boundaries it cannot solve all the problems simultaneously or equally well and the direction of the original thrust becomes increasingly ambiguous. Religious symbols slide under the net of sociological prohibition and reappear in disguise, carrying explosive charges which have to wait on time and circumstance. Meanwhile symbolic universes strive towards a minimum unity, incorporating the ambiguities and disguises in a single multi-media world. Perhaps the real analogue of this logic is music. There is a root or generator which breeds certain fundamental divisions or relations which then shade off into fainter and fainter harmonics. Each root or generator stands in ordered relationship to other generators. It cannot be complete in itself except in a condition of absolute rest; and there is an ineluctable 'wolf' in the cycle of related generators. The overall development of the system is towards greater and greater ambiguities and creative uncertainty. The meaning of the harmonic universe is internal to itself, and each axis is central only as the hub of relations and meanings. It is as useless to ask what does C mean as it is to ask what God means: C and God are equally pivotal. The analogy clearly breaks down, but music is closer to religious thinking than either ordinary logic or poetic tradition. Ordinary logic is too unified and impersonal; poetic tradition is too fragmented and personal.

Yet it is nevertheless possible to distinguish key elements from peripheral or merely decorative elements. The roots deriving directly from the one, particular unique ground are carried by certain fundamental symbols. It is these which bear the basic code. The logic of Christianity is carried in such codes as virginity and the heavenly city which were developed earlier. So there are strong lines of force and weak ones, axial symbols and decorative symbols. The strong lines are simultaneously a theologic and an ecclesiologic, theology and ecclesiology, an architecture of thought, of people and of stone. The point about a minimum congruence applies equally here. They are stretched over the kind of frame I indicated earlier, with points of easy and elegant fit complemented by points of tension and strain. There will also be significant gaps. But the lines of symbolic force will lie nevertheless across the following formal framework. They must propose an exemplary humanity and a contrary perverse humanity. They must elaborate a cycle of approved benedictions and maledictions, with their appropriate objects and recipients. They must divide children of light from children of darkness. They must point a Way to perfection and identify a malign source of imperfection. This Way can then be converted into a map of divine and human, demonic and natural territories. The territories must be regulated by a law governing their relationships and powers, and the law must contain the conditions of its own abrogation. Control and release, law and grace must be promulgated simultaneously. And all these ways and powers must exist within some particular articulation of time and history, their axes, modes, internal divisions, tendencies and directions.

So the fundamental symbol becomes double-edged, ambiguous, comprising established substance and dangerous shadow. That dangerous shadow is not however impotent: it is a time-bomb lodged in an alien structure. It is a latent

explosion, a part of a complete paradigm, all the elements of which are attached to explosive shadows. That paradigm is the very idea of a double structure, and the danger lies in the way the double structure is articulated through every institutional area and every concept. The mesh stays in place but it is the very defences of the *status quo* which are mined. Those defences simultaneously push back any second wave of conceptual subversion and constitute a fifth column within the world of established forms.

The fundamental double structure is the idea of the two swords and the two cities. Second birth is linked to a second law and to a second city.

The concept of two births, of two swords, two realms, two laws, two cities, expresses the dangerous shadow behind the established substance. Theologically it can be seen as a pervasive reserve about 'the world', and sociologically as an irreducible element of differentiation. Christianity creates the image of a Doppelgänger, a ghostly and spiritual alternative which dogs every legitimation of the principalities and the powers. Every judge, every king, every lord and every lady, is doubled by another jurisdiction as well as supported by that jurisdiction: the law of God above the law of man. The kingdoms of this world are potentially the kingdom of Christ. There is no large concept of human authority and almost no detail in all the ceremonies of legitimation which is exempt from this infiltration.

Take, for example, the way in which the signs of royal majesty and military strength are infiltrated with powerful and redemptive reversals. In Christian imagery the insignia of king and advancing army, banner and conquered city are converted to signs of a prisoner and a sad procession, expelled from a city behind the banner of the cross. Vexilla regis prodeunt: 'The royal banners forward go.'

Of course, infiltration must wear the necessary disguises. And it must operate within a frame which partially nullifies its

impact. For example, the Kingdom of God will be redefined as co-extensive with the historical reality of the Church, and the special law of God will be utilized as the basis of ecclesiastical privilege. Again, the specific law of God's kingdom can be represented as applicable only to an enclave within the Church, so that the division between the things which belong to God and those which belong to Caesar serves to create a 'middle wall of partition' inside the Church itself. The Church makes the idea of God's realm the foundation of its own hierarchical structure. For example it is perfectly possible to see the distinction between the lay and the priestly as a conservative redeployment of the distinction between what is God's and what is man's. By the same token the partition within the church between nave and chancel expresses the shadow by inverting its meaning. In other words the degree of radical thrust ensures there is an almost equal and contrary thrust which redeploys the radical concept upside down. So not only do Caesar and God collude but the very structure of alternatives is converted into a perverse hierarchical form. The hierarchy of priests symbolically represents the special sphere of the spiritual, and the fatherhood which belongs to the priestly office constitutes a counter to every form of secular paternalism. In this way the shadow, the alternative, the double-nature if you like is subverted. And those radicals who wish to reassert the alternative must initially attack the symbolism in which it became encased. It is precisely the previous advance which has to be destroyed before the next can be attempted. And it is precisely this destruction which will undermine the second advance. The second wave will have to jettison just that set of conceptions which are the key to radical criticism.

Once the second wave of assaults is well under way it is often the half-submerged concepts of the first wave which re-emerge with their revolutionary potential. But they cannot emerge with that potential until they have been nearly

destroyed. The dialectic balance between second wave and first wave cannot be maintained. The rival conceptions must divide into potent contradictions dedicated to mutual destruction. For example the dialectic between those who believe that God's realm is most nearly achieved in a double structure of institutions and concepts, and those who believe that this double structure is the main satanic barrier to universal redemption cannot be held. In short the alternatives must subvert themselves in the very attempt to realize themselves which is another reason why their faces are disguised and turned backward.

I have argued that the double nature of Christian concepts is realized in details as well as in large-scale structures. I will conclude with three examples that embody precisely the significant detail I have in mind. Take first of all the right of sanctuary. In a sense, of course, it offers a very limited protection. Yet a set of symbolic associations is thereby established which enables the believer to recognize the corruption into which those associations necessarily fall. There is a continuous interplay of redemption and fall, in that redemption establishes the kind of tiny symbolic enclave which makes clear the falsity of its own claim. The 'sanctuary' is the domain of peace and love outside the corrupt realm of violence. So the Church offers 'sanctuary', that is a small space within which violence is abrogated. That space is defended by the notion of sacrilege, that is the sacred law of grace above the secular law of retribution and reciprocity. Sacrilege and privilege go together: a special area set apart. The boundary of that area becomes more and more sensitive because instinctively people realize that here lies the symbolic frontier of hope. To violate *that* is to violate hope itself. A reference point has been established from which to define corruption and to recognize the fall. This is why Becket's murder is so significant. At one level it is merely a clash of two jurisdictions which are both corrupt and collude in mutual

corruption. At another level the very idea of two realms and of a law of God above the law of man is threatened. A parallel analysis could be applied to the refusal of the Church to take direct responsibility for burning a heretic. The concept of the secular arm is the residual sign of God's realm. It does not become the community of peace and love to execute judgement on the erring or dissident.

The same point may be illustrated from the very notion of canon law. The separate jurisdiction allowed to the clerical estate expresses a quite radical idea: God's realm embodied here on earth. The New Testament says that God's children do not take each other to law before the secular courts. The Church appropriates this idea and expropriates the radical thrust. It now becomes an engine of clerical privilege: the right of clerks to be above the law. The abrogation of law has been converted into the legalization of privilege.

The same process occurs when clerics are exempted from military service. Such an exemption carries profound implications: can a father-in-God kill a brother-in-Christ? The sense of horror aroused by a priest who kills witnesses to the universality of God's Kingdom. All men are one in Christ and those who represent Christ must not violate that unity. Yet precisely that symbolic boundary provides a source of privilege. True equality between men insists that even those who preach the gospel of peace shall kill their brothers like everyone else. Indeed, so profound is this boundary and so jarring is the resulting paradox that the peacemakers are psychologically thrust into the role of warmongers. This is because a radical doctrine cannot really face the concept of a grey limited fight and has to turn every war into a crusade. Yet this too has a curious impact on the collective conscience. The compulsive Christian idealization of war becomes so patently corrupt that it undermines the very idea of a crusade and the whole notion of *milites Christi*. The trouble is that every revolutionary putsch must claim all of life and everyone for

virtue, and can only succeed in the universal establishment of corruption under the banner of incorruption. St Paul's great affirmation is exactly inverted: this incorruption must put on corruption.

The last exemplary detail is taken from the very act of legitimation itself: the enthronement of Popes and the coronation of kings. The Pope was the universal vicar of Christ and also *servus servorum Dei*: at his enthronement he received a symbolic warning: *Sic transit gloria mundi*. Yet it is the universality of his role as servant which ensures he will make claims to universal dominion. The virtue of catholicism is its corruption.

Yet the symbolism of the universal father still carries inside it the boundary that marks off the glory of this world from the glory of Christ. Just so in the coronation ceremony the sword of state is entrusted to the sovereign as a trust from God. The sovereign will then try to misuse the idea of trust as a direct legitimation of his role. The crucial limit indicated by the notion that all power is held in trust is precisely the basis on which the powerful will claim that they exercise power by divine right. Even so, the symbolic boundary tells everyone that here is a limit. When kings or emperors crown themselves, as did William I and Napoleon, they cross that limit and affirm legitimacy without limits. When English kings placed the royal arms over the rood screen they were on their way to unlimited legitimacy. They placed their own armorial device at exactly that juncture in symbolic space which both separated lay and priestly and proclaimed the boundary of God's Kingdom. The device was removed and replaced at the door. There is a limit to legitimation, and, for that matter, to secularization. Sacred space is very odd: it is always cross-cut. Sacred boundaries lie across each other, creating joint sectors either doubly sacred or doubly secular. It is impossible to simplify and unify that space.

These symbolic enclaves of grace do not remotely exhaust

the implications of the double structure. The protected area of transcendence and grace provides an emplacement from which the idea of independent intellectual contemplation and judgement may draw strength and reinforcement. In the same way the right of conscience draws sustenance from the potency built up within the distinction between the law of God and the law of man. Thomas à Becket and Thomas More together are the twin saints protecting the precious enclaves of conscience and judgement.

11

The Pursuit of the Equal and the One

I will begin by returning to one or two basic assumptions. The only prolegomenon to an analysis of how men pursue the equal and the one is a statement of social reality, more especially the reality of hierarchy and division.

Human society depends on three elements: continuity, contiguity, hierarchy. Continuity is rooted in inertia. Human anticipations and plans require some degree of predictability and human identity requires some continuing, recognizable frame within which it can be realized. There is no society without order and the very idea of order implies and requires persistence. Social action is predicated on repetition and social understanding depends on a repertoire of received stereotypes.

The frame of social identity has to have an edge. The edge may be sharp or vague, permeable or impermeable, but it will still demarcate insiders from outsiders, natives from offcomers. Insiders will be those intimately linked in a web of association which has been built up by work and family ties and shared modes of understanding. Insiders are usually those who were there first: first come, first served is a very important prop of social construction. The distinction between insider and outsider defines an essential perimeter of graduated obligation. The perimeter may contain many concentric circles, and the widest, faintest line may even include the whole of humanity, but there will still be a

distinction between strong ties and weak ones, strong obligations and weak obligations. The principle of first come, first served is supplemented by the axiom that charity begins at home.

The necessity of continuity and the constraining power of contiguity are not easily disputed. The principle of hierarchy may seem at first glance to be in a slightly different case. There are, of course, acephalous societies and groups which are very fragmented and resistant to organization. So hierarchy in the sense of superimposed grades and linked chains of super-ordination and subordination is not absolutely universal. It belongs to all complex social organization, but the simpler societies exhibit it only in attenuated form. In this context hierarchy means something a little weaker than classes or grades or sets. It is simply that every society generates foci for determining what is allowed and legitimate, and these foci will inhere in categories of persons. No group is without its usual channels and those who open and close the locks along those channels. Not everyone will agree about what is legitimate or appropriate or allowed, but the flow of action will be channelled along certain lines of social force, organized around certain points of social magnetism.

Suppose then that society comprises these basic elements of continuity, contiguity and hierarchy. Continuity may be translated as inertia and predictable order: tradition. Contiguity may be translated as particularity or as association: the primacy of near over far, long term over short term. And hierarchy may be translated in terms of social magnetism and lines of force, as well as in terms of settled grades of superordination and subordination. These constitute the preconditions of viable social life. There may be others, less germane to the argument that follows, but these at least count among the essentials.

The lines of social force and the boundaries of identity, association and obligation will be coded in an accepted map

of signs and images. The structure of understandings will be projected onto a screen. Men will see themselves as screened on the social map. Words and images will convey the self-understanding of the group. These words and images will cluster around the means of persistence, distinctions of power and social magnetism, boundaries of obligation and belonging. The projections will embody a landscape of social signs taken at a particular angle. This constitutes the angle of social vision. Usually the angle of social vision will include group origins and group ends and promulgate a charter of acceptable practices and approved ways of being and conceiving. It will govern a man's relation to self, to his fellow men, to his society in general, to nature and to the world of gods or spirits or whatever is regarded as ultimately real and valuable. The maps and charters may be more or less comprehensive, more or less reflected within each separate psyche, but they will provide a frame of words and images within which men can experience and relate. Men know themselves and their neighbours and their gods in pictured sign, in verbal signal and in the accepted demarcations of social time and social space. Their world is bounded, categorized, partitioned.

In the course of history there have been a myriad projections, taken from every angle, some of them very comprehensive and inclusive, others more acute, side-long, fragmented and partial. The great world religions are immense repertoires of themes, often brought together from more partial or fragmented visions and comprising consistent sets. These sets are the fundamental structure of options, the limited basic range of alternatives. A fundamental set provides a context for the repertoire of themes, constraining their internal relations and likely paths of development. Christianity is just such a set and Buddhism is another and very different set.

So each world religion is a mighty language, a framed

landscape of related signs and linked images, a shared, consistent set of options. A world religion must code the underlying structure of social necessity: inertia, contiguity, hierarchy. But it will also code the transcendence of the underlying structure. Social necessity will be complemented by various versions of transcendence which embody intimations of change, universality and equality. These intimations arise partly by an extension of social experience or a near universal canvas such as was provided by the Roman Empire, partly by a realization that alternatives do exist, and partly by a direct perception of how traditional and revolutionary, universal and particular, hierarchical and equal, exist in complementarity. It is very difficult to specify precisely how men come to conceive of a basic shift from the particular to the universal and from the hierarchical to the equal. Nevertheless, this shift does occur, though not all at once and not without enormous regressions. Such a momentous shift of balance must activate huge counterweights. There is a moment of fusion, an axis or crossing point when in principle the vision has moved from a primary emphasis on the particular and hierarchical to a primary emphasis on the universal and equal. All the regressions after that will be counterweights but not deadweights. They will be poised against the reality of the fundamental shift.

The great shift is towards unity and the abolition of partitions: between man and man, ruler and ruled, insider and outsider, man and God. Men aspire to create one, sole, unified world in which the partitions of time and social space are broken down. They desire to make all one: ut omnes unum sint. So the whole structure of partition is declared redundant. Man has overcome the inertial power of the old division signs and inaugurated the single sign of unity. He has broken through to universality and equality. The argument which follows is about what happens when the breakthrough

to unity encounters the underlying necessities of social life: inertia and tradition, particularity and contiguity, hierarchy and social magnetism. The setting of that argument is the one major version of the breakthrough which we call Christianity and which we acknowledge in the division of time between BC and AD.

Redemption is concerned with the achievement of unity and at-onement. The middle wall of partition is abolished. But the hope of what may be is defined against the reality of what is. What is revealed and uncovered must be protected from the corrosions of the 'world' as presently established. The border of the new truth must be distinguished from the territory still held by error. Universal truth cannot admit any compromise with error. Those who seek truth must be separate and distinct. So unity breeds disunity and the universal embrace creates antagonism. The little flock of the redeemed will become estranged from their old affections and associates and will in turn be rejected by the world in general. When men seek to make all brothers they begin a process of estrangement and activate profound antagonisms.

This is the first paradox: the abolition of all frontiers creates an even more fundamental frontier between the abolitionists and the rest. There is a second, complementary paradox. Those who break up the ancient inertias of tradition must establish a new tradition of revolution. The new idea can only maintain itself by stereotyping, repetition, reinforcement. And being new it may require more intense reinforcement than the old. Change requires inertia, the dynamic must have recourse to the static. This change and this dynamic will be the basis of a new division of time. New order is posed against old order, New Testament against Old Testament, and the precise connection between the two becomes an important problem. Does the new negate the old, fulfil it or subsume it? The New Testament stresses fulfilment rather than negation. 'I am not come to destroy but to fulfil.'

But division cannot be avoided. Men are divided into children of light and children of darkness, and time is divided into the new age and old order. Unity creates division. To seek unity is to initiate schism. The New Testament records the dilemma: not peace but a sword, the setting of brother against brother, the breaking up of the family.

Unification is about the One. It seeks at-onement and reconciliation. To reconcile is to bring together. But the dynamism of unity makes for borders, breakages, divisions and stark alternatives ranged against each other. An alternative is an 'alter', an other. The one generates the other; one begets two. So the Christian myth is made up of warring alternatives and demands a positive or negative response. The gospel of peace must be realized in an image of relentless warfare. Mankind is offered a choice, either-or. The universal breath of the spirit conflicts with the particular affections of the flesh. Flesh must be brought into subjection to spirit and the redeemed must triumph over the damned: not peace but a sword. The sign of atonement is a division sign, a sign for rising and falling. The apocalyptic discourses in St Mark and in the Revelation of St John describe what the new age must mean.

So what is the logic of universal love poised against the structure of man's natural affections and the necessities of society? It is that the universal must be carried in the particular. The worshippers of the One cannot collude in the worship of the Many. The luke-warm and Laodicean will be excommunicated: 'Because thou art neither cold nor hot I will spue thee out of my mouth.' Unity in faith, hope and love requires an edge of intolerance. This edge must cut-off or compel: excommunication or compulsion and re-education. To be one in love demands the highest discipline, and where discipline fails as an inner achievement of the spirit it emerges as external compulsion. Where love does not impel by inner conviction 'love' will compel by force.

A terrible inner logic joins free encounter in love and in mutuality with inquisition and excommunication. When this logic becomes linked, as it must do, with the brute force of local tribal consensus and the demands of order and authority, the result is the religious version of totalitarianism. Inquisition is as much a consequence of love as it is a perversion. Love generates inquisition and inquisition is the degeneration of love. The Jewish criticism of Christianity is correct: the border between those who espouse the universal religion of love and others will be marked by hate. Crosses become swords. In the first instance those who desire unity will be in receipt of violence, and in the last instance they will administer violence. Love is not niceness or manners. The demands of love initiate a discipline more intense than the demands of civilized decency. Love and atonement require sacrifice. Love is war. The disciples of love assemble under a bloody sign.

The disciples of universal love assemble in the cause of Christian liberty. They are a liberation army 'washed in the blood of the Lamb'. This military image introduces one further paradox. Just as the search for unity creates new divisions, and just as love creates borders manned by hate, by compulsion and excommunication, so the quest for equality requires discipline and hierarchy. The disciple of equality is a man under orders. Egalitarian hopes are based on equal submission to one Lord. This seeming contradiction is not peculiar to Christianity. The brotherhood of Islam is rooted in submission. The comradeship of communism demands total obedience. In the New Testament we find a surprising characterization of friendship: 'Ye are my friends if ye keep my commandments.' There is a link between equality in love and obedience to command.

The egalitarian impulse in Christianity is clear and radical. All men are to be kings and priests 'in Christ'. Where everyone is a king and a priest there kingship and priesthood are abolished. The free and equal relation of man with man

permits no mediation. At the same time it requires the mediation of the New Covenant. Just as political comradeship in the cause of liberation demands the mediation of a single political authority so the brotherhood of love demands the mediation of the one Lord. If men are to reach the Promised Land they have to march as one army, not meander across Jordan as the fancy takes them. Yet the relationships amongst political comrades or Christian brothers are held to be qualitatively different from other relationships of superordination and subordination. The Master is as the servant and the servant is made into a friend. The last celebration of the disciples was a rite of union, reversal and of commandment. The usual relationships were inverted: he who would be lord of all must be servant of all. The brothers were united in the self-giving of the Lord and in sharing one with another through him. And they were given a commandment: Do this. So it was a mediated unity and they were enjoined to share in the New Covenant.

The disciples were the chosen. Every radical brotherhood breeds an élite, either an élite of power or an élite of suffering. The political hero and the saint are both elect. The relationship between equality, unity and election is nicely caught in the hymn 'Elect from every nation yet *one* o'er all the earth'. In principle everyone is called but in fact few are chosen. A core is always refined out of the mass and the core members have to act on behalf of their weaker and more confused brethren. The monastic orders have to carry on the spiritual warfare for the rest of humanity; the Communist Party has to act on behalf of the proletariat until false consciousness is overcome, by enlightenment or by force. And of course once any universal religion or universal party takes office the notion of the elect becomes fused with the reality of élitism. In Christianity the fusion remains partial, because Christian faith retains a distinction between God and history, between truth and established power. In

Communism the fusion is total because God has been subsumed in the historic destiny of the Elect and so their truth has come with power. Of course all radical brotherhoods seek the final union of truth and power, one way or another: 'Thy Kingdom come, thy will be done, in earth as it is in heaven.' But in Christianity that union is understood under a sign of reversal: the cross is the power of God. Power is realized in weakness and this displays the true weakness of the world and of the powers that be. For Communism truth comes with power 'in time': the active power of the proletariat is co-extensive with the advance of truth and in due course of time men will see face to face rather than through a glass darkly. Both Christianity and Communism eventually act to ensure that men do not look through false glasses. The Inquisitor is the arm of the religious elect and the KGB the arm of the political elect. Equality does indeed breed hierarchy and comradeship terror.

But this is not the only relation of equality and hierarchy. All radical brotherhoods demand exacting resocialization, and resocialization requires supervision. Moreover it is important to recognize how the paradox of equality and hierarchy plays into the paradox of revolution and tradition and into the paradox of universality and division. A brief examination of what is involved in a radical, universal brotherhood may perhaps show this interplay more clearly.

The brotherhood aspires to realize the universal kingdom of God, to bring unity where there was division, peace where there was war and equality where there was false distinction. Holy nations, holy kings, holy priests, holy places and holy lands are all part of the geography of partition and therefore abolished. Relationships of domination are dissolved in the disciplines of love. The inertia of generations is broken by regeneration; the loyalties of the family extend to include all mankind. This is unity and it is coded in images of unity: one God and Father of all, who is in all and through all; one

Lord, one faith, one baptism. All nations and tribes and tongues stand before God, Christ represents humanity in the holy place, the middle wall of partition is broken down, the suffering servant is one and the same triumphant King. The faithful wait for the coming of New Jerusalem, in which there shall be no temple because the division of church and world, holy and profane has been overcome. 'Be of good cheer, I have overcome the world.'

This is the aspiration, clearly stated in the New Testament. But what is required of the radical brotherhood? First, the brothers must distinguish themselves from humanity at large, and this means demarcation and separation, that is particularity. Then they must ensure that the life of the brotherhood is distinct from the life of the world. The pull of tribe and family must be rejected and this means control over the natural affections. Agape must counteract Eros. Control means discipleship and discipleship demands discipline. Discipline is rooted in the repetitive rhythms of continuous resocialization and in foci of authority which ensure the maintenance of new standards. The enclave of grace is sustained by rules and the brothers are subordinate 'in love' to fathers superior. A whole hierarchy of spiritual fathers appears parallel to the ordinary structure of paternity and patriarchy. Thus unity has given rise to division and this division is further realized in a complete and comprehensive duality: Church – World, spirit – flesh, body of Christ – body of this death. Without the hope of unity this comprehensive duality could not exist and would relapse into mere inertia, particularity, hierarchy. Division is predicated on unification, just as relativism is predicated on objectivity. Indeed the two problems are related: it is men's pursuit of unity which must express itself in division, just as it is men's pursuit of the one truth which must express itself in awareness of ubiquitous error.

12

Modes of Change: Including Marxism and Sectarianism

This final chapter is concerned with the ways in which the latent paradigm of Christianity is imprinted and transformed. The paradigm contains a double structure, church and world, children of light and children of darkness, pressing towards unity and unification. There are several ways to seek unity and two are to be considered here: the Marxist heresy and Christian sectarianism. Each of them encounter in-built limits, so that they then exemplify the brokenness of the human situation in the very attempt to find a final cure.

The chapter begins with the way the latent paradigm is sunk and imprinted in the collective psyche. It then takes two primary elements, the idea of martyrdom and the idea of the master made servant, showing how they carry forward a potential for change. Then the rhetoric of Marxist and Christian subversion are run together to show how the paradigm and one of its major mutations are related. But of course they are still different, so there follows a Marxist critique of Christianity and a Christian reply. Critique and reply both show up limits, brokenness and frustration written into all attempts at unification. These same limits are then considered as they are found in Christian sectarianism and in the symbolic arsenal of sects, for example pacifism, nakedness, silence and tongues. The last section takes the

central signs of Christianity to show how limits are recognized and also transcended, simultaneously acknowledged and pressed against.

The Latent Paradigm

The paradigm is reproduced in three main forms: the formal structure of dogma by which is meant incarnation, atonement, resurrection, ascension; the basic imagery, such as garden and city, wilderness and way, mighty acts and holy people; and the structure of concepts. All three forms are implanted deep in consciousness, though the structure of concepts is not often grasped *as such*. Few people recognize how deeply axial concepts of time are imprinted, or how the binary view of issues is presented by ideas like 'the world' set over against 'God's Kingdom' or 'the children of darkness' set over against 'the children of light'. If men acquire the axial concept of time this does not mean that they grasp the importance of the *general* idea of a qualitative shift in the temporal order. To think in terms of a frontier separating truth and error, maleficence and beneficence, God and Mammon, is not to perceive the underlying structure. These general ideas and fundamental patterns lie latent in the mind, too close and intimate to be seen.

Not only do they lie latent in the mind but they lie latent in culture. There has to be a structural opening before latent possibilities are released or potent translations made available. For some observers the period of latency seems very extended and they conclude that a paradigm shift such as we see in Christianity really made rather little difference. Or they conclude that the main elements in the shift were already partly in being. So indeed they were, since no shift occurs until most of the necessary elements have been assembled. Bultmann in his *Primitive Christianity* gives an overview of the

varied elements building up to the Christian explosion.[1] Once the chemical union of all these elements has occurred the new paradigm must implant itself by successive repetitions. This will take time, but not a long time in the perspective of human history. A thousand years is 'but a day' in the story of humanity, let alone the sight of God. Friedrich Heer has rightly suggested that a religion only achieves a penetration after one or two millennia.[2] Consummation has to wait on a slow assemblage of potencies. It depends on the vast secret arsenal of concepts, a structure of expectation, anticipations, hopes and disappointments. A slip-way has to be laid down before what has been patiently constructed starts to move. George Steiner has pointed out the qualitative difference in a culture which must be made by countless repetitions of the gospel story and sayings; and Herbert Butterfield has suggested that this is also true of preaching. The effect of liturgy, gospel and word, is indeed part of a secret history ignored in the chronicle of battles and economic transformations.

The Church creates a world of thought and anticipation which must arouse disappointment with the Church. This illustrates the point about expectations. Only a partially successful church can create a climate of expectation which defines its success as disappointing. The Church is a kind of autodestruct, most clearly successful when undermining its own formulations.

Two Illustrations: Martyrdom and Inversion

This chapter will illustrate these contentions, beginning first with two items in the paradigm: martyrdom and the general pattern of inversion, whereby the master of all becomes the servant of all and the prostitutes enter the kingdom of heaven before the pharisees. From these two items it will be possible

to slip to the Marxist mutation and then to various sectarian or utopian experiments.

The concept of martyrdom is so familiar as to seem natural. That is what is meant by imprinting: the concept appears inevitable and inherent. Martyrdom is not merely courageous persistence in beliefs or in loyalties: it is the achievement of victory through defeat and the validation of truth by willingness to die. Clearly *too* many martyrdoms result in the extinction of the faithful. Nevertheless, martyrdoms are the seed of the Church and the seed of political movements as well. A political hero who dies in the fight for freedom or in the class struggle is living and dying and living again on psychic capital long invested in the idea of martyrdom. Latimer told Master Ridley to be of good cheer even at the stake because they would together light such a fire in England as nothing could put out. Irish nationalism lives off the death of martyrs. In other words the court of history has been tilted in such a way that the executioner is condemned and the victim declared innocent. The divine victim presages the role of victimage.

Authority trembles to create martyrs and victims, unless it can provide some acceptable form of philosophic annihilation to justify physical annihilation. This nihilation is normally achieved by drawing on the moral bank of previous victims or strugglers. New Inquisitions must declare themselves trustees of the bank of virtue. Church authorities managed to condemn in the name of the martyrs just as the ignoble army of the Khmer Rouge murdered in the name of the noble army of strugglers. Each establishment must try to expropriate the bank of virtue to which martyrdom has made such a major contribution. Trade Unions, for example, do well to persecute religious objectors to union membership in the name of the Tolpuddle Martyrs and to invoke the poor of the earth whenever they press for an increased differential.

The underlying point is simple: authority has been forced

to justify itself by reference to groups who were not themselves in authority or party to wealth and status. Once authority justifies itself in these inverted terms it offers a rhetorical possibility to the opponents of authority. Of course such rhetoric will only come fully into play once there is an opening for the poor to speak and incentives for others to speak on their behalf. The structural possibility needs to be there before full advantage can be taken. But so also does the structure of rhetoric need to be present. Christianity has put all the successors of Pontius Pilate at a permanent disadvantage, including the Church itself. But that again is very characteristic: Christianity undermines its own cultural embodiments.

The idea of martyrdom leads naturally to the general pattern of inversion. This pattern is proclaimed over and over again in the foundation documents of Christianity. Longfellow's poem about King Robert of Sicily puts the point very nicely. King Robert overhears the monks chanting the Magnificat and declares it objectionable and subversive: 'He hath put down the mighty from their seat and exalted them of low degree.'[3] Those who are bidden to come to the feast are replaced by guests picked up on the byways at the last moment. The prodigals are as well received in heaven as the faithful. The master is as the servant, and the servant is as the son. Children enter into the Kingdom of God and wise rabbis are excluded. The poor inherit the earth and the rich enter the Kingdom with singular difficulty. One image after another checks, qualifies, or inverts the accepted hierarchy of knowledge, virtue and power. Weakness itself is a kind of strength. And with these signs of inversion go signs of reversal: it is the stone the builders rejected which becomes the head of the corner; it is the crucified one who rises again and ascends into the heaven of heavens, whence he shall come again as judge. The judgement itself weighs all in equal scales, but it is Lazarus who lies in Abraham's bosom. Almost every

Romanesque tympanum tells us the same story of condign and equal judgement.

All these images are to us primary platitudes, but that is precisely the effect of imprinting. A rhetoric of inversion now and reversal and judgement to come is a powerful engine against every buttress of power. It can be seen, for example, in the idea that the poor must in the end be victorious, and that the struggle can conclude in no other way but defeat for the ruling class. The poor, including the poor in spirit, are granted ontological superiority. They are accorded justifying grace in the present and victory in the future. Such notions feed directly on the paradigm imprinted by Christianity. The link between Marxism and Christianity is very clear in this respect.

Running Marxist and Christian Rhetorics Together

But the link is strengthened by the structural relationship between Christianity and Marxism notably with respect to axial time and binary opposition. Marxism and Christianity both offer a leap to freedom 'in the fullness of time' or of history, and both demand an Either-Or: 'He that is not with me is against me.'[4] The children of light confront the children of darkness. The 'time of troubles' or the onset of crisis will lead to signs or economic portents. False prophets will appear here and there, misleading some for a while, but when the true revolutionary epiphany occurs it will be as the lightning from east to west. Man will then be reconciled to man and the contradicitions of human nature and human society resolved. A new man will appear whose fullness of stature complements the fullness of time. He will express and know the truth directly and reject all distortions of himself or reality.

The limited and distorted revelation of the old dis-

pensation is now absorbed into the fuller revelation. It is therefore otiose, and such virtues as it seems to possess, the respect for the law or for individual freedom, are so many whitenings of what is already a sepulchre. They are apparent goods lodged in systematic evil. The divisions and partitions of the old dispensation will be meaningless in the new once the canker of self-love or – alternatively – the cancer of class organization is removed. And all this will happen because it is written in the womb of prophecy or the womb of history. History is gestation, groans and troubles, dangerous births. The whole creation groans waiting for deliverance. Marx and St Paul lean on the images of the womb.

In those sentences Marxist and Christian rhetorics have been run together. The overlap is more than a set of incidental similarities, analogies or poetic borrowings. It depends on precisely the fundamental structure of ideas. The individual expressions are alike because the structure is so close. When structures are very similar it becomes more than ever necessary to observe where they differ and how certain operations can transform the one into the other. Here are some illustrations.

Setting Them Apart Again

One operation is a simple change of voice from passive to active. The crucified saviour and the martyr both act passively: they sum up and cancel the suffering of man and bear in their own bodies the resistance which the world offers to truth. That resistance is sin, located in the very structure of relations, condemning men to alienation from the true end of their being. But in Marxism the concept of martyrdom is stood on its head: the triumph of the hero of the revolution is not in the eschatological future, but here and now, soon, on this very earth. The hero suffers briefly now, but it is his

enemies who will eventually suffer. He fights against principalities and powers with his raised fist. The cross by contrast only offers the field to evil. Indeed, passive suffering is part of a general retreat from the attack on the social forces of domination and from the attack on the domination of the natural world.

Another operation which complements the change of voice is the shift from individual choice to those objective relations which provide the restrictive context within which choices *must* be made. To condemn riches is not enough: one must destroy the structural relationships which are caused by capital and which perpetuate the capitalist class. Indeed, the appeal to the individual ignores the fact that the power of objective relations deprives him of the capacity to affect the fundamental course of events. He can only be effective when he has handed back that illusory choice and subordinated himself to the objective vehicles of revolutionary power. Individuals have no power of themselves to save themselves, but they will have true individuality once the nexus of objective, oppressive relations has been eliminated. The illusory freedom of the old order is the essence of alienation. There may, of course, be an interim, a carry-over period, in which the subordination of the person is greater than under the old social order, but this is a redemptive, interstitial moment, prior to the emergence of true individuality. One must always remember that the good face of bourgeois liberty appears to Communism, as Pharisaism appeared to Christian liberty: the best and therefore the worst of the old order. The paradigm of the redeemed man under the old dispensation is the paradigm of alienated man under the new. The Marxist views Christian virtue as St Augustine viewed pagan virtue, that is as splendid vice.

Marxist Critique of the Double Structure

These operations and other complementary ones are designed to eliminate just the double structure which has been identified as central to Christianity. In the eyes of the new revelation these doubles, 'church' and 'world', temporal judgement and eternal judgement, express only a social disease, a schizophrenia. The double, the Doppelgänger, must cease to be a powerful shadow and unite in a single substance. God, the universal penumbra, must be incarnated in the movement of history and lend His illusory omnipotence to the power of the vehicles of history. The time bombs located in the established structures must be set off, released from the fantasy world of symbolic forms and made active and real in the life of man. A secret code lodged in established structures is only an alienated image, which must be re-energized, activized, incarnate in all men. The heavenly father may seem to be challenged by the son but in the end the son is always incorporated in the false Trinity, co-opted into the regime of domination. *In nomine domine* contains the accent of domination even as it also contains ambiguity. That ambiguity is just enough to mislead: sufficient light to attract and insufficient to enlighten. Therefore the virtue of Christianity, this *double-entendre* and this ambiguous validation of the world, is the most dangerous of illusions because it can look enlightened. Christianity enables people to be dominated by their own hopes because it includes genuine hope inside the structure of false hope.

And the more genuine that hope the more tragic the incorporation. There is one form of Christianity more dangerous to truth than any other and that is the form which is closest to truth. A seeming progressive Christianity, like a seeming free man, is the final trick of illusion and must therefore be exposed and destroyed. That destruction need not occur immediately because pragmatic necessities make an

alliance of genuine progress with illusory progress highly desirable. Marxists and progressive Christians may work together in the interim but this is not because the end is not certain, or the end of those Christians in doubt. The unity of truth will command their elimination. It is only the false tolerance of bourgeois society which allows men to collude with religious error, and that is only because the enlightenment of capitalism is dark enough to need darkness. Real enlightenment would have no commerce with superstition. When the true light is come there can be no darkness at all. Neither God nor revolutionary man can tolerate darkness. For in Him and in them is no darkness at all.

This means that the *whole* structure of Christianity must be incorporated without remainder. It is not enough to suggest that certain items may be left to religion because not fully covered by revolutionary theory and praxis. For example, the realms of individual virtue, vision and judgement cannot be handed over as the residual sphere of illusion. To hand *that* over is the final and most subtle betrayal of revolution in the name of false liberty and false liberality. The natural world is a universe and the social world cannot and must not be a multiverse. Psychic space must be unified. The true revolutionary cannot tolerate religious illusion in the name of bourgeois tolerance. The revolutionary manifesto is not an interesting reinterpretation or a creative extension, but a new summa, a complete reincorporation of old contradictions in the inclusive paradigm. It speaks to the Old Testament of bourgeois liberties as Matthew and the writer to the Hebrews spoke to the Jewish legalities of the old dispensation. Nothing from that old dispensation must slip through into the new dispensation except as incorporated within the new Book of the Revelation and in Marx's gospel. Social and symbolic space must and will be unified: *all* the middle walls of partition must be broken down.[5]

If a new paradigm in science or social relations must subsume the old paradigm then the boundaries of the *double-entendre* must be erased. They are the geography of contradiction, the semantic signs that harmony is *not* achieved. The separate existence of the spiritual arm is just such a sign of contradiction: it must therefore be utterly subordinate to the secular arm. The protective boundary set around the individual conscience is another contradiction, rooted in relationships which divided the truth of man from the truth of society. Men will only become free when that last protective boundary of individual freedom has been removed. The idea of the free church or the individual conscience is a partial notion, conceived in negativity and separation, protecting a false limited freedom because there was a false limiting reality. Only when that freedom is gone and that boundary removed will men be truly and wholly free. Only then will their collective and reasonable service be perfect freedom. For when the perfect is come that which is in part will be done away.

By the same token every utopian plantation or monkish colony of heaven is an expression of contradiction. The boundary around the walled garden of the sect, the monastery wall, the social and geographic seclusion, are signs that the Kingdom of freedom has not arrived. Like the division of nave and chancel the seclusion of monk and the social boundaries of utopia belong to the regime of domination. They can only work by half-measures and by passive resistance. Their passive resistance and their pacificism is the parody of active resistance. The boundary of the monastery must be eliminated and the armed frontiers of the sect removed. The sectarian boundaries are there, and are so carefully manned, because the redemption of the whole has been given up and conceded to the enemy. Those utopians who man those frontiers may appear to be facing towards the light of revolution but they are in fact containing

that light and facing backwards. This is the obverse side of
Christian ambiguity. A subtle bourgeois establishment may
suppose the Christian ambiguity secretly directed against
established power. But from the point of view of established
revolution the reverse is the case. The seeming progressive
images are really looking backwards. Thus all utopianism
must be converted to realism and the frontiers of communal
utopia rubbed out until brought into the universal circle of
society.

Spiritual élitism such as we find in sect and monastery is the
reflection of social élitism and contains the established image
in inversion. Social élitism breeds the spiritual élite as its
reflection and contrary. And the established social élite live
off this contrary because it siphons off contradiction in the
very act of expressing it. So the Molokan and Doukhobor
communities must realize their true end through an-
nihilation. A Molokan will be a true Molokan when he
ceases to be a Molokan and becomes a New Man. If he resists
he is a victim of a distorting social reality and needs
rehabilitation. If he resists rehabilitation then he is ill. The
new science of the new man must deal with his persistent
recidivism. He belongs to the community of the mad or the
criminal. Thus the continued existence even of progressive
Christianity is no more or less than the pathology of
revolutionary triumph. It signifies a lack in the revolutionary
regime and must be treated as symptom of that lack, not as
pointer to alternative realities or alternative possibilities. A
short way with sects is to smash their boundaries and release
the prisoners of religious fantasy. The limited must be
forcibly united with the universal. The double structure must
be destroyed. All men must be reformed in the image of the
one, universal truth.

Christian Comment on the Marxist Paradigm

This is how Marxism views Christianity, more especially 'progressive Christianity'. It is new unification confronting old unification. In fact, however, the Marxist approach is yet another version of the final solution. The solution is: dissolution. Once a political sect becomes a political church, exercising control over a whole society, then it must define its boundaries as *terra sancta*. The discipline of the early political disciples becomes the universal law of the new society. The original organs for the maintenance of integrity and doctrinal rectitude furnish the basis for a new holy office. Thereafter it is only a very short step to an Index Librorum Prohibitorum marking the boundaries of truth and preventing the incursion of error or slurs on Soviet 'socialist' reality'. It may even be that the Puritan thrust which maintains the discipline of the Party Militant turns against any potential agency of chaos, including love. Thus it appears that in contemporary Cambodia (1978) fierce restrictions have been placed on the expression of romantic sexuality. The unity of the elect cannot allow the particularity of romantic affection or what it regards as the diversion of energy to non-political ends.

Political religions must lay claim to the whole of life and forbid the exercise of private option. Privacy is condemned as a bourgeois notion separating the political from the personal and thereby castrating the political. And it is also a Christian notion since transcendence lies beyond the confines of the given and outside the body of society. Privacy and conscience must be prohibited because both presuppose that the true corporate reality of the new society is not fully present, or that the true body has not yet arrived. Marxist theory knows that the truth is come and demands that all recite the Ave Verum Corpus.

True Christian churches and sects exhibit some of the same

disciplines and prohibitions as these exemplified in Marxism. All such tendencies are attendant on the push to unification. They are stronger in Marxism, partly because politicized religion is new and raw, and partly because the freedom of the individual has been defined as negative and God has been abolished as otiose. Marxism constantly struggles to close the gap between social power and truth, between the immanent reality and the transcendent potentiality. The potential is not 'out there' but already incorporated, at least in principle. Fantasy cannot float freely any longer because it has found an appropriate point of attachment. God's lightning has been finally earthed.

Christianity acknowledges just this gap, defined by the divine transcendence, and also allows the individual mystic to leap across the gap. So the Christian push to unification stops short of incorporating God in the approved social vehicle of truth, and leaves some margin open. It is true that the margin is not always very great. Traditional Catholicism allowed very limited rights to error and even now, progressive Catholicism allows quite limited rites to Catholic traditionalists. Not merely so but the margin cannot be fully exploited except in those groups which have given up both the corporate eschatological hope and a defined, absolute focus of truth. The ordinary Protestant denominations, by virtue of an individualistic emphasis and incipient pluralism allow the fullest range to the necessary margin. Churches have historically tended to identify truth with the organs of an inclusive ecclesiastical society, and sects have made truth nearly or totally co-extensive with their own corporate reality. The margin of individual interpretation now existing in contemporary Western societies is a rare historical achievement, at least as concerns those world religions that have pursued the goal of unity.

The new union of truth and power, theory and practice, which now extends its influence over larger and larger

sections of contemporary society must fight against any 'practice' which is divorced from the exercise of political power and organized revolution. This means it must lean very heavily on religious practice because it seeks to restore the alienated believers to the domain of scientific truth.

Thus revolutionary power and scientific validity are co-established in an indissoluble union. Social and cosmic reality are proclaimed one and indivisible. To fight against the new powers that be is to challenge the universe and history. Private interpretation is abolished, not by fiat, but by scientific decree. The dream of a unified truth has become reality. Mankind is united in knowledge: the active rituals of science, that is Marxist science, can be man's only viable practice. Thus, while in Western societies some of the high priests of knowledge may occasionally inveigh against fringe science, or complain that politicians are uninformed bunglers, in Communist society there is one single organ combining correct political judgement and scientific verity. The roles of politician, scientist and priest are finally reunited, not necessarily or always in one individual and glorious person, but in the unity of practice. A professor of scientific atheism is therefore an exponent of the established truth with special reference to those who continue defiantly to 'practice' religiously. The theory says they ought not to exist and the scientific practice must work out ways to ensure that in the end they do not and cannot exist. The practitioners of scientific atheism and their allies in Soviet sociology must engage in an irreconcilable struggle against all phenomena which disturb or contradict the unity of power and truth. The mere existence of religion is an offence against unity.

Of course, in a very limited sense, the ideologians of the East are counterparts of theologians in the West, except that the theologians are not part of the structure of power even in the Church let alone in the wider society. Theology is not exactly a sensitive redoubt of the Western political

establishment. Ideology is certainly *the* sensitive redoubt of the Eastern political establishment. This is why established ideologists toe the party line and why they are allowed out only on parole.[6] They are therefore totally alienated from their own product in a way theologians are not: the contradiction could not be more obvious or complete. The push to unity has engendered alienation and contradiction. Where truth is established a man is *on* parole but does not *possess* his parole.

The Sectarian Variant of the Paradigm

Sects are experimental models: mock-ups to some, instalments of perfection to others. These models are take-off points of change. Sometimes they provide examples mainly for the initiates. Sometimes a model is put on public view, staged and exhibited. New ideas are taken from the new model and re-used without recourse to patent or acknowledgement. The seeds in the package of change are unclassified and unmarked. Markings and acknowledgements would be damaging and in any case most borrowing is accompanied by forgetting. Indeed, whole detachments of rhetoric can silently melt away and reappear under the opposing banner, for instance the reappearance of Puritanism under the protection of Women's liberation, or the radical vocabulary of exploitation and commercialism refurbished in the arguments of anti-pornography crusaders and traditionalists.

The clear logic of the Marxist theory and the massive contradictions to which it gives rise allow a fruitful comparison with the variety of ways in which sects and utopian or idealist groups seek the goal of unity. Two groups are especially useful for such comparisons: the Unification Church and the Doukhobors. The dynamics of Marxism, and

for that matter the dynamics of anarchist sects, can best be understood in the context of sectarian Christianity. After all, Engels and Kautsky both asserted a genealogical continuity with Christian sects, though sectarianism is condemned as otiose with the dawning of the new era of scientific Marxism.[7] Thomas Münzer was early enough to be advanced; Weitling was late and contemporary enough to be abused; the Doukhobors stayed around long enough to be annihilated.

The Unification Church is a body which seeks the unity of faiths, the unity of scientific knowledge and the unity of East and West. The aspiration to a unification of religious practice and scientific thought not only places it within the genealogy of Marxism and of Comte's 'Positive Church' but runs parallel to those religious movements which regard revelation as part of the theoretical and descriptive order known to science, such as Christian Science, Scientology and Spiritualism. The unity of science is made contributory to the unity of mankind.

What is particularly interesting is the sharp tension which has developed between the claims of the Unification Church, otherwise known as the Unified Family, and loyalty to the conventional family. The Church is constantly accused of breaking the ties of its members with their families of origin in order the better to redirect love and loyalty towards a sectarian end. This accusation is a standard reaction of society at large to religious initiatives, since these channel feeling upwards to some ideal or to God the Father or his earthly representative, in this case the Korean religious leader, Sun Myung Moon. Early Methodists were accused in exactly the same manner, and so too are the Exclusive Brethren and the Children of God at the present time. The sectarian group is thus placed at war with ordinary settled society in exactly the same manner as the political cell and the monastic cell, and for exactly the same end: the universal brotherhood of mankind. The classic text is to be found in the New Testament

itself: 'He who puts mother and father before me is not worthy of me.'

The creation of a new cross-cultural unity can either choose celibacy as did the Shakers in nineteenth-century America and the whole monastic movement or else it can regulate sexual attraction and marriage within the sectarian confine.[8] This means eliminating conventional notions of choice and even limiting the right of unrestricted contact between spouses. In the Unification Church marriage partners are chosen by higher authority, apparently so as to maximize the fusion of colours and cultures. Spouses are on call to be sent hither and thither on the task of salvation, and the offspring of 'blessed' marriages are the nucleus of a new humanity, removed from the ravages of original sin. Thus the corrupt consequences of the temptation of Adam and Eve are reversed.

The radical reconstitution of the human family means that the New Testament is subject to reinterpretation. So far as can be gleaned from the Biblical record it would seem that early Christianity dealt with the particular affections of the flesh by declaring that some men and women might be 'eunuchs for the kingdom of heaven's sake'. However, unification theology sees Christ as destined originally to marry and produce the perfect family. It was the failure to consummate this divine plan which necessitated a new initiative on the part of the Reverend Sun Myung Moon who has himself married the Mother of the Universe and begotten perfect children. The logic by which the record of Christianity is rewritten is impeccable and illustrates the extraordinary consistency of theological thinking as it reorders concepts to fit the requirements of a new vision. The thought processes of radical religious groupings may appear as a mythological mish-mash to the outsider, whereas they are usually well-ordered and seamless throughout. The thrust to unity is not only inclusive but consistent.[9]

The logic of sexual control is not the only way in which particular affections may be rendered to create a new brotherhood. Sexual promiscuity may be deployed for precisely the same purpose. The Children of God profess the same unifying purpose as the Unified Family, and do so through making Eros an agent of Agape. There are thus several roads to the same unifying end: celibacy as embraced by the Shakers, the subordination of marriage to celibacy as insisted upon by Catholicism, supervised marriages as are insisted upon in the Unified Family, or the antinomian espousal of promiscuity. What the outer world labels promiscuity, and what the sect sees as loving availability, eliminates the sense of 'mine' and 'thine' and is logically and emotionally consistent with community of goods.

It not infrequently happens that an initial thrust towards asceticism puts on too much pressure and there follows a sudden shift to promiscuity. The communes of divine love are sometimes accused of precisely this, and the accusations are often correct. Unity in love literally embraces all mankind, especially those who have found the true focus of unification. This indeed is why practices like the kiss of peace have to be so carefully controlled lest brothers and sisters are tempted to convert earnest kissing to kissing in earnest. If control does break down then the dissolution of the sect generally follows rather rapidly. The antinomian heresy spread abroad by radical chaplains in Cromwell's army could raise up no permanent structure by which to ensure continuity.[10]

The Doukhobors also professed the goal of unity, and at one stage in their history believed this by taking all their members into God. The 'Christs' and 'Marys' of radical Doukhobor theology removed the limits around the idea of incarnation and declared all men gods, as if the resistance of sin and the recalcitrance of structure were already overcome. Once a sect is composed of free and equal godlings the ordinary rules of communication and exchange can easily

collapse in anarchy. A spiritual élite, fulfilled with all grace and heavenly benediction, may do as it wills. Each human person mirrors each and every other without alienation or mediation.

The symbolism of the Eucharist is treated as already realized in reality. At the same time the universalization of the godhead in the co-equal members of the sect builds up a high wall between those who have shares in God and those who have not. The wall is a boundary across which fully liberated sectarians may make forays into the territory of evil. Thus Doukhobors committed arson as a sign of liberty, lighting the fire of the universal spirit. This in turn tempts the wider society to attack the boundary and assert the authority of the state.[11]

The Symbolic Arsenal: Pacifism, Nakedness, Silence, Tongues

Within the symbolic arsenal of the sects are acts and images which run against the limits set by society. The rejection of war, the espousal of nakedness, silence or tongues, are all weapons used from time to time in the sectarian armoury but blunted and made ambiguous by the realities of the social world. This armoury is worth a cursory inspection.

Pacifism is one important element in the movement towards unity and complements the idea of Armageddon, just as asceticism and celibacy complement the antinomian heresy. This is not to say that all sects reveal polarities of this kind, but it is to suggest that there are strong psychic links between holy war and pacifist withdrawal and to note that the unity of mankind may be achieved either by the sword of the Lord or by the appeal of universal peace. Peace is an essential precondition of a world-wide brotherhood, and groups which seek human unity will tend either to espouse the crusade or withdraw from all the structures of violence,

including the coercive violence of the state and the institution of magistracy. Those which adopt the method of withdrawal are inclined to retire behind a high wall and there build up the select planting of the Lord. The socialization of the elect behind the wall must be exacting, both to prevent incursions and corrosions from the outside world and in order to carry out a variety of novel experiments in social organization. The aspiration to unity and brotherhood requires heavy control behind the sectarian boundary or the monastery wall. The result is a 'heavy', almost peasant-like character or a curious innocence and simplicity of approach alien to the ironies, humours and paradoxes of sophisticated society. The theme of simplicity and innocence lies very deep in the sectarian hope.

So too is the adoption of nakedness and silence, since nakedness makes all men one in their natural uniforms, and silence is uniform and perfect throughout. Moreover silence not only witnesses to the light but mutely speaks of a light that has been obliterated. Refusal to speak witnesses to the unspeakable and the repression of the true universal tongue. Silence talks political volumes. Quaker silence was multivocal in just this way. The Puritan Word wrought mightily and went forth like a sharp sword. Yet the Word was turned aside and the sword used against the professors of truth. When the old dispensation was restored the revolutionary Word went into liquidation and renewed itself as silence. The silence expressed what could no longer be said and signified withdrawal. So silence not only speaks of the unbounded but also of human bondage. The Society of Friends became speechless because they had touched the limit. The revolutionary sword was replaced in its sheath. Quakers would fight no longer for the Kingdoms of this world nor for the Kingdom of Christ.

And nakedness had rather a similar meaning. To strip off was to reject the vestments of the given and embrace the

naked truth. It was to go forward into a new state and to return to the innocence of Adam and Eve before they sewed themselves fig leaves. To go naked is to walk back to the frontier with innocence and try to cross it. It is a sort of symbolic *satyagraha*, carried out in sacred space. To streak is to protest and to deny an old corrupt régime. It declares the wholeness of man.

In this way certain religious symbols are the accompaniment of social revolution: they precede, accompany and succeed social disturbance. For long periods silence and nakedness lie rusting in the armoury of symbols, carefully incorporated and exhibited within the visible church. Silence balances the word, music complements silence. Or subversive silence is shunted away into the monastic siding. There is careful integration of symbols. The conventional state is robed, dressed, its private and indecent parts well covered. Nakedness proclaims the corruption of those private parts and the potential innocence of every part. It is a Christian war pursued by symbolic means.

Where the Word has been assimilated to ordinary language and to the mundane categories of the given the Christian warfare may be continued in tongues. To communicate outside ordinary language transcends conventional discourse as surely as silence. After all conventional speech is related to roles and hierarchies: who speaks to whom under what conditions and to what effect. Speaking in tongues denies this whole structure of roles and hierarchies, even though the ordinary practice of tongues *has* to be regulated by a structure of roles within the Church. This revolutionary act belongs to the whole binary structure of Christian concepts because it reverses a linguistic fall. Babel is confusion and separation; Pentecost is lucidity, connection and vision. Here there is clearly a link with light and darkness because a body 'full of darkness' is in confusion. Lucidity belongs to the world of light and those that have received the light. Paradoxically, the

reversal of Babel is itself confusing to those who do not know the language. The end of confusion is signified by confusion.

This paradox belongs to the spiritual élitism which often occurs in Pentecostalist groups. It means that the storming of one frontier is soon followed by the erection of another. Those who understand the new language become separated off from those who do not. In a sense the wall of partition is broken in that *all* speak the word. All have found their voice and preaching is not confined to the ordained or certificated or educated. The gift descends on everybody including ignorant and unlearned men. Yet the wall of partition is re-erected in typical sectarian manner along the frontiers of the initiated. This does not mean that no breakthrough has occurred. On the contrary whole categories of people speak on their own account, albeit under divine inspiration. They celebrate a unity which transcends all the partitions proposed by ecclesiastical orders and social orders in general. This transcendence is both anticipation of what may be in the social future as well as release and catharsis in the social present. To achieve equality and a voice is a primary step in social progress.

There is a limit: a spiritual élitism, a spiritual humility, and this requires the affirmation of a universality realized only in the enclave of the redeemed. The creation of an enclave is the usual consequence of universal gospels, whether they are political or religious; and the more intense the hope the more the borders of the enclave are marked and remarked, drawn and redrawn. Mere Brethren are very soon Exclusive Brethren. The greater the hope the more violent the schism. Those who want to embrace all mankind are soon forced to the Augustinian conclusion: *compelle intrare*. Rival sects and outsiders must be compelled to come in. Sartre's description of the necessity of terror between comrades is a good modern translation of the fear of God.[12]

So as men approach the frontier in tight political cells, or in

excited enclaves of redemption, they draw their boundaries
tighter to ensure that no boundaries remain once the last
frontier is crossed and the final partition broken. Each cell
and each enclave defines all others as the archetypes of
alienation and false consciousness. To trek to the last frontier
does not allow a vision of varied paths and alternative
possibilities. As was asserted earlier: *only an individualized
notion of redemption which suspects collective or structural trans-
formation can conceive such variability.*

To force men to see the light, to compel the heretic and
outsiders to come in, to draw the skirts of deviation tighter
and beat the bounds of truth: these are just some of the
unavoidable limits that confront those who seek the de-
struction of limits. Political movements acknowledge such
limits by purging those who do not accept the rectitude of
defined theory and designated practice. They indicate that
universality lies only in the future by their use of concepts of
'the interim' and by distinguishing between the leaven of the
party and the *Lumpenproletariat* of the rest.

Religious movements carry the same stigmata, and these
signs of failure are most indelible amongst those most sure of
success. They are space-time vehicles of hope heavily protected
and encased for a voyage designed to break all previous
records and limits. A sect is a capsule which aims to achieve its
end only as that limit is reached. Meanwhile every kind of
hope carries the sign of limitation and erects a symbol of
partition. Some signs are in architectural space, some in
concepts of speech or silence, some in the fundamental idea
of God.[13] When the Church safeguards the uniqueness of
Christ that is a limit between human perfection and mankind
in general. The edge of the sacred element defines the margin
of the divine. The silence speaks of what cannot be spoken
and the plain white wall of what cannot be seen or re-
presented, that is, made present.

Here is a strange example, written by the last priest of a

church aspiring to be catholic and apostolic which is in fact now just a few scattered and despairing remnants.[14] This priest outlined a sequence in time which was also a sequence in sacred space. At the first outpouring of light God was worshipped in the sanctuary. Then in the second time he was worshipped only in the upper and lower choir. Now finally he can only be worshipped in the lower choir. We are now in the period of great tribulation after the breaking of the sixth seal. Before the seventh seal there is silence in heaven for the space of half an hour.

The logic is clear: as the moment of fullness approaches the reality of negation is more absolute. Every hope of freedom encounters precisely this necessity.

Signs of Transcendence: Light, Silence, Incarnation

For ordinary believers there remains open an area of uncertainty: how long, O Lord, how long? Resistance and limits are acknowledged and this makes possible, justifiable, and necessary the liberty of individual conscience and the separate existence of Church and state. To acknowledge the long-term, embedded character of resistance is to leave room in which some limited progress may be made, and some limited free space allowed, however intermittently and partially. Meanwhile the great signs of transcendence remain, moving outside the possibilities of extant society and beyond the potential of the social. The highest ranges of transcendence are exposed in poetic word, in music and silence.

Silence can either be described as a negation, as the Communist inquisitor would have it, or it can be seen as a way of carrying on the Christian warfare by other means, or of preaching the Word without speech. But silence means more than this. Silence is a way of crossing the frontier which

also acknowledges the frontier is there. It conveys trans-
cendence and plenitude under the negative sign. Silence is
like light and music because it enables the fullness of Deity to
be present among men *now* even as it points forward. It is also
like the blessed sacrament: infinity in a grain witnessing to
what already is, as well as what is to come.

Silence is what cannot be spoken. Yet the silent holy of
holies speaks: *Sanctus, Sanctus, Sanctus, Dominus Deus Sabaoth.
Pleni sunt coeli et terra gloria tua.* This is the silence which mortal
flesh keeps before the Beatific Vision. It is a full silence: pleni-
tude, majestas. It is equivalent to YHWH, the secret name
of God which cannot be spoken. Concerning that which
cannot be spoken men must needs be silent. Nothing can be
spoken in the presence of the transcendent Word, that which
was, is now and is to come, the Alpha and Omega, first and
last, origin and end, the Amen.

This is a fullness of silence complementing a fullness of
sound and witnessing to the Word. The language of
Christianity speaks of silence before the entry of the Word
into the world: the Word within the world unable to speak a
word. Before the last seal is broken there will be silence in
heaven. Heaven as symbolized in Revelation comprises light,
music and silence. These are the three modes of statement
which press against the last frontier. Nevertheless that
frontier is recognized. The light cannot be embodied except
broken and refracted. No man can stand naked before the
uncreated light. That is why the partition in the interior of
Eastern Orthodox churches acquires yet another meaning.
Not merely does it mark a limit and define a double structure:
it also allows the vision to move through a narrow doorway.
The light is caught and reduced to what human sight can
receive without damage. The Uncreated Light is kept at bay.

The image of light infiltrates St John, the scholastics
and Neo-Platonists alike, and radiates through English
metaphysical poetry to Shelley, Wordsworth and Eliot. So

powerful an image, which speaks of the unspeakable can and must be inverted. The union of light and silence is complemented by the union of darkness and silence. Ultimates are conveyed by opposites:

There is in God – some say – a deep but dazzling darkness.

All such symbols of unity and purity leads to other symbols like the circle of the ring:

I saw Eternity the other *night*
Like a great *Ring* of pure and endless light.[15]

Indeed it is darkness which leads by secret stairs to the divine union:

Upon a gloomy night
With all my cares to loving ardours flushed
(O venture of delight!)
With nobody in sight
I went abroad when all my house was hushed.[16]

There are two kinds of Light: visible and invisible. There is on the one hand the universal speech of the visible world. God said: let there be light and there was light. We apprehend this directly without mediation because it is a given, Datum. The language of light is impressed upon the open book of nature, which is there to be read by everybody.[17] But the invisible light of the incarnation is screened off, and confined to particular limits. The word made flesh is a gift but not a datum. Christ does not belong to the primordial order of experience or cognition. Moreover the numinous quality of the created world is cut away and reduced to ordinariness. It belongs only to the order of encounter, and is subsumed within the everyday. The unspeakable name has acquired an

ordinary form of address. The transfiguration and the resurrection are closed 'events' available only to a personal response.

This conventional contrast between the universal speech of the creative Word and the dialect Word spoken in privation and obscurity gives rise to translation inside the language of religion. The images of the primordial order of experience are redeployed and reordered in the order of encounter. This redeployment is not merely a poetic device using incidental comparisons and analogies, but affirms the relation between the natural order and the spiritual order. The elements of the one are inherently appropriate to the elements of the other. The universal speech of light is not separated off from filtered light as confined or encountered or realized in privation and obscurity. Ordinary wine and bread can carry the full load of 'I' and 'you'. The doctrine of the Trinity is designed in part to affirm this unity between the universal speech and the dialect, and between what exists now in privation and what exists in glory. The broad language of nature is not divorced from the dialect of existence. The terms of nature can stand for the realities of personal knowledge.

Because Christianity asserts that the levels of cognition and encounter are unified as well as distinct it generates a language in which the two levels are run together. Classic Christian devotion reopens the universal speech of nature even as it encounters the godhead hid in human form.

> For passit is your dully nicht,
> Aurora has the cloudis perst,
> The Son is risen with glaidsum licht,
> Et nobis Puer natus est.[18]

Notes

1. R. Bultmann, *Primitive Christianity*, Edinburgh: Collins, 1960.
2. F. Heer, *The Medieval World*, London: Weidenfeld and Nicolson, 1962.
3. H. W. Longfellow, 'The Sicilian's Tale: King Robert of Sicily' in *Poetical Works*, London: Routledge, 1866.
4. In the New Testament this is complemented by Luke 9, vv. 46–50: 'Forbid him not: for he that is not against us is for us.'
5. There is an important problem here which can only be indicated briefly. Because I am concentrating on the relation between the Marxist idea of liberation and previous dispensations, liberal or Christian or liberal-Christian, I have run liberal and Christian notions in tandem. I have run Christian and liberal notions together just as earlier I ran Christian and Marxist notions together.

This can be done provided the three rhetorical forms are recognized as distinct. For many Protestants there is a natural conjunction between liberal freedom and individual Christian conscience. The two ideas support each other and undergo a common Marxist critique. So Protestants can read the paragraphs above without too much discomfort. But historically Catholics have fought liberal freedoms in the name of the union of metaphysical truth and the civil power. They have shared a fundamental idea with Marxism, which is that error has very limited rights over against the organic unity of truth and the powers of society. This means that Catholics can often shift to Marxism by jumping the stage of individual liberty of conscience altogether. My formulation is very Protestant in that it assumes an old dispensation which conjoins liberal freedom and Christian conscience.

Of course, the picture is very confused at the moment because the late catalyst of Vatican 2 enabled Catholics to discover Protestantism and Marxism simultaneously. They could deploy arguments based on the combination of liberal and Protestant premises against the notion of ecclesiastical authority. *And* they could also deploy Marxist critiques of liberalism in the third world, more especially in Latin America. Indeed, many intellectual Catholics have devised a double and inconsistent critical position, uniting existentialist notions of

the Protestant variety with Marxist critiques of social structural arrangements. It is paradoxical that this Catholic individualism is so recently released for the ecclesiastical format that it retains a religious frame of reference, whereas the Protestant variant has been free floating for so long that it has become a generalized cult of spontaneity.

6. The author has been invited to successive talks with professors of scientific atheism, only to find the talks unaccountably cancelled. In quite another context a sociologist of religion explained he could not come to a meeting because he was 'having trouble with his left eye'. This was thought to be code language for political difficulty. Unhappily he was indeed suffering exactly as he said.

7. In this analysis there has been an implied comparison between the medieval church and the Inquisition on the one side and the Communist Party and the KGB on the other. However, this is unnecessarily offensive to the Inquisition. Medieval society allowed and instituted a complete and varied counter-culture comprising the monastic orders. Contemporary Russian society indeed possesses a counter-culture but it is not even tolerated let alone instituted. The counter-culture is banished to Gulag Archipelago where *laborare est orare* acquires a new meaning. And, of course, the ramshackle tyrannies of the early nineteenth century now look like havens of tolerance and liberty when placed against the achievements of progress in the Soviet Union and indeed in every other Communist society.

8. For the resolution of the problem of sexual regulation amongst the Shakers cf. J. Whitworth, *God's Blueprints*, London: Routledge, 1975.

9. For discussion of the Unification Church (or Unified Family) cf. E. Barker ('Living the Divine Principle: Inside the Reverend Sun Myung Moon's Unification Church in Britain', Extrait des *Archives de Sciences Sociales des Religions*, no. 45/1 – 1978) and J. Beckford ('Through the looking-glass and out the other side: withdrawal from Reverend Moon's Unification Church', *Les Archives de Sciences Sociales de Religions*, January–March 1979, pp. 60–78).

10. Cf. G. Huehns, *Antinomianism in English History*, London: The Cresset Press, 1951.

11. The Doukhobors are portrayed in F. C. Conybeare, *Russian Dissenters*, Cambridge, Mass.: Harvard University Press, 1917;

The problems and polarities of pacifism are discussed in D. Martin, *Pacifism: a sociological and historical study*, London: Routledge, 1965.

12. J.-P. Sartre, *Critique of Dialectical Reason*, London: New Left Books, 1978.

13. Cf. S. Campbell-Jones, 'Stability and Change in Religious Communities. A sociological study of two congregations of Roman Catholic Sisters', PhD, LSE, 1975. In this work Dr Campbell-Jones illustrates the *gestalt* switch in two orders. This study has been rewritten as *In Habit*, London: Faber, 1979.

14. This is taken from 'The Third Stage', a privately circulated undated work by a priest of the Catholic, Apostolic Church in Paddington. This hierarchical, liturgical church is also a millennial sect and its priest describes the stages of its worship and also stages prior to the millennium.

15. H. Vaughan, 'The World' in *A Treasury of Seventeenth-Century Verse*, ed. H. J. Massingham, London: Macmillan, 1950.

16. St. John of the Cross.

17. Here begins a potent group of images of purity, perception and clarity of perception, linking together spiritual light and 'intellectual day'. Grosseteste's great treatise on the metaphysics of light proceeds immediately to optics. The same images lie in the poetry of Milton, the science of Newton and the music of Haydn's 'Creation'. They have to do with apprehending the universal order and form a poetic prolegomenon to science. They also lead to visions of the earth restored in celestial light such as are found in the whole poetic tradition from Thomas Traherne to Wordsworth.

18. W. Dunbar, 'On the Nativity of Christ'.

Index